Lettering

The History and Technique of Lettering

by **Alexander Nesbitt**

Associate Professor,
Rhode Island School of Design

Published by **Dover Publications** Inc., New York

Library of Congress Catalog Card Number: 57-13116

Manufactured in the United States of America.

To the memory of many craftsmen and artists

who, throughout the centuries,

have designed with letters . . .

Preface

Contents

Preface

This book insists on the design value of letters and types above all other considerations. Such a viewpoint is not new—it has simply been neglected. All of the early history of the crafts, when letters were often used solely as ornament, may be looked upon as a precedent. Writers have now and then diverged from their treatment of lettering as an isolated discipline to suggest this viewpoint; but they have usually done little more about it. These conclusions are based on a rather thorough examination of the available books on lettering, type, and layout. Although there are many good and useful books among them, few of the writers have presented this particular viewpoint in a consistent and purposeful manner. The foremost intention of this book, therefore, is to impart an interest and understanding of letters as design.

The first and largest section of the book is devoted to a concise and accurate illustrated history of our letters—really a history of the design of these letters. This section is most important to the student or craftsman, for, once he understands the traditions of his craft—what others have created and contributed before him—there is a chance that he may become a properly discriminating worker. For some reason there is a general assumption that the history of letters has been written many times in the lettering books published during the past half century. Such is not the case; many books do not include a history; practically all the others present it in a hopelessly abridged or chopped-up fashion. Apparently there is a need for a concise and accurate history.

This history deals with the design of letters from their earliest stages until the present. Just enough of the beginning of writing has been discussed and illustrated to give the reader a basic understanding of it. What preceded the fully developed Roman inscriptional letter is properly a matter for palaeographers—hardly something to be discussed at length in a book such as this.

From the time of the classic Roman capital up to the present, however—twenty centuries of evolution—everything that is vital to understanding the

major developments is related or shown. This restriction to "major develop-
ments" is the meaning of the term "concise" as applied to this history. The dis-
cussion and illustration of these developments is again limited to two or three
examples, at the most, of the letter or type in question. Thus it has been possible
to present a genuinely comprehensive history of letters without becoming com-
plex or straying into byways or blind alleys. As for the "accuracy," that is as
dependable as careful research can make it.

The arrangement is chronological, with the exception of Chapter V. National-
ism, which is a misleading factor in any study of art, has been subdued as much as
possible. The entire conception of history is simply based on design changes
brought about in the course of time: changes in style, changes caused by the rise
of a new area of major activity, and those changes wrought by dominant artistic
personalities. The effects of various economic and political happenings have
been noted.

Most of the examples of writing and lettering were written or drawn to suit
the purposes of this book. They were copied from originals or facsimiles—some
quite freely, others exactly. Generally, they were done in a much larger size; so
that in the reproduction the design of the letters would be clear. Type, which has
been neglected in most lettering books, is—in this book—considered as an in-
separable part of the history of letters. All the specimens were enlarged and care-
fully retouched, to give the reader the benefit of clean designs. Of course, line
reproductions of type do not give the effect of the original impression; but all
that matters in this case is the understanding of developments, design, and style.
The student or craftsman may approach original pages or specimens with some
degree of understanding and confidence once he understands this history. In
most instances, the type reproduced here is larger that the original; this has been
noted. Where no notations are made, the letters are approximately of original
size. Repetitious ABC's have been avoided, most of the alphabets being arranged
in letter families.

The second section of the book is a practical course in lettering; Chapter XI
is an explanation of the scope and intention of the exercises that make up the
course. There is no question about the usefulness of a lettering course as a means
of training the eye, hand, and the design sense. This course is planned with such
training in mind. It is meant to be flexible; it may be used as it is or expanded.
The whole book, of course, has the purpose of inspiring the graphic artist to

work at letters, type, and page arrangements as creative design.

Each chapter, with its illustrations, is a self-sufficient unit. Reference to illustrations in any one chapter is always to the illustrations contained in the chapter —unless a specific reference is made to other chapters and their illustrations for purposes of comparison. Since the text and illustrations are so closely integrated, the contents of the book are arranged as chapters and illustrations, the latter taking the place of the customary subheadings.

There are a number of individuals, firms, and institutions to whom I am indebted, in various ways, for their kindness and assistance to me, while working out this book. In the first place, I wish to thank Mr. Samuel Golden, of the American Artists Group, for his confidence in me and in this book. I am obliged to Mr. Robert L. Dothard, of The Hildreth Press, Inc., for the use of the Hildreth and Fales specimen book; and to Mr. William Van Zutphen for permission to use the Elzevir page. A considerable part of my research was done in the library of the Traphagen School of Fashion, with the kindly assistance of Miss Helen J. Smith. In this connection I wish to express my gratitude to Miss Ethel Traphagen.

Mr. Stanley Morison, whose learning and authority have been of so much help to all who work with letters and type, must be thanked for permitting the use of material from the Fleuron, and from On Type Faces, published by The Medici Society. I am indebted to Dr. William C. Hayes, of the staff of The Metropolitan Museum of Art, for his suggestions concerning Egyptian writing. Mr. George W. Bricka has been most helpful in respect to material contained in the book, Poster Design; and Mr. William Zorach has granted me permission to reproduce pages from Zorach Explains Sculpture.

The following New York book dealers have given me assistance in various ways, both from their stocks of fine books and from their wide knowledge of the book business: Mr. Philip C. Duschnes, Mr. William Helburn, Mr. Walter Schatzki, and Mr. E. Weyhe.

Charles Scribner's Sons has graciously consented to the use of my free copy of the rock-tracing from Paul B. Du Chaillu's, The Viking Age. The Oxford University Press has kindly permitted me to use specimens of their Fell type, and reproductions of several plates and part of a page from their book, Catalogue of Specimens of Printing Types by English and Scottish Printers and Founders, 1665–1830. The Dial Press has allowed me to reproduce the jacket of Flight from Reason.

To The Metropolitan Museum of Art of New York, I wish to express my thanks for permission to use a line drawing of the stela of Ta-Bakhet-en-Khonsu; this being made from a photograph of the original stela in the museum. I am also indebted to The Pierpont Morgan Library for permission to reproduce portions of pages from books printed by Simon de Colines and Robert Estienne.

The following firms and individuals must be thanked for permitting the use of various parts of advertising material: the United Fruit Company, the Equitable Life Assurance Society of the U.S.A., the Artcraft Lithograph and Printing Company, The Theater Guild, Clapp & Poliak, Inc., Helena Rubinstein, Inc. and Mr. Charles D'Costa, of Lascelles, de Mercado & Co., Ltd.

Most of the page and specimen material was taken from my own collection of books and specimens. However, it is evident that I am indebted to a number of world-famous typographic firms; and this indebtedness is hereby acknowledged. A list would be too long in this place, so a credit has been given in all instances in the caption accompanying the example of the type shown.

Beyond the individuals, firms, and institutions mentioned, there are many friends and co-workers whose views and methods appear in this book as a result of many years of contact and assimilation—I am most grateful to all of them.

<div align="right">Alexander Nesbitt.</div>

New York, February 27, 1950.

During the past seven years this book has served well in my classes at Cooper Union and New York University. The first edition was a little on the expensive side—I am pleased that Dover Publications is issuing the new edition in their inexpensive series; so that the book will be more available to students.

<div align="center">A. N.
Associate Professor of Advertising Design
Rhode Island School of Design</div>

September 1957

xii

Contents

List of Chapters and Illustrations

Part 2: - Forum type, Frederic W. Goudy - Weiss initials - Cloister roman and italic - A Garamond produced by the Stempel type foundry - Bembo, Monotype Corporation of London - Paul Renner's Futura - Memphis - Ultra Bodoni - Alternate "Gothic" - Rudolf Koch's Neuland - Lydian - Nicolas-Cochin - Koch Antiqua - Bernhard Cursive - Trafton Script - Narcissus - Greco Adornado.

xvi

scripts - *Stages of working out a headline in a built-up roundhand* - How to use the ruler and pen for straight lines - *Diagram of finished headline* - Exercises with the brush - *Simple capitals and minuscules for the brush.*

Lettering

Section One—The History of Letters

From the Beginning up to the Greeks

The Beginning:

Writing, in the widest sense, is everything—pictured, drawn, or arranged—that can be turned into a spoken account: everything, then, that can again be expressed or even thought in simple sounds or words. The fundamental purpose of writing is to convey ideas; but man was a designer long before he wrote; and it follows that in his pictures, drawings, and arrangements the design factor took a prominent place from the beginning. This factor will be given primary importance throughout this book.

It is clear that writing was not invented at any set time or place, but grew out of independent origins at different places and in various epochs of history. Every primitive people had a language and something resembling writing, an early stage of actual writing or a substitute. All sorts of articles and arrangements were used to communicate beyond the limitations of time and place. Stone mementos were erected to recall the events of history; courier-staffs, which had been designfully carved, were sent through the country ahead of a war-party; sticks or pieces of wood served as account-sheets, the reckoning being given by the number of cut-in notches and their pattern; the Incas of Peru conveyed information by means of the quippu, a varicolored complex of knotted strings; the American Indians used the wampum belt to commemorate their treaties and bargains. Such substitutes for writing have maintained themselves in various parts of the world until our own times. Actually, many of the signs and symbols of daily life —the barber's pole, the three balls above the pawnshop—are related to the early stages of the development of writing.

Picture-Writing:

The further development of writing grew out of pictures. Again, there was no isolated discovery—picture-writing was born out of the natural urge to imitate. A good many of these early pictures, of course, represent not writing but aes-

1

thetic expression; it is impossible, however, to separate clearly the need for expression from the desire to communicate news or knowledge. As a matter of fact, this dual nature of writing continues through the history of letters: there is always the possibility of aesthetic satisfaction beyond the mere setting forth of information. In its simplest state this picture-language is universal—it can, in fact, be understood by everyone. What is represented is a chain of thought that is subject to varying interpretations by different readers. This is idea-writing; an example may be called a "pictograph." The Norse rock-tracing and the American Indian pictograph, shown in the illustration, are typical of all such writing—whatever the period.

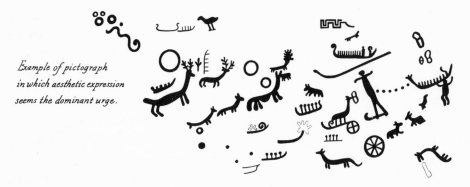

Example of pictograph in which aesthetic expression seems the dominant urge.

Rock-tracing of reindeer, etc; possibly representing a journey to the far north by the man wearing snow-shoes. Bohuslän, Sweden. Freely drawn from Du Chaillu, "The Viking Age"~Charles Scribner's Sons.

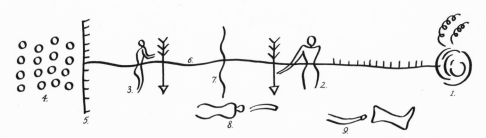

Story of a raid by the Ojibways on the Sioux — 1. Ojibway camp 2. Ojibway chief 3. Sioux chief 4. Sioux wigwams 5. Prairie with a few trees 6. Line of march 7. River at scene of raid 8. Slain 9. Arm brought home as trophy.

Water

Mountains

Star, Heavens

Net, Texture

Ears

Sun, Day, Light

Child

Tree

Heart

Rain

Dog

Field

Weeping

Sun

Swallow

Finding

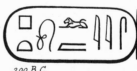

200 B.C.

Cartouche of Ptolemy with
explanatory diagram.

3

At the word-writing or "ideographic" stage, there is an advance to the point where every word—definite object or abstract conception—is represented by a picture. The Sumerians, Chinese, Aztecs, Mayas, but notably the Egyptians in their hieroglyphs, all worked out word-writing systems. Word-pictures, as used by the Sumerians, Chinese, and Egyptians, are illustrated.

The remaining steps before the appearance of the phonetic alphabet may be followed best in the Egyptian writing, although the process was similar for all writing that went through a normal development. A word-sound-writing, in which the word-symbols were compounded to make words in a rebus-like manner, was the next step: the symbols for man and drake, to take an example in English, would be put together to make the word mandrake. A simplification was also achieved by using the same symbol for words of the same sound, for homonyms. Finally, a system of syllable-writing evolved; the symbol now represented the syllable and was consequently used in more elaborate combination. When it represents a sound or syllable, the symbol may be called a "phonograph." From this syllable-writing it was just a single step to the employment of the symbols alphabetically; but the Egyptians never quite achieved that, as we understand it.

The picture-writing of the highly cultured, ancient peoples has survived mostly as relief carving in wood, stone, or some other durable material. Through these examples, which have escaped the ravages of time, we are able to follow the evolution of writing. The Rosetta stone, which was cut at a late date in Egyptian history—about 200 B.C.—is a remarkable example. By enabling scholars to compare the same text in Greek, demotic script, and hieroglyphs, it became one of the keys to the understanding of Egyptian writing. The cartouche of Ptolemy was copied from a reproduction of it; on the stone the cartouche is reversed, reading in the normal manner for Egyptian writing, from right to left.

Look at this picture-writing of the early cultures, especially the Egyptian hieroglyphs, from the standpoint of design. Not only is a story being told, but one may enjoy the most fascinating display of flat design. It is noteworthy that these hieroglyphic symbols were arranged around doorways or in other positions—to be read left to right or down in columns—very much for the sake of design. Most Egyptian monumental inscriptions made use of hieroglyphs; the bulk of literature, letters, accounts, etc., however, was set down on papyrus or other materials, in hieratic or demotic writing.

4

Egyptian Hieratic Script — copied with a square-cut reed pen — original on papyrus.

First used like the hieroglyphs, in vertical columns ~ finally written in horizontal lines, right to left.

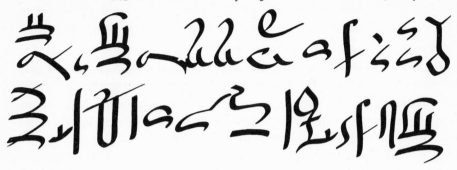

Egyptian Demotic Script — copied with a speedball pen original on papyrus.

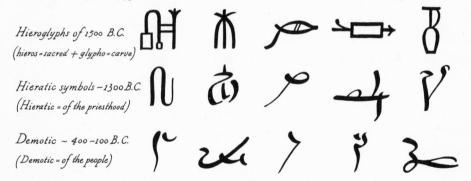

Demotic Script was the final, everyday Egyptian writing

Comparison of Hieroglyphs with Hieratic and Demotic symbols, showing gradual simplification

Hieroglyphs of 1500 B.C.
(hieros = sacred + glypho = carve)

Hieratic symbols ~ 1300 B.C.
(Hieratic = of the priesthood)

Demotic ~ 400 ~ 100 B.C.
(Demotic = of the people)

Cretan symbols ~ 1600 ~ 1100 B.C.

5

Abstract Alphabet:

The greatest step, probably, in the history of writing, was the invention of phonetic writing. It is not possible to establish the first actual use of a phonetic alphabet. The last few stages of picture-writing, which have been discussed, show the concern with phonetics, or the representation of sound; to portray the exact sound of the spoken language more accurately had been a constant objective. Not all peoples had to make their own way through the difficult process of writing development. The Egyptians are remarkable in having evolved it practically entire, during the latter part of their cultural history, a period of some four thousand years. Three stages of writing—ideographs, phonographs, and alphabetic symbols—were used simultaneously in the later writing; the Egyptians never altogether discontinued any one method, but carried the old along with the new. With the other peoples of the eastern Mediterranean, who now concern us, the situation was different. Alphabets were passed from one people to another, so that the receiving people could build upon the foundations of those who gave; writing systems influenced each other or were combined. The Phoenician writing, for example, shows possible influences from Babylonian, Egyptian, and Cretan designs. The inventors of various writing innovations must, apparently, remain unknown. However, in estimating the cultural achievements of any people it is not very important that they invented their own writing system. The main consideration is: what the people in question accomplished in their own or the borrowed writing.

The change that took place in the appearance of the symbols is of importance; our major interest is based on them as designs; in fact, the heading, "Abstract Alphabet," was deliberately chosen to convey the idea of abstract designs— the final alphabet, far removed from realistic pictures, is usually called the phonetic alphabet. In Egyptian writing, the symbols, which at first had been realistically pictorial, were gradually stylized. This, however, had little to do with phonetics, but was a simplification employed by the scribes for their own convenience. Finally, the symbols became abstract. This process may be followed in the illustrations of the Egyptian hieratic and demotic scripts. It is well to remember that each of our letters is also an abstract design—it can be traced back through various stylizations to a picture.

The Greek Alphabet:

Our alphabet really begins with the Greeks. It is generally conceded that they

6

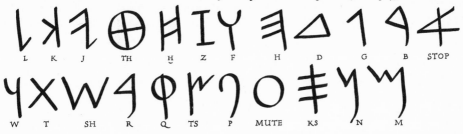

Phoenician reads right to left — small key letters give only approximate value.

L K J TH Ḥ Z F H D G B STOP

W T SH R Q TS P MUTE KS N M

Classic Greek Alphabet after 400 B.C. — note relation to our own and Phoenician alphabets.

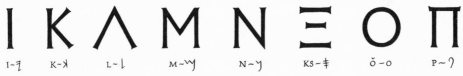

A B Γ Δ E Z H Θ

A~𐤀 B~𐤁 G~𐤂 D~Δ Ĕ~𐤄 DZ~I Ē~H TH~⊕

I K Λ M N Ξ O Π

I~𐤆 K~𐤊 L~𐤋 M~𐤌 N~𐤍 KS~𐤎 ŏ~O P~𐤐

P Σ T Y Φ X Ψ Ω

R~𐤓 S~W T~X ü~Y PH KH PS ō

These last letters and the vowels were Greek additions.

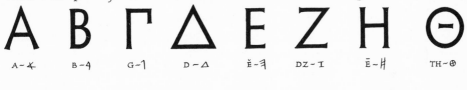

K L E O P A T R A S

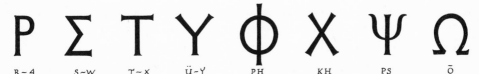

This Greek current writing is freely copied from a document of 101 B.C.
The joined letters and their relation to the Roman current writing are noteworthy.

7

borrowed it—from whom and by what process remains the basis of endless disputes among palaeographers. The first Greek inscriptions using this alphabet date from about 800 B.C.; but it must have been adopted and used at an earlier date. On the whole, the theory that the Phoenician style of the North Semitic writing system afforded the source for this borrowing seems the best, though there are others. A comparison of the Phoenician and classic Greek alphabets is shown in the illustration; naturally there is a considerable difference, for the Greeks made gradual changes. One of these was the change from right to left writing, to the method we use now; the Phoenician letters—as they may now be called—are facing in the direction handiest for right to left use. As often happened in the history of letters, there was an intermediate stage: in this, alternate lines of an inscription read first one way and then the other. This writing was called "boustrophedonic," that is, turning like the ox at the plowing.

With their alphabet of twenty-four letters the Greeks established the course of western culture; they provided an alphabet suitable for all the Indo-European languages. This was done simply by providing definite symbols for the vowels, which, in these languages, are important. The Egyptian and Semitic alphabets had been made up of consonants with inherent vowels, a system unsuitable for the accurate recording of the sounds of speech. At first there were various Greek alphabets, but in 403 B.C. the Ionian version was made the standard; in the age of Hellenism it was widely disseminated by the Macedonian invasions. Alpha and Beta, the first two Greek letters, show the source of the word ALPHABET.

In studying the designs of the Greek letters, the influence of geometry and Greek design in general should be considered. The severe, classic letter, a style suited to "incised," or cut-in letters, was employed for inscriptions and some manuscripts. These manuscripts were written on the papyrus of the Egyptians or, at a later date, on parchment. Our word paper comes, in one way or another, from papyrus; parchment is derived from Pergamon, the name of the city in Asia Minor where this writing material is said to have been first used. As early as the third century B.C., an uncial letter seems to have found a place in manuscripts. This style, as will be seen in the next chapter, was of importance in the later history of letters. A much freer, flowing hand was employed in everyday writing. These everyday hands will be called "current," as they appear; they are important in the evolution of small letters at a much later period of history.

Chapter II.

The Roman Contribution

Roman Capitals:

The most publicized inscription is undoubtedly the one on the base of the Trajan column in Rome, cut into the stone about the year 114.* What the inscription says is, oddly enough, of little interest to most of the people who have written about it; their minute examinations and fervent admiration are devoted solely to the design of the letters. Of course these letters are remarkable; but, actually, they are typical of all the inscriptions made at this time within the reaches of the Roman imperium. These letters were not "built in a day" any more than was Rome; they represent at least seven centuries of development, from Etruscan times to this era of the power and glory of the Empire. They are perfect in function, as a good design should be, conveying that sense of power and glory perfectly.

The Romans borrowed from the Greeks through the intermediacy of the Etruscans—according to the hypothesis now dominant. While the Etruscans always wrote from right to left, the Romans changed: first to the boustrophedonic system; later, to the procedure from left to right, following the Greeks. Roman letters evolved along with their architecture, as a part of the general feeling for design. One should realize that the history of letters is always a part of the general history of style. In the case of the Romans, the connection between these rounded letters, and the arches, vaults, and cupolas of their architecture is obvious.

The A, B, C names for our letters seem to have been given to them by the Romans—possibly by the Etruscans before them. These names were the final result of the "acrophonic principle": at an advanced stage in the development of letters the word-symbol was used to illustrate the first letter of a word, the symbol retaining, however, the word as its name, as in the Semitic alphabets. An example in English would be to illustrate the sound of M by the symbol for Man, because

* B.C. dates have been so marked; all other dates are A.D.

9

Man begins with M. The letter M, however, would still be called Man. The Greeks, when they adopted the Phoenician alphabet, followed the Semitic names for the letters quite closely: 'Alph became Alpha; Bēt, Beta; etc. At some point between the period of the Etruscan borrowing and the development of the Roman alphabet, the Greek names were dropped in favor of the easier A, B, C designations.

The Trajan capitals shown here were copied from carefully selected studies of the inscription. (In this historical section the derivation, design, and influence of all the letters and types discussed will be explained simply; practical problems, connected with drawing or rendering letters, or designing layouts, will be treated in the second part of the book.) Letters cut into stone are called incised; black letters on white paper do not give the same effect; but the effect that is achieved—magic symbols skilfully or knowingly arranged on a clean ground—is the one that has fascinated mankind since the dawn of time. It is this effect, in the most inclusive sense, with which this book is alone concerned.

The letters H, J, K, U, W, Y, and Z are not to be found in the Trajan inscription; they have been added to the alphabet to suit the style of the other letters. The J, U, and W were not contained even in the classic Roman alphabet; the design of the consonant J was differentiated from that of the vowel I about the fifteenth century; the vowel U, from the consonant V beginning about the tenth century; the W, which is really a ligature, VV, derives its name from the use of V as U in twelfth century England— therefore, VV is "double U."

The arrangement on the page is in letter families. These relationships should be carefully studied and the angles and explanatory dotted lines noted. In the first line the kinship is established by the V, which in each letter has approximately the same angle at its vertex. The letters in the second line are all based on an almost full circle, with a certain flattening of the top and bottom rounds in the C, D, and G. Narrow letters occupy the third line; here the relationship is mainly one of width, although for practical purposes E may be considered the basic pattern for F and L—to a limited extent B is the pattern for P and R—the S is based on two tangent circles, one above the other. K, X, and Y all have junctures at the mid-point; the angle and position of each juncture should be noted. The letters in the fifth line are all related to I; that is, they are based on the single upright stroke. N and Z are both letters that depart from the logic of thick and thin strokes; actually, they have the same design in different positions. In the

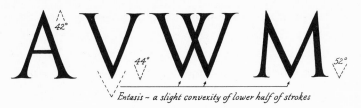

A V W M

42° 44° 52°

Entasis ~ a slight convexity of lower half of strokes

O C G D Q

full circle

Inside oval on tilted axis

E F L B P R S

Ogee line *Serifs are a double ogee*

K X Y

90° 54° 74°

H I J T U

N Z

slightly curved

Entasis

The classic Roman capitals ~ from the Trajan inscription — about 114 ~ these letters are carefully built up.

Trajan letters the cross-strokes are slightly above center, at the optical center, the A, F, P, and R being excepted for optical reasons.

The width of any letter and its relation in this respect to the other letters of the alphabet is a fundamental part of the design of the letter. This principle applies, for these letters, to the weight of the strokes also: about one-tenth the height of the letter is the weight of the heavy stroke—the light stroke is one-half to three-quarters of this again. This variation of light and heavy strokes comes about quite naturally through the use of a square-cut pen or brush held at an unvarying angle to the work. Another result of the use of the pen or brush is the "serif," the spurred or bracketed ending to the strokes. It is generally agreed that the Trajan capitals were painted on the stone with a square-cut brush and then incised by the stone-cutter.

The incised Roman capitals have had, and still have, the greatest influence on the design and use of capital letters. They have remained the classic standard of proportion and dignity for almost 2,000 years, and seem destined to continue in this function for some time to come. Many attempts have been made to tamper with these designs, to condense or expand them, to equalize their varying widths; but the results have been generally poor. This does not mean that these models must be copied slavishly; one is bound to develop a personal conception of letters; but the basic Trajan designs should be studied until they are familiar. One ought also to be familiar with the evolution of these letters between the fall of the Roman Empire and the present. Only a complete understanding of their design and of their entire history is a sound basis for taking liberties—let beginners never try it.

Many attempts have also been made to find a system for making these letters; mathematicians, artists, and designers such as Luca Pacioli, Albrecht Dürer, and Geoffroy Tory worked out constructions for capital letters. The Roman capitals, however, evade all efforts for capture by exact rules. Still, it is best to study the finer points of the Trajan capitals in some handbook specifically devoted to them; architects especially had better do this—for they often need constructions for large inscriptional letters.

Roman Manuscript Letters and Everyday Writing.

Quadrata—Square Capitals:
The Roman capital—"capitalis," as the inscriptional letter was called—appeared

NONALITERQVAMIQVIA

REMIGIISSVBIGITSIBRACC

AIQILLVMINPRAECEPSFHK

FELICESOPERVM·QVINIAMLV

EVMENIDESQVESAE·TVMPAR

COEVMOVE·LAPETVMB

QVALISADINSTANTIS SIGNA

IVBAE·CLASSESQ fRHh OPSUVX

AdcDDEFGhiKLMMNOP

qXSfTU

Xvvsticorumboth Omnibussdx

X YSTICOR UM ET TH OM NIBUS

in a pen variety named the "quadrata," which was made with a square-cut reed or quill. Square capitals were used for such splendid Roman manuscripts as the Virgils of the fourth century. Since this style demanded rather painstaking work on each letter, writing a manuscript was a slow process; it is only natural that a style that flowed more readily from the pen should have displaced it. The rustica, a style that is obviously easier to write, took the place of the square capitals in the fifth century. They were never again employed as a text letter in manuscripts; their use continued, however, in special pages, headings, and as initials. Gradually, over the centuries, they assumed the function of the capital letter as it is found today in our writing, lettering, and printing. The square capitals in the illustration were copied from a facsimile page of a fourth-century Virgil—they are approximately the size of the original letters. In the upright stroke of the L, which rises above the other letters, is indicated the beginning of the evolution of "minuscules," or small letters—the capitals are often called "majuscules."

Rustica:

The derivation of the name "rustica" for this freely-written, rather elegant letter has never been clearly explained—the style is anything but rustic. Most of this fourth- and fifth-century writing seems to have been influenced by Greek artistry and craftsmanship. Brush-lettered verses, mottos, and the like, produced in this style, were found on the walls of buildings in Pompeii; but the letter as used in manuscripts was written with a square-cut pen, generally held between the index and second fingers, as illustrated. This manner of holding the pen accounts for the thin upright- and thick cross-strokes, as well as the lateral compression of the rounds and the left to right drag in the curved strokes. The letters in the illustration were freely copied from fifth century examples; it is apparent that more letters began to venture above their neighbors, notably the F and B. The rustica in turn was displaced as a manuscript letter by the uncial; but rustics were used in manuscripts until the eleventh century—serving as initials or for emphasis in the line, as italics or small capitals are now used by the printer. For placard writers or those interested in freely-written letters these rustica designs are worth studying.

Everyday Writing:

The "current," or everyday, writing has had, throughout the entire history of letters, the greatest effect in the working-out of new and simpler styles. It is

14

really from these current styles that the minuscule letters finally evolved. The Romans used this everyday writing for their correspondence, accounts, and informal manuscripts, examples having been found on lead and wax tablets and on papyrus. These letters were written with a stylus or a stub pen, held, usually, as for rustica; there was, due to the tool, little variation in the width of the strokes. Through rapid writing the letter-designs degenerated; and in order to help the legibility certain letters were carried above or below the general level of the others. This tendency, as has been indicated, had an effect on the formal manuscript letters. It must be understood that the development of letters very often went the way of least resistance—the way of carelessness and bad habit. This is the explanation of phases in the evolution of letters that are peculiar or illogical.

The "older" Roman current letters shown are of about the same period, 50 B.C.; in the differences between the upright current and the "current-cursive" may be seen the degeneration of design and the tendency of the letters to acquire "ascenders" and "descenders." (The ascender may be defined as the stem that rises above the body of the letter; the descender as the stem or tail that drops below the body, the body being typified by letters, like a or c, that do not have ascenders or descenders.) There has been a certain confusion of nomenclature attached to Roman everyday writing. Often it has been called "cursive," a name that, strictly speaking, can be applied only to letters written at a slant. Not all everyday writing, Roman or other, is written at a slant. To avoid difficulty it is best to call all everyday writing "current"; if it also slants it is "current-cursive." This makes the necessary distinction between everyday writing or lettering that is upright and the kind that slants or leans. It also makes possible the use of the term cursive for carefully drawn letters, or types, that slant. The older Roman current was a rapidly-written majuscule letter; minuscule tendencies and "ligatures," or joined letters, developed in the third and fourth centuries with the later current style. All cursive writing, of course, is the result of the natural tendency of the hand to move in the direction of the writing, especially when writing rapidly.

Uncials:

The uncial letter was used by the Greeks as early as the third century B.C.; during the Alexandrian phase of Greek culture, which lasted until about 500, this style was much favored. The Romans undoubtedly borrowed the style from this source and gave it the name "uncial," which is explained by the simple fact that

these letters, in some of the early manuscripts containing them, were an "uncia," or a Roman inch in height. Later uncials were far from uniform in height, but the name persisted, as is so often the case with names.

The uncial, as it was first employed by the Romans, was a rounded, freely-written majuscule letter, much more suited to the rapid penning of manuscripts than were the square capitals or the rustica. Test letters of the style are A, D, E, G, H, M, Q, and V, which begins to look like U; these are new designs—it was largely the influence of current writing, both Greek and Roman, that produced them. The examples of early uncials were copied from facsimiles of a fourth-century manuscript; letters not appearing in the original have been added. Signs of the evolution toward minuscules are to be found in the new designs already mentioned and in the rudimentary ascenders and descenders of the letters D, F, G, H, L, P, and Q. Early uncials were written with a slanted pen; but in the sixth century the straight-pen style of the Greek uncials was adopted; the appearance of this later uncial is shown in the illustration. The effect of pen position on the design of letters may be studied by referring to the small pen diagrams; the work is assumed always to have been placed horizontally in front of the writer. Some of the straight-pen uncials in the more elaborate manuscripts were "built-up" designs—that is, they were made of compound, instead of single strokes. This again was a laborious method of writing a manuscript, but was persisted in until almost the ninth century. For special pages and for initials, the built-up technique was invariably used even after this date, both for uncials and square capitals.

Half-Uncials:
Semi- or half-uncials have been found in the Roman area dating back to the third century; but there is a long period, between that time and the sixth century, which has afforded no examples of writing in this style. The half-uncial obviously shows considerable influence from the more evolved style of current writing then in use; and it is a step further in the trend toward minuscule letters. A comparison of the half-uncials illustrated with the later current and the uncials will amply confirm these observations.

All the earlier letters could be planned and confined between two guide lines; but the half-uncials, as is apparent, required four guide lines—or at least sufficient allowance between lines for ascenders and descenders.

New designs appear among the half-uncials: the loop of the *a* is brought up to

adecghmgu *Test letters*

ofcghLpg *Letters showing ascenders and descenders.*

Freely copied with a reed pen ~ 4th century Uncials.

TRANSIERUNTJORDANE

ETABIERUNTTOTAMPRÆ *Position of pen*
←— *ligature*

INCASTRAMADIAM ET KXZ

Straight-pen Uncials ~ 9th century

The initial shows the typical use of built-up square capitals ~ usually gilded.

S CJENDUMTAMEN

NEGUISTGNARUM EXSJ *skew*

Positions of pens which may be used. *1* *2*

Thickness at top of ascender is made by pushing the pen ↑ up and then making the down- stroke.

INSTAURATIO·NULLATRANSLATI
s

Word-break signs

CIGNATUR·NONAURUM·CETERA

POSTREMO·NIHIL QUOD PRAETERA

ADUENTICIAE BFHKXZ *Pen position*

Half-uncials ~ 7th ~ 8th century ~ freely copied with a reed pen from a facsimile.

the top of the back stroke; r is a partly finished majuscule design, with the top loop swung to the right in a broad sweep; s has been flattened and made an ascending letter—this is the long s of early English books and of the German text; most of the other letters show their derivation from uncials, except that ascenders and descenders are now definitely a part of the design. The upper loop of the B has been omitted; d has acquired a perpendicular stem; the top of the e has now been closed; l is now simply an ascending stem; F has not as yet found its place; and T has still to develop its cross.

The history of uncials and half-uncials is part of the history of the Christian Church from the fourth century to the ninth; they were essentially "church letters." The association has been so strong that it has limited the usefulness of both designs to work having to do with ceremonies or festivities of a religious nature. Christmas or Easter cards may be lettered in these styles; the calligrapher will certainly choose them for church manuscripts. There is no rule, however, which prevents their selection for other purposes; taste and discretion must decide.

Chapter III.

Runes and the National Hands

Runes:

Before Christianity had penetrated the Germanic areas of Europe, bringing with it the Latin alphabet, the inhabitants used the runic alphabet—often called the "futhark," after its first six letters. Both the origin and development of the runic alphabet are subjects of much controversy. The most plausible theory links it to the Greeks, through the intermediacy of the Alpine people of northern Italy. Runes had apparently been used as magic signs and pagan symbols before they were assembled into an alphabet. The word rune is of Germano-Celtic origin; it has the general meaning of "secret"—relating undoubtedly to their first use and to the aura of mystery that surrounded all early writing. The earliest runic inscriptions date back, perhaps, to the fifth century B.C., the earliest certain date, however, being of the second century. The alphabet was in general use from Scandinavia to points on the Black Sea by the year 500. Practically all runic writing has been found on carved bones, ornaments, weapons, or on the rune stones. Over two thousand of the latter have been found in Sweden alone, where runes were being written in remote districts until almost modern times. They are, as a matter of fact, still employed by northern European peasants for good-luck signs, magic symbols, and the like. In England this alphabet underwent a somewhat different development from the twenty-four letter alphabet on the continent—this number of letters, by the way, corresponding to the number in the Greek alphabet. The runes had a slight influence on a few of the letters and sounds in the modern European alphabets; they must be regarded, however, as an evolution aside from the general development of our letters.

There are very few manuscripts in which the runic alphabet is found; the example was taken from a facsimile page of a fourteenth century codex. It is noteworthy that the design of the letters is entirely in verticals and straight or curved oblique strokes—a design well suited to carving in wood. It would be well to

consider the value of these designs as inspirational material for trademarks, monograms, and ciphers.

The National Hands:

With the collapse of the Roman Empire toward the end of the fifth century, Roman culture collapsed too. Writing, which had been part of the general culture—understood and used by the average Roman citizen—ceased to belong to everyday life. To escape the ravages of the "wandering of the peoples" and the struggle for supremacy, culture—and with it writing—withdrew to strong and safe retreats, cloisters, and monasteries, which were founded in ever-increasing numbers. In these hide-outs of culture and learning, which were not all part of the early church system, the Roman manuscript styles continued to have a place. When times were calmer once more, and the imperium had been partially re-established under Germanic leadership, the practice of writing and the knowledge of letters began to spread out from these places of refuge in which they had been preserved. This revival of manuscript writing and calligraphy worked out a bit differently for each of the larger "national" groups that were now in control of sections of the old Roman domain. Each of these areas developed its own writing or "national hand." The two most important national hands are those of the Irish and the Franks. While the Lombardic and Visigothic writing styles were employed for long periods and went through considerable development, they did not exert a lasting influence of much consequence; they do not, therefore, concern us beyond a brief mention. The national hands shown do not exactly represent a sequence of development; they were more or less contemporary, and influenced each other.

Irish—Anglo-Saxon Writing:

The example of Irish writing was copied from a facsimile page of the *Book of Kells,* so named because it was found in the church at Kells. Whether or not the work was done at the earlier Kells monastery is uncertain. It would carry us too far afield to discuss this manuscript at length. Especially is it impossible, without four-color reproductions, to give any idea of the decoration of the pages and initials— "magnificent doodling," as it has been called. The manuscript was written and illuminated during the ninth century, perhaps earlier. The Irish variety of half-uncial was certainly based on the half-uncials carried to Ireland by the missionaries of the Roman Church. Half-uncials became the national hand of Ireland; they are in use today for various special purposes—even as a type style.

ᛁᛚ:ᚦᛏᛦ:ᚸᛏᛁ:ᛁᚠᛏᛚᛚᛁᛦ:ᚦᛏᛁ:ᚠᛏᛦᛏ:

ᚦᛁᛚᛁᛁᛁᛏᛏᛏᛁ:ᛏᛦᛦᛏᛦ:ᛦᛏᛦᛦᛁᛁᛏ:

ᛏᛦ:ᛏᛁᛁᛏᛦ:ᚸᛏᛏᛦᛏᛏᛦ:ᛁᚸ:ᛁ:ᛁᛁᛁ:

The "Futhark" alphabet ~ there is a relation to the Greek letters.

ᚠᚢᚦᚨᚱᚲᚷᚹᚺᚾᛁᛃᛈᛇᛉᛊᛏᛒᛖᛗᛚᛜᛟᛞ

| F | U | TH | A | R | K | G | W | | H | N | I | J | P | | Z | S | T | B | E | | M | L | NG | O | D |

The initials are characteristic Celtic designs ~ there is a relation to the runic designs.

Irish Half-uncials ~ about 9th century

E autem praegnantabus &

nutriantabus in illis diebus :

act autem ut non fiat fuga

uestra hieme uel sabbato

Rt enim tunc tribulatio magna

qualis non fuit ab initio mu

diusque modo neque fiat

nisi breuiata fuissent dies

Æ→

đ x ꝣ ᵹ

Written with a reed pen ~ slightly slanted.
The initials are carefully drawn.
Letters not in text.

These letters were made with a slightly slanted pen, which accounts for the pull to the right in the rounded letters; on the whole, they are not freely written but done in a painstaking manner. Observe the characteristic triangle at the top of most upright strokes. The dual designs for the a, d, n, and s are evidence of a transitional style; one design of both the d and n is typical of uncials; other uncial designs are the u and t; the capital R is preferred, most likely for clearness. Really new and strange characters are the g and z. An indication of the trend toward minuscules may be seen in the appearance of the f. The weight of the thick strokes in this style is about one-fourth the height of the body letters. There is a decided linking of the letters along both the base and waist lines. Actually, the entire alphabet has been subtly redesigned to suit its purpose and the people who worked with it.

The kingdoms set up by the Angles, Saxons, and Jutes in what is now England were gradually converted to Christianity during the seventh century. Since this conversion was largely effected by Irish monks, it is only natural that Irish writing should have been carried to England; and it is generally acknowledged that England was almost entirely indebted to Ireland for its national hand: Anglo-Saxon writing. It is customary to speak of Irish-Anglo-Saxon writing as "insular writing." Our example of the Anglo-Saxon style is from an eighth century manuscript. The pen is now held at quite a slant, giving the letters a prickly effect that earned for them the designation "pointed writing."

The kinship of these letters to the Irish half-uncials is striking. In this style the letters are narrower and closer together; the triangular tops are set on the stems at a different angle. It is evident that they were more quickly and freely written. Dual designs are again present for the d and s, the long s having a thorn that makes it look like the r; e, f, and g show interesting changes in design; the r is difficult to distinguish from both the long s and the n; descenders are longer than ascenders and are sharply pointed. Some of the peculiar and baffling characters in both the Irish and Anglo-Saxon examples are ligatures, many of them interesting as designs for letter combinations. The Anglo-Saxon scribes introduced two runic signs into their alphabet, for the th and the w. Uncial letters appear throughout this manuscript as initials and small capitals. One may observe that here, for the first time, there is evidence of word-spacing.

Insular writing had a singular importance in the further development of writing and letters in Europe. Some of the leading monasteries and cloisters on the

continent were founded by Irish and Anglo-Saxon monks, whose writing, of course, influenced the manuscripts produced in them. The Irish monk, Columban, for instance, founded the cloister at Bobbio, in Italy, in 612. Actually, scholars and scribes moved about in such numbers that a genuine internationalism may be said to have prevailed. (This situation continued all through the Gothic period and on into the Renaissance.) Insular writing and influence have been found in manuscripts produced within what are now the borders of Italy, Switzerland, France, and Germany. The writing reform decreed by Carl the Great (Charlemagne) in 789 gradually terminated the use of insular writing on the continent; the Carlovingian writing slowly swept away all competitors. In the British Isles insular styles were employed until the thirteenth century, giving way finally to the Gothic letter. Present-day English calligraphers still use variations of the insular writing for hand-written church services, psalters, etc.

Merovingian and East-Frankish Writing:

Gaul, now France, had been under Roman influence for a long time before it became a province of the Empire about 50 B.C.; and it follows that the Gauls were accustomed to Roman letters and writing styles. With the collapse of the Empire Roman protection disappeared in the provinces; and Gaul was overrun by the Franks during the fifth and sixth centuries. The latter adopted many of the elements of Roman culture as it was manifested in Gaul, among these being the writing styles, which they gradually altered to suit their own tendencies. By the end of the seventh century Merovingian writing was the national hand of the Franks; it was named after the Merwig dynasty founded by Chlodwig (Clovis), who established the Frankish kingdom in conquered Gaul.

The example of Merovingian writing was freely copied from a facsimile of an eighth-century manuscript. It is evident that the Roman half-uncial and the later current writing are the major influences, although there are Gallic and Frankish factors naturally present that give the style its characteristic appearance. Merovingian writing is somewhat illegible due to a degeneration of the basic letter-designs and the use of endless confusing ligatures—a comparison with the Roman half-uncial will make this quite clear. Degeneration of design is apparent in the o, the bad t, and in the letters forming the various ligatures. Word-spacing was not very well observed. However, the tall ascenders, which kept the lines quite far apart and are typical of the style, gave a certain elegance to a page of Merovingian writing; and it was probably for its effect of pomp and luxury

that it was chosen as a court hand by the rulers of the Holy Roman Empire, until almost 1100—long after the Carlovingian writing reform had ended its use as a book hand. Present-day type and letter designers frequently select tall ascenders to obtain a suggestion of refined grace.

The East-Frankish writing or "Scriptura Germanica" (German writing) was an intermediate style, the direct forerunner of the Carlovingian minuscule. It was developed in the eastern area of the Frankish kingdom—an area that included Basel and Salzburg, extended north to the Bohemian forest, westward along the line of the Main river, and included both sides of the Rhine almost to its mouth. This area had close contact with Italy to the south; it was the locale of great activity on the part of Anglo-Saxon monks; and it was at the same time under the rule of the Frankish court. The influences on the style were also three-fold: Lombardic or Old-Italian, Anglo-Saxon, and Merovingian. Out of a fusion of these three evolved a style possessing so much individuality that it must be considered one of the national hands.

On the whole, the style is quiet and clear, needing but a few minor changes to make it a satisfactory book hand. The original of the example was done at the St. Nazarius cloister in Lorsch toward the end of the eighth century. There is a notable avoidance of too many ligatures and the word-spacing is consistently indicated. The influences can be quite easily followed: the st ligature shows Italian influence; the two a's and the triangular heads on the uprights are Anglo-Saxon; while the thickening of the tops of the ascenders is Merovingian. The g, judging by the way the tail has been added, is a typical German design.

East-Frankish writing had a more than passing influence on the manuscripts produced at the schools and monasteries in Aachen, Rheims, Corbie, Autun, Lyons, and Tours. Because of its clearness and simplicity it had begun to displace the artificial and hard-to-read Merovingian script as early as the reign of Pippin (715–768). It was undoubtedly the direct inspiration for the Carlovingian writing.

Lombardic and Visigothic Writing:
Before closing this chapter, Lombardic and Visigothic writing should be discussed briefly. There has been objection to the name Lombardic—many writers feel that "Old-Italian" is the proper designation; and it does more accurately describe the writing. The Ostrogoths, who were the first conquerors of the Italian peninsula after the fall of the Roman Empire, carried on the Roman writing

exultationem condicionis hu
ut tua dignatione mundat,
aptemur· perdñm ñm bf q

P R D G S

Letters are at a slight angle due to pen position.

Merovingian writing — 8th century

quismn& homines diligia,
Inas Iniquitie argsmns;

ES O T AER

Reed pen position

East~Frankish · Scriptura Germanica

magna/karlus/bella
contra aquilonbm·
dfh ſt

EM ST

Pen position

This ligature shows Italian influence.

Freely drawn from facsimiles — reed pen.

styles—Theodoric, their king, appointed Cassiodorus, a Roman patrician, as his chancellor and as the conservator of all things cultural, especially books and writing. When the Lombards overthrew the Ostrogoth kingdom in 568 they apparently accepted the writing styles they found; during their rule, which lasted some two hundred years, there was considerable Anglo-Saxon influence, especially at the cloister of Bobbio. In 774 Carl the Great added Italy to the Frankish Empire. He did have definite ideas about writing and instituted reforms, which do not, however, concern the course of Lombardic or Old-Italian writing. This became most degenerate in design, and in its final state was a distorted style known as Beneventan writing, the use of which was confined to southern Italy and Dalmatia, and centered in the cloisters of Monte Cassino and La Cava. Early in the thirteenth century, the Emperor, Frederick II, forbade the further use of Beneventan writing, deeming it a corrupt and illegible style.

The Visigoths also continued working with the Roman writing styles, which they found in favor when they conquered the province of Hispania and set up their kingdom, about 419. Their writing was related to the Merovingian, since their original domain included southern Gaul, as far north as the river Loire. Visigothic writing shows a gradual deterioration of letter design until the overthrow of the kingdom by the Saracens and Moors in 712 ended at once all specifically West-Gothic writing tradition. When, in 778, the Franks drove the Moors across the Ebro river—adding this northern part of Spain to the Frankish Empire—they established their own writing practices: the Carlovingian style then became the dominant hand.

The Carlovingian Minuscule; Arabic Numerals

Foreword:

Carlovingian writing was named after the dynasty of which Carl the Great is the chief representative. In order to understand the basis of so important a letter-design as the Carlovingian minuscule, it is best to review briefly the development of western Europe up until then. In the first place, one must give up the idea that the ability to read and write was in any way as widespread as it is today; the everyday use of writing had disappeared with the end of the Roman Empire and its culture. In the approximately three hundred years between the fall of Rome and the reign of Carl—from the end of the fifth century until the latter part of the eighth—there had been generations of unrest and confusion, caused by the collapse of the Empire and the "wandering of the peoples." These latter were almost entirely Germanic and had, on the whole, lived for a long time on the fringes of the Empire; they were possessed of a considerable culture of their own as well as definite organizing ability. When they had finally come to rest again and some order had been restored, there was a slow reappearance of cultural activity—the beginning of the learning of the middle ages. The practice of writing and the knowledge of letters and books, which had been preserved in cloisters and retreats—in certain instances under the protection of wise and capable rulers such as Theodoric the Ostrogoth—slowly became more prevalent. New cloisters and schools were established, where monks and scholars might acquire the craft of writing and study the work of the scribes of antiquity. All writing was in the hands of men of the church or men of law; and all writing, of whatever "national" character, was derived in one way or another from Roman manuscript or current styles. Another point to remember is that all scholars had a common language: Latin. But references to nationalism, such as one often en counters, are invalid at this period in the history of letters. It is a memory aid, perhaps, to separate the various writing styles of the Ostrogoths, Visigoths, Lom-

27

bards, Franks, Anglo-Saxons, and Irish into "national hands," although these belonged to rather similar peoples who did not then, with the exception of the Irish, exist as nations. Gradually, the Franks became masters of western Europe and proceeded to organize it further. This organization, whether it was in the realm of government or art, had decided Germanic tendencies developed upon a Roman basis, which, of course, includes Byzantine influences. Romanesque architecture, which had its beginning in Carlovingian times, shows this clearly; and it is equally true of the letters that developed then. Once again, it is quite evident that the history of letters is a part of the general history of style.

The Standard Hand:

The Carlovingian writing represents the first attempt, after the fall of the Roman Empire, to reestablish a standard hand throughout western Europe. The reader must have noticed that the national hands—with the possible exception of the East-Frankish—are all a bit hard to read. And these examples, it should be remembered, were chosen for their good, representative design and clarity—they do not give any idea of the many corrupt styles and personal aberrations that were practiced by slovenly and poorly trained monks and scribes. Mention has been made of confusing ligatures—along with these, all sorts of abbreviations were used, including "tironic notes," a shorthand devised during Roman times by Tiro, the secretary to Cicero. From all this it ought to be clear—as it was to Carl and his advisers, after most of the former Roman imperium in the west had come under Frankish control—that some standard writing style was necessary to help bring order out of chaos. Carlovingian writing was the answer to the need. Whether it was Carl's idea, or one put forward by the group of scholars and ecclesiasts who surrounded him in the court at Aachen, is of little consequence. The important point is: according to a decree issued by Carl in the year 789, all extant literature, legal codes, ecclesiastical services, etc., were ordered rewritten in this standard hand.

Alcuin of York:

Up to the period with which we are now concerned, it has been more or less impossible to connect the name of an individual with the developments in writing or letters—the contributions were almost entirely anonymous. The inability to personalize achievements is somehow distasteful to mankind, so, when the writers on letters were able to seize upon the figure of Alcuin of York, and make

him the hero of the development of Carlovingian writing, they did so with gusto. The usual story is not particularly well-founded: briefly, Alcuin is supposed to have created the Carlovingian style himself; and the royal decree then spread it over all of western Europe. Even the most cursory examination of the evidence, however, does not support this idea.

Alcuin was born in England in 735—at that period a scene of constant feuds among tribes and ruling families—and, like so many of the Anglo-Saxon monks of his generation, he finally, because of the unsettled conditions, quit his native land for the continent. He seems to have met Carl while on a journey to Rome; and returned later to Aachen, the seat of the Frankish court, as his teacher and the head of the palace school. There is no question that, when Carl issued his reform decree in 789, Alcuin, as his adviser concerning books and letters, was in a position to influence greatly the choice of the "standard" hand. This is the point at which we are to believe that Alcuin personally devised the Carlovingian style. However, it can be clearly shown that the style had long been evolving— as all styles must—in the East-Frankish and early Carlovingian hands, which had been used at Aachen and elsewhere. Without doubt, Alcuin had recognized the superior design and clarity of these letters and, in conjunction with other gifted scholars and scribes at the court, had gradually cleared up the designs until there appeared what is known to us as Carlovingian writing. It is quite probable that the evident virtues of the style finally brought about the reform decree.

That the scriptorium at the monastery of St. Martin of Tours, where Alcuin was abbot from 796 until his death in 804, was the center of the development of the Carlovingian hand is another part of the usual Alcuin story. The style of Tours, however, was really a special variety of the Carlovingian—this may be visibly understood by studying the two examples carefully. There is much insular character in the Tours manuscript—the linking of the letters, for instance —whereas the Otfrid writing is clearly new, the letters detached. Alcuin is said to have experimented with insular elements at Tours; and it seems from the evidence to be true. Alcuin's work at Aachen and Tours, as an organizer and educator, merits the greatest respect; but that he also personally developed Carlovingian writing is a bit more than doubtful.

The Minuscule:
With the Carlovingian minuscule, the final development of the small letter, as we know it, was accomplished. We can read this letter just as easily as we read our

newspapers. Technically, it is not quite correct to speak of the Carlovingian letters as minuscules—there was still no consistent use of capitals in relation to them; in other words, there was as yet no dual alphabet of capitals and small letters, which could be used as our present-day alphabet is. However, these "first small letters" should be studied carefully and their development checked, forward and backward. In doing this one will come to know the generations of letters thoroughly; and can choose and use styles to suit every purpose.

The example from Otfrid's Evangelienbuch (Book of Gospels) was chosen as being characteristic Carlovingian; it was copied from a reproduced page. Written by Otfrid and some of his associates in the cloister at Weissenburg, about 868, this is the first known book in the German language. Otfrid became a monk at Weissenburg and then studied at the Fulda abbey, which had been dominated by the insular writing tradition for a long period, but which was also situated in the East-Frankish area of the empire. Upon his return to Weissenburg he opened a school of literature and wrote a variety of works in prose and verse. The manuscript of the Evangelienbuch has been the subject of extensive study.

With few exceptions, the letters are completely acceptable to us as small letters—the designs for j, v, and y were either never, or only rarely, used at this period and, of course, are missing in the text. An interesting letter is the w, in its early German state. Represented by uu, it shows exactly what happened later in England, where vv became "double u." This development of the w has been explained in discussing the letters that were absent from the Roman alphabet. The f, the tall s, and t are not quite what we are accustomed to, but are easily recognizable. A few missing letters have been added—others may be found in the second example. This also was produced in the ninth century. Here, the pen was held at a somewhat greater angle, which accounts for the different disposition of the thicks and thins, and especially for the sloping back of the a. In the originals the size of these letters is rather small, since they were written with a quill pen. Both the copies were done with a reed pen, very much larger than the originals, in order that the design of the letters should be clear. The first example represents a more advanced development of letter design than the Tours specimen; the little strokes above the letters that indicate, among other things, the beginning of the dot over the i, were added long after the manuscript was written. These letters were produced with great ease and rapidity by a pen held just about as we are accustomed to hold one. The ascenders and descenders are about equal in

Vnſer druhtin nithiumin ·

erſie thar tho mánata · uua ͭ

Juo buab quad uueitent ·ͣ

giuuiſſo ſagen ih iz iú tha

Nuthie tigóte ſint ginánt ·

*Carlovingian minuscule ~ copied from a page of
Otfrid's Book of Gospels ~ latter part of 9th century.*

fkpx

Pen slant

Etrelictaciuitatenazar

naum maritimam·infin

galileae terra fratreſ;

Copied from a page of the Prüm Gospels ~ Written at Tours ~ 9th century.

Pen slant

31

length—slightly less than the body of the letters. The use of square capitals as initials should be noted. These are built-up designs, the I showing the manner in which the J was gradually differentiated from it.

The Carlovingians accomplished tremendous tasks in the revival of art and learning: specifically to our interest, all of the existing literature was carefully and efficiently copied in the new hand, while, of course, much valuable new work was also done. At various times there has been this necessity for clearing out bad practices and bad designs. The Carlovingian minuscule was as important a development as the standard Roman capital—for it was this style that became the pattern for the Humanistic writing of the fifteenth century; this latter, in turn, was the basis of our lower-case roman type.

Arabic Numerals

Although all of our letters are the result of a long, and often peculiar, evolution from Roman writing styles, our numerals came from another source altogether: the culture of Islam. The Romans had a system of numbers with which we are, on the whole, familiar: certain capital letters provided their symbols, the I's, V's, X's, L's, C's, D's, and M's being used in arrangements to denote quantities, dates, ages, etc. Dates in architectural inscriptions, title pages, diplomas, etc., still afford a place for the Roman numerals; chapters in books are often numbered in this way. If at all long, however, Roman numerals are difficult to read—MDCC-CXLIX for 1849, for instance—and from the mathematical and practical viewpoints are of little value. If one delves into the history of mathematics, one finds that much of the early searching was for a system of numbers that would work easily and well under all conditions. What was being sought, really, was the zero—it took a long time to find it and to learn how to use it. The focal point of mathematical activity moved from place to place over the centuries: from Egypt to Greece, to Rome, to India, where mathematicians finally found the use of the zero—perhaps during the sixth century. Exactly how the Indian system of numbers came to the Arabs is uncertain—possibly through an Indian ambassador in 773, more likely as a result of the incursions into India made by the Arabs from 700 onward—in any event, the Arabic world became the next dominant area in mathematics, and the system of numbers was named accordingly. Western Europe learned its numbers from Islam; first, through the Moors in Spain, about the tenth century; and later, through the Crusades of the twelfth and thirteenth centuries. By the thirteenth century this new and better system of numbers was

A variety of early Indian numerals.

Eastern Arabic numbers.

Ghobar, or Western Arabic numbers.

General style of 11th century numbers in Europe.

Later variety of European numbers.

Claude Garamont ~ 1545.

being widely employed by European merchants and mathematicians. Since the numbers were introduced by the infidels, there were many attempts to suppress them; but so great was their value in trade and mathematics that that became an impossibility.

Of course, the designs of the numerals changed greatly as they moved from India to western Europe—the illustration makes this clear. The first line shows one style of the early Indian numerals; line two represents the Eastern Arabic designs; and line three the later Ghobar, or Western Arabic, numbers. These Ghobar designs begin to look like the numbers we know; they also resemble the numbers in the fourth line, which, in general, were the numbers prevalent in the eleventh century European manuscripts. The zero is missing in both this line and the later version of line five, for the simple reason that its significance was not generally understood until a somewhat later date. In line six is shown what may be considered a norm or standard: the type numerals attributed to Claude Garamont, made about 1545.

One should study these Garamont numbers as carefully as the classic Roman alphabet. Typographers call them "old-style"; they do not line up, top and bottom, as do the numerals in most type designs. Most of us have been taught to make even-height, "lining," or "ranging" numbers in school, and have difficulty in recognizing the superior merit of the old-style designs, at first. The variety of position of the numbers in the old-style system helps their readability, and should be adopted wherever possible. Improper design, and consequent illegibility of numbers, is the cause of much confusion and many mistakes in the business and technical worlds. A comparison of typewriter numbers, for example, with the Garamont designs, will make clear how poor the former are in both design and legibility—in both these factors the marked differentiation of the numbers, one from another, is of the greatest importance. The false design idea of uniformity —making letters equal in width and numbers the same in height—is responsible for much of the trouble. Of course, there are endless variations and limitations affecting any sort of design, but one should try to preserve the descending character of the 3, 4, 5, 7, and 9; and the ascending character of the 6 and 8; the 1, 2, and o are in the class of body letters, having neither ascending nor descending elements; the zero should always be differentiated from the small o.

34

Gothic Letters and Types

Foreword:

The name "Gothic" started as a term of depreciation among the Humanists of Renaissance Italy; it was meant to be synonymous with rude or barbaric. To these men, anything that was done north of the Alps could not be considered otherwise; their entire interest lay in the revival of all the elements of classic antiquity. Gothic style has nothing whatever to do with the Goths; according to an obsolete meaning of the word, Gothic meant Germanic or Teutonic. This, if the pitfall of nationalistic interpretation be avoided, represents one clue to the entire period; the Gothic style was definitely northern. It was, however, a style greatly influenced by Saracenic art—an influence that resulted from the crusades. It was also the culminating expression of the middle ages—roughly, the Gothic period lasted from 1200 to 1500.

In this chapter it will be better, for two reasons, not to follow the chronological sequence of letter development. First: the rejection by the Italian area of the conclusive phases of Gothic influence and its reversion to classic style, make it necessary to consider this development separately; this will be done in the next chapter, which deals with Humanistic writing and the beginning of roman type. Second: the fact that the design and use of Gothic letters has been a continuous process, up to the present day, makes it advisable to include characteristic specimens from Gothic times until the present; to review, in other words, the whole history of letters in—or related to—the Gothic style, without reference to other simultaneous tendencies and evolutions. Regardless, then, of chronology, the major discussion of Gothic letters is confined to this chapter.

Gradual Changes in the Carlovingian Style:

From the ninth century through the eleventh, Carlovingian writing was the dominant European hand. In the ninth century the Frankish empire was di-

vided into two parts—roughly, along what is now the northern border of France. During the tenth century the northern part was, on the whole, the most important—its Saxon rulers taking over the title of the Roman emperor. Under these rulers culture and learning flourished; the re-writing of books in the Carlovingian hand was continued—it is known, for instance, that great numbers of books, particularly the classics, were brought from Italy into what is now Germany and undoubtedly copied in the standard hand. Late in the eleventh century there were various changes noticeable in the design of the Carlovingian writing; in fact, there was a tendency for new national hands to develop—cloisters and schools had increased in number and there were almost endless regional and personal style variations. It is not at all necessary to become involved in this maze; the important change was a certain angularity of the rounds, which in the true Carlovingian had been full and even. This change is plainly to be seen in the first example, which was copied from a reproduced twelfth-century manuscript page—a manuscript made in the area of what is now Belgium. By the thirteenth century the change, a so-called "breaking" of the letters, had been carried out to a much greater extent; the final Gothic characteristics of the letters, however, were added from 1200 onward, under the influence of the Gothic style.

The Evolution of the Gothic Letter:

The spirit of the Gothic style manifested itself as an unhindered striving upward; verticals gradually supplanted horizontals as the dominant lines in architectural design; the pointed arch replaced the round arch of the Romans; the peculiar almond shape, the mandorla, was much favored. Early vertical writing effects appeared in the court hands, previously mentioned, which were a continuation to the point of absurdity of Merovingian writing. This tendency is usually presumed to have started in the area now northern France. Actually, the early broken letters were not essentially Gothic; it was only when the powerful Gothic spirit took hold, in the thirteenth century, of most of western Europe—centering on the present north of France, southern Germany, England, and contiguous territory—that the letters became typical Gothic designs, in which all the rounds, and the tops and bottoms of all the vertical shafts, were broken. In order to subordinate horizontals as much as possible, the distance between lines was gradually reduced, the final relation of intervening distance to the body-height of the letters being about 1 : 1. Ascenders and descenders were consequently shortened to a minimum. The weight of the thick strokes is from one-

Collegerunt pontifices & p

Ampersand
ET

ses concilium aduersus ihm.

rlq. Omſ lectionis euusdem.

Compare with Carlovingian.

omnes qui uidebant eos: et timu

it omnis homo. Et annuntiaue

runt opera dei: et facta euus intel

lererunt. Letabitur iustus in

domino et sperabit in eo: et lauda

Check mention of starred letters in text – Note use of capitals, which were in color.

zet wol der eren stat siv sprechent

waz mac bezzer sin. dan edele richer

lip. der dc mit werke machet sclim

sin leben mit zvliten heit nach tü

Strokes at word endings done by using left corner of pen – often split off center thus. →

fourth to one-fifth the height of the body letters; the white areas, sometimes called counters, between the strokes in such letters as the o and u, approximate the thickness of the stroke; about the same amount of white area is allowed between all letters; between words about twice this area is sufficient. There is a general narrowing of all the letters, which adds to the vertical effect; the spacing of letters became a matter of making equidistant upright strokes.

These changes may be followed, from the twelfth century to the fifteenth, in the examples shown. The fifteenth-century specimen may be accepted as the culmination of specific Gothic period design; it illustrates all the style requirements of the final phase of the period. Vertical lines dominate the page; the texture is relieved only by the initials and decoration. Here lettering is used almost solely as ornament, an extreme example of letters as design; the whole effect—spacing, tone of page, arrangement of initials—should be carefully examined.

The best name for this particular style is "textur," or "textura," from the Latin "textum," which means a woven fabric or texture. It is apparent that the name suits the style perfectly. The same name may also be applied to the type design based upon the severe Gothic letter; "lettre de forme," the French name for this type, is not particularly suitable. "Old English" and "Blackletter," which are sometimes used to denote Gothic letters in general and the severe style in particular, are names better avoided; they are extremely misleading and indefinite. Any letter may be made into a Blackletter by making the stems, or thick strokes, wider than the counters; Old English, if it means anything, indicates that this letter was also used in England during Gothic times. As an amusing commentary it may be mentioned that the Gothic letter, in its own time, was known as "littera moderna."

The major design factors have been indicated; there remain to be mentioned a few other changes that occurred in the alphabet during the evolution of the Gothic letter; most of these may be followed in the starred (*) letters of the four examples shown. In the early Gothic there was often a thickness added to the top of the ascender, on the left side; the later designs, especially those produced in the French and English areas, show a forked top on the ascender—theoretically, the top of the ascender, in the severe Gothic, should also be broken. The straight-backed d was finally replaced by the uncial design; the tail of the g, which had been written in one stroke, finally required an extra stroke. When the letters came to be written more closely together, the i's, m's, n's and u's often

seniaam nutiga dans pecta
tozum·veniam atoz requiem
in secula seculozum antpph̃
Requiem eternam dona eis do
mine·et lux ppetua luceat eis ✕
Domine exaudi·et clamoz·ozem
Eus qui homi collecta
nem de limo terre ut
angelozum impleres ruinã
ad ymaginem et similitudi
nem tuam formasti ut et
ipsum lapsum ad locum p
ditum renocares in cruce moz
tem passus sincti miserere
quesumus animabus om

15th Century — drawn from a reproduced page.

Book of Hours — northern France — ↑ ↓ *note how pen strokes overlap.*

Initials and decoration in gold and colors in original.

39

touching each other and allowing a chance for confusion, it was found necessary to put an identifying stroke over the i. This stroke at length developed into the dot. To the long s was assigned the initial and medial positions in a word; the final s is always shaped like a figure eight; the long s was used with and without the thorn at the left of the shaft. The point was added to the top of the t during the thirteenth century; gradually a differentiation between the design of u, as the vowel, and v, as the consonant, was effected; three letters, the w, y, and z— which had always been a bit foreign to Latin—became, at last, definitely a part of the alphabet. Finally, the z was redesigned, acquiring a descender and, often, a stroke through the middle. From the end of the fifteenth century onward, influences that were not specifically Gothic—that of the Renaissance, particularly —determined the design changes in these letters.

The Use of Gothic Letters:

Gothic minuscules are the most logical and, when used in mass, the most ornamental of all letters. There is much misinformation abroad concerning them and their later development and function as type. They are generally considered hard to read—a characteristic quite noticeable in the textur; however, the charge is largely unfounded where later developments are concerned, given the condition that early training has been equal in both roman and Gothic; as a matter of fact, the word-picture in a good modern fraktur seems to have a slight advantage over the roman. Many writers have ably defended the Gothic letter and, from the standpoint of design, it deserves defense. One need go no further than to remind the reader that William Morris was devoted to all things Gothic. No letter designer can be said to know his craft completely, who does not understand and thoroughly appreciate the Gothic letter. From Gothic times to the present, the letter has shown an amazing vitality—in the development of the schwabacher and fraktur types, during the Renaissance and up to the present day. A variety of textur gave the pattern for the first type; all textur types must be based on the fifteenth-century, severe Gothic style. (Schwabacher and fraktur types are described later in this chapter.) Lettering artists or illuminators will find much use for the textur in all sorts of work of an extremely formal nature, or that dealing with religious, festive, or medieval subject matter. This is a fine design for architectural use, especially when employed as a raised letter.

Gothic Capitals:

It was during Gothic times that the dual alphabet—the consistent use of capitals

ABCDEFGHIJKLMN
OPQRSTUVWXYZ

12th Century Initials ~ from a ms. done in the French area ~ early Gothic in design.

ABCDEFGHILM
NOPQRSTUVXZ

13th Century ~ from a Bible in the British Museum.

ABCDEFGHIKLM
NOPQRSTUWXYZ

14th Century ~ Typical Gothic capitals ~ so-called "closed" letter.

ABCDEFGHIKLMN
OPQRSTUVWXYZ

15th Century ~ from English and German area designs ~ suited to 15th century minuscule.

ABCDEFGHIKLMN
OPQRSTVWXYZ

Early 16th Century ~ the famous Dürer design ~ Renaissance influence.
This style forecasts the "fraktur" type design.

with small letters—finally came into being. This point has been touched upon in the preceding chapter; only in a few rare instances, however, is it possible to discover the consistent combination of one style of capital with small letters, during late Carlovingian times—instances where it might be said that a dual alphabet was in use.

At the end of the eleventh century, square capitals, uncials, and some rustica letters were being used for initials or versals (an initial used to start a verse); they were quite well mixed by this time; and one may enjoy the strange play of early initial designs in any of the books devoted to them. The alphabet of the initial artist in the middle ages was limited to some twenty-two letters—there was no J, U, W, or Y; even K and Z were rare. To give the reader any visual representation of the innumerable early initial designs that were created by genial scholars and scribes is not within the range of any book. In general, the ornament of these initials and versals was based on the following: lines that followed the main strokes of the letter and pen "doodling" that filled the white areas in and around the letter. Often too, the organic strokes of the letter itself were detached and rearranged, flourished, or repeated. Historiated or illustrated initials are entirely outside of our discussion. The twelfth-century example of capitals is a simple and clear illustration of the manner in which initials and versals were treated; there was often more elaboration and usually two or three colors, red and blue generally. Initials have been included in most of the examples throughout this history to give a better idea of their appearance and use. Toward the end of the thirteenth century the decoration of these initials had become so rich that the scribes preferred to draw them with a pointed pen. Of course, elaborate initials had always been made with a variety of pens and brushes—whatever would achieve the effect desired. The main reason for using built-up letters, however, was that the change from the heavy to the light stroke was so extreme that it could not be achieved with a broad, square-cut pen; in fact, in many instances the initials were far too large. These elaborate initial styles developed into the highly ornamental, foliated initials of the fourteenth, fifteenth, and sixteenth centuries. The Tagliente initials will give a good idea of one variety of these; they are, however, based on filigree work rather than foliage designs.

It should be noted that in the preceding paragraph "initials" were dealt with. In this, the concern is with "capitals" and there is a definite difference, which has been explained and must not be overlooked. Gradually, alphabets of capitals

were assembled for use with the small Gothic letters; in describing the thirteenth century, it is possible to speak with assurance of majuscules and minuscules in the Gothic alphabet. The small letter achieved a standard design—the Gothic was essentially a minuscule design. The capitals, however, under the free play of the scribes' fantasy, existed in a bewildering multiplicity of designs. Among the stiff verticals of the minuscule page, these florid capitals served the same purpose as the elaborate windows and foliated ornaments among the verticals of a Gothic building: that of ornamental accessories. It would be impossible to show the range of Gothic capitals; in these examples from the twelfth century to the early sixteenth, though, one characteristic set of capitals from each century may be examined; the gradual design trend is clearly discernible. In our first two sets of capitals the V and U are simply alternate—square capital and uncial—styles of the same letter; other missing letters have been added. The twelfth, thirteenth, and fourteenth century capitals clearly show their mixed derivation from square capitals and uncials, with here and there a touch of rustica influence. They remain true to this derivation throughout their entire development, following along the lines laid down in the twelfth century. What are often called "Lombardic" capitals are merely this fusion of square capitals and uncials; the use of this name, as has already been mentioned, is of doubtful value or helpfulness. The first three sets of examples are built-up designs; the next two are single stroke letters—some of the flourishes may be made with a fine pen or can be managed with a square-cut pen, split off-center to the left. After a good deal of trial and practice, it should become clear that one could design personal varieties of such initials and capitals; but it must be stressed that a good many genuine Gothic designs need to be mastered before making the attempt.

The lettering artist or designer will constantly find use for elaborate initials —to suit purposes where dignity, elegance, pomp, or a festive character are required. There is no better source for these than the Gothic capitals and the manuscript initials that preceded them. Given a thorough understanding of Gothic letters, it is possible to design them without depending too much on borrowed ideas.

The influence of Gothic capitals can be traced in many styles of display lettering and type, much of it corrupt in design; this is particularly true of many type designs made during the nineteenth century, the so-called "gay nineties" or Victorian period type.

Rotonda—Half-Gothic Letters:

The name "rotonda"—or "rotunda"—when applied to letters, simply means round; the designation "half-Gothic," which is the term applied to the later type designs derived from this letter, is perhaps a better name for the style. It indicates, at least, that the design is transitional. "Round-Gothic," a name often used for this letter, represents, in a way, a contradiction in terms; since the true Gothic tendency is to break all the rounds, that does not seem a particularly appropriate appellation. Of all these names that we have for a really fine letter-design, it may be best to accept "rotonda," the name used in the Italian area, where this style developed.

It is quite apparent that the scribes south of the Alps followed the rest of western Europe in altering the Carlovingian hand; one may check this by comparing the rotonda letters with the Carlovingian, and with the twelfth and thirteenth century specimens of the Gothic development. However, while the northern European penman pursued the design of Gothic letters to its logical conclusion, his southern colleague never went much further along the course of Gothic letter evolution than is indicated by the design of the rotonda. There was, of course, much severe Gothic found in the Italian area—due to the constant interchange of scribes and scholars between the areas; but on the whole, one may stress the gradual isolation of the Italian peninsula from the decisive, final influence of the Gothic style. The rotonda, which was employed during the thirteenth century, continued unchanged during the fourteenth and fifteenth centuries. The Spanish peninsula was affected by this style and made much use of it; here, though, the influence of the French area was strong and the final phases of Gothic development appeared.

In examining the rotonda design, note especially the square endings of the uprights—an indication that the Italian area scribes preferred the horizontal design principle; they would not, in other words, take the final steps of Gothic style development. Noteworthy varieties of letter formation are the following: the a is slightly different in design from any yet encountered, a transitional design; the d has been changed at times to the uncial design, a concession to Gothic influence; r, as in the fifteenth-century Gothic example, is often made by utilizing the loop and tail of the majuscule letter (R); to make the w and y it is only necessary to combine two v's for the first, or add a tail to the v for the latter; z, which was rarely written, may be made as indicated or patterned after the fourteenth-century Gothic letter.

44

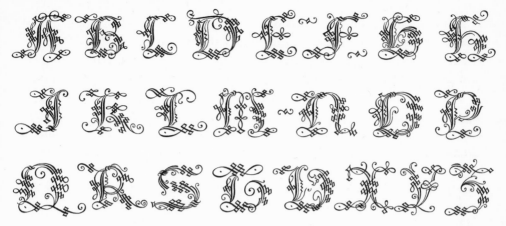

Omnipotens sempiterne
deus vespere mane et me
ridie maiestatem tuam supplice
deprecamur:vt expulsis tecor
dibus nostris peccatorum tene
bris:ad veramlucem que chrif
tus est nos facias peruenire.P.

Late 15th century ~ copied from a reproduced page ~ missal from Italian area.
Note how the square-cut endings of the uprights emphasize the horizontal lines.

gbk
z

Known as "rotonda"~ this style is important in the "half-gothic" type designs.
Pen position is changed slightly for rounds.

Mention must be made, at this point, of the separate development of initials in the Italian area. By the fifteenth century the fantasy of the scribes had produced initials of a peculiar kind, made of elaborately interlaced and swirling pen strokes; the capitals, M and P, in the rotonda example, show a simple treatment of this style; the Tagliente initials, the development of the style by one of the famous sixteenth-century writing-masters. These designs were carried into northern Europe during the Renaissance and were much favored, especially in the German area. In this development there is a definite Oriental influence.

Rotonda has been used as a basis for a few present-day type designs, both in Europe and the United States. There is a clean, crisp appearance to the style that makes it adaptable for a great many purposes—from those emphasizing tradition and solemnity to others demanding the suggestion of strength and efficiency.

Gothic Current Hands—Everyday Writing:
During Gothic times the practice of writing became ever more widespread; no longer were the monasteries and chancelleries the sole centers of writing activity; the professional lay-scribe made his appearance—this calling became highly important as a means of livelihood to great numbers of needy and itinerant scholars. The greater the number of those who could write, however, the more numerous became the styles and designs of everyday writing—for, while the formal designs were well established and not too easily tampered with, the informal everyday hands derived from them were subject to the varying individualities of the writers. It would not do to attempt a detailed account of the individual current hands used by Gothic scribes in the various areas; that is not at all necessary and would, if anything, confuse the general picture. What is necessary is to show examples of the important styles—those that had a later influence, especially on type design. For, once again—as with the earlier history of writing—we find that the current hands are the decisive factors in determining new styles and continuing the evolution of letter design.

The first example is the most important; it was the basis for the larger number of the current writing styles and, later, for the schwabacher type design. This style was widely used throughout all the Gothic areas. It is often called simply, "Gothic cursive"—although "current-cursive" would be a more definite name (the general name "notula" may also be used). The style is genuinely Gothic—retaining, however, many of the rounds of Carlovingian writing. The French name was "lettre bâtarde"—the latter word meaning, when applied to writing,

Pour lheure aux champs a
Et ses oyseaulx veoir faire
Sa fême aussi dames et dam
ʒ w

15 th Century ~ Gothic Current-cursive ~ everyday hand of western Europe.
Copied freely from a facsimile of a French manuscript poem.
Pen split off center

Wer nach siner durst leben
Der mag nicht gesin ein ar
hungert dürst frürt dich

Copied from a facsimile page of a poem by Thomassin von Zirclaria.
Written about 1415 for Katharina of Burgundy. There is a marked tendency to keep the pen on the paper.

Magica / que / multiplicat
madian gentilis / diabolica
balaam non / mento debeat

1426 ~ from a facsimile page ~ Bury St. Edmunds' record book.
Note still prevailing Anglo-Saxon influence. Pen is pushed around many of loops.

a running or cursive style. In the French variety of the design, the annoying mannerism of bearing down on the quill when making the long s and the f is noteworthy—a speckled page was the usual result. The letters that particularly carried over into the later type design were the a, d, g, h, o, v, w, and y. It is apparent that the a has been returned to an earlier state; the d is pointed at the bottom; g is once more made with a simpler tail; the final stroke of the h is swept back in a point to the left; o is given a point at top and bottom—the mandorla shape—typical of schwabacher type; v is started with a flourish from the upper left; the w is based on two joined v's; and y has a straight left-hand stroke with a curved back-stroke. Gothic current-cursive was a rapidly written style, always with a slight inclination to the right; it was used for documents, records, and the like—it seems, also, to have been favored for the poetry of the period.

The second example was made in the German area, in Alsace; it too, is a manuscript poem. The use of the pen is much freer than in the first style; the general inclination is again toward the right; but here and there letters are tilted to the left—largely through the effort to complete the stroke without lifting the pen from the preceding letter. Noteworthy are the loops at the tops of the ascending letters b, d, h, and l; the d is the sort of letter we are familiar with in handwriting styles. This example is about midway in development between the basic current-cursive and the later handwriting styles of western Europe—which, in the course of time, developed into the scripts we all know and use. The sixteenth century type, Civilité, cut by Robert Granjon, was based on a Gothic current design such as this.

Our final example displays a still more rapid use of the pen; this is everyday writing in the true sense; it represents a record kept at an abbey. On the whole, this English area specimen fits quite well into the general style picture as it appears before us. There is a definite trace of the Anglo-Saxon writing in these letters. The reasons for this are not hard to find: the Gothic letter had supplanted the strongly entrenched Anglo-Saxon as a formal book hand—a feat that the Carlovingian writing had never been able to accomplish; in the everyday writing, however, the Anglo-Saxon tendencies still came through, as was natural. This style is quite close to the later English secretary hands.

These designs are ideal as a basis for developing an individual handwriting that can be set down rapidly with a broad pen. There is in them a wealth of untapped material for freely written headlines, etc.—for purposes where one would like to avoid the use of the seventeenth and eighteenth century script styles.

48

Johannes Gutenberg and the First Type:

The facts in the story of Johannes Gensfleisch zum Gutenberg and his so-called "invention of printing" are few but convincing. He was a citizen of Mainz; and this German city was the birthplace of the printing craft. Through legal records it is known that Gutenberg was working at a "printing process" in the city of Strassburg in 1436; he paid out rather large sums to various craftsmen who aided him; and concluded a contract in 1438 with three of them concerning the practice of an art that was to be kept secret. He had a press that had been built by one of the local craftsmen; used lead; and made castings that could be melted down again. His name is not found in the records of Strassburg after 1444, when he paid his final tax bill; in fact, he disappears from all records for four years. When next Gutenberg's name crops up in archives he is once more in his native city, borrowing money. During the four-year hiatus there appeared several printed books made with movable type, particularly a Latin grammar; everything points to the Gutenberg workshop as the place of origin of these publications. In 1450 he made an agreement with Johann Fust whereby his workshop became security for a loan of 800 gulden, with interest at six per cent. The loan was made specifically to "complete the work on books." During 1454 the papal Indulgences were printed in large quantities. These were of two styles: in one the text type was a forerunner of schwabacher; in the other it was a half-Gothic design. Legal records show that in 1455 Gutenberg lost his workshop to Johann Fust in a court action involving the principal and interest of the loan made in 1450; his great work, the "42-line Bible," was issued sometime during this year of misfortune—probably by Fust. In 1457 Fust, together with Peter Schoeffer—who was a gifted scribe and had been Gutenberg's assistant—published the great Psalter. This work undoubtedly took years of preparation; it is highly probable that the preparation was done largely by Gutenberg. When next he is mentioned in records, in 1465, the impoverished inventor has been taken into the court of the archbishop of Mainz and granted a small pension. From 1465 to 1468, when he died, Gutenberg continued to experiment with printing devices; sympathetic friends seem to have supplied him with the necessary equipment to continue, to the end, the work that had been his life and in itself his greatest reward.

A little discussion of Gutenberg's invention is in order. What really was devised or perfected was the use of movable type—almost exactly like the foundry type of today. Printing had been done before this time—in fact, the Chinese had printed from wood blocks as early as the eighth century; and the process had

gradually been carried to Europe, where it was first used for the manufacture of playing cards. However, that Gutenberg did develop the first practical printing press seems quite likely. There had evidently been some earlier, crude attempts at printing with movable type—there were many men trying to solve the problem of the more rapid reproduction of the lettered page. It is probable that the processes of etching and engraving were produced in the course of some of these experiments; the woodcut technique was known and used extensively for block books. There are rival claimants to the incorrect title inventor of printing; but the arguments always end the same way: with the admission all around that Gutenberg's production far surpasses that of any of his rivals both in technical perfection and aesthetic value. His system of cutting punches, making matrices, and casting type in adjustable molds has continued to the present—although now the various operations are done mostly by mechanical means. He developed the technique of the type founder. It is chiefly as a designer of letters, however, that we are interested in him in this book.

It is evident from the examples that Gutenberg's designs were based on the best fifteenth-century manuscript styles—this could not have been otherwise. There was apparently a long and close collaboration between Gutenberg and the scribe Peter Schoeffer; their ideal, which is easily understandable, was to produce books that looked as though they had been written by hand. In this they succeeded. To achieve the desired effect, it was necessary to have many more characters than are now used by the printer. Compare the two type specimens with the fifteenth-century Gothic hand, the textur, and study the translation of the general effect of the latter into this wholly new medium of type. These specimens are superb examples of the severe Gothic letter; the first is about one-third larger than the original; the second, about two-thirds the original size. Further study should include a comparison with the textur produced by Rudolf Koch, one of the German designers of this century. This design is illustrated among the recent alphabets at the end of this chapter.

While it is unnecessary to discuss the design of the severe Gothic further, certain minor changes from the manuscript letter are worth noting in the two specimens. The stroke above the i has now become a semicircular loop—closer to the dot. In the example from the Psalter, lines four and six, is the word "impij" —showing the j design among the minuscules; the actual separation of the vowel i from the consonant j did not come into general use until the sixteenth century.

Quid loquar de secli hominibz. cū apłus paulus:vas electōnis. ⁊ magister gentiū. qui de consciencia tatū ī se hospitis loquebat. dicēs. An experimentū queritis eius qui in me loquit xp̄t. Post damascū arabiāqȝ lustratā: accēdit iherosolimā ut vidēt petrū ⁊ māsit apud eū diebz quindeci. hoc eni mistio ebdomadis et ogdo=

nocte Et erit tanqȝ lignū qd plātatū est sec9 decursus aqȝ: qd fructū suū dabit in tpe suo Et foliū ei9 nō defluet: ⁊ oīa qcūqȝ faciet psperabūt Nō sic impij nō sic: sed tanqȝ puluis quē picit ventus a facie tre Ideo nō resurgūt impij in indicio: neqȝ ptcōres in ꝯsilio iustoꝝ. Qm nouit dns

The thorn or "trait" on the left side of the ascenders of b, f, h, k, l, and long s helps the eye to follow the line, by offsetting the strong vertical effect a bit; k is a new design, to be found in the fourth word of the first line, first example. The little sign that looks like a 7 with a cross-stroke is the tironic note for et or and; it appears in both specimens, as do other abbreviations long since out of use.

The capitals in the Psalter example were printed in red. This is the first work in which multiple-color printing was used. Actually, there were three colors used throughout: blue, red, and black. A complicated method of inking the forms made it possible to produce a two- or three-color job in one impression. Usually, in the early printed books, space was left for the "rubricator"—the worker in red—to draw in initials and decorative material. This practice of special initialing, which continued until the middle of the sixteenth century, is illustrated in the 42-line Bible specimen; often a small character printed in the center of the area identified the necessary letter.

By 1500 the new craft of printing with movable type had spread from Mainz to all parts of western Europe. For the most part it was carried to the various areas by German master printers or journeymen. The textur, in most cases, was the first type used; but local conditions and taste soon brought about the development of other styles. A large part of the history of letters from this point onward is to be found in their use as type designs—largely, these are based on the manuscript designs that we have already encountered.

A factor that contributed to the rapid spread of the printing craft was the general use of paper, which displaced vellum almost entirely for the leaves of books. The Chinese, it seems, were the first to use paper as we understand this material; the knowledge of its manufacture and use traveled westward via the Mohammedan world, probably entering Europe through Spain, during the eleventh century. By 1500 it was being produced in sufficient quantity to fit exactly into the tremendous rise in book publication brought about by the craft of Gutenberg and his followers.

Half-Gothic Type:
The example of half-Gothic type is from the earliest type specimen sheet of which there is an extant copy, dated 1486. It was issued by Erhard Ratdolt to announce the opening of a printing establishment in his native Augsburg— upon his return from Venice, where he had gained great renown as a printer of

ue maria gᶠa plena dominus tecū bene dicta tu in mulierib⁹ et benedictus fruct⁹ uentris tui : ihesus christus amen.

The half-Gothic type used by Erhard Ratdolt ~ from a specimen sheet issued at Augsburg, 1486.
The size is approximately ¾ that of the original — Ratdolt is called the "father" of decorative type initials.

Darnach fürt die miltikeit in dem schilt em der heyss et Gallander Der ist solicher natur / derus vn Jacobus spreche Wenn d vogel w zů einem siechen / so erkennt der vogel wol ob mensch ster bē soll oder genesen Ist das der sie

An early schwabacher type used by Johann Bämler of Augsburg, 1474 ~ excerpt from "Von den 7 Todsünden".
This example should be compared with the Gothic current-cursive and the "original schwabacher" face.

Deus Jacob miserere mei Et mitte in adiutoriū meum proprium angelū gloriosissimū : qui defendat me hodie : et ꝓte gat ab omnibus inimicis meis

Transition to fraktur ~ type used by Hans Schönsperger in 1514.
It follows a design used by the writing-master, Leonhard Wagner.
Note first real dots over i's.

a b d o s
Textur ~ all rounds broken

a b d o s
Schwabacher ~ mandorla rounds

a b d o s
Fraktur ~ Renaissance influence ~
half round ~ half broken.
Study this chart of style difference.

53

fine books. That Ratdolt had worked for years in Venice is the clue to this fine type design: it had been cut to satisfy Venetian taste, which was accustomed to the rotonda style. This type was clearly based on rotonda; the specimen should be compared with the manuscript hand (see p. 45).

It is always difficult to determine who worked out the designs for the early type faces. Ratdolt's associates in much of his work were Bernhard Maler (Pictor) and Peter Löslein; the former produced many of the illustrations for which Ratdolt's books are famous; Löslein seems to have been a letter designer—he may have made the initial that is part of the specimen. The point the reader should remember, however, is that most of the early printers were capable and versatile craftsmen and scholars.

Although the half-Gothic design and its influence have been sufficiently discussed under the rotonda heading, it is best to explain briefly the dual position of the half-Gothic types in the development of type design generally. These half-Gothic faces—a "face" is a style or design of type—were used by many printers both north and south of the Alps, and in Spain. The differing designs may be divided into two classes: those that are related to, or in harmony with, a stage of development of the Gothic letter; and those that represent the transition to roman type. Ratdolt's letter seems to fit the first category; in the next chapter it will be necessary to consider the transition to the roman face. The initial is clearly based on the Roman classic capital and shows Renaissance influence; it belongs to a set which is the forerunner of many famous initial alphabets by gifted type designers.

Schwabacher Type:

The schwabacher type, as has already been stated, was based on the design of Gothic current-cursive writing. All the early printers made use of type faces designed after the current hands; these were used for secular works, books in the popular taste, etc.—in contrast to the textur, which was almost exclusively employed for religious or legal literature. The first type used in England—by William Caxton, in 1476—was a so-called "bâtarde"; probably cut in Flanders; and following the French area mannerisms of the absurdly thick f and long s. While the printers in the French and English areas very soon gave up these types, the German area designers developed and refined the style; it has continued in use in Germanic countries until the present day. It is not possible to find a meaning in the name "schwabacher"—it may refer to one of the numerous small towns

of that name in southern Germany; or, it may have been some sort of nickname. However, it is the definitive name for this type style, having been attached to it for most of its existence. The French name bâtarde may be used to designate the early French and English area development. It should be pointed out, though, that this name has been applied rather indiscriminately. For instance, the Italian cancellaresca also was called bâtarde when it was introduced into France in the sixteenth century.

Our example shows an early schwabacher that, however, manifests most of the design characteristics of the style. Compare these letters with the first example of Gothic current-cursive and with the modern "original" schwabacher face, at the end of this chapter. It will be seen that most of the letters have reached a final design—many of them, as mentioned previously, carrying over from the manuscript hand. Even though this is a type, one must perceive that it is based entirely on the broad-pen letter; it could, in fact, be written with such a pen. Schwabacher is a more readable type than textur. It is noteworthy that the capitals fit with the small letters a bit better; they have been simplified—are not used so much in the manner of initials. In some instances they are based on the minuscule design: note the F, H, V, W, Y, and Z of the "original" schwabacher. Among the small letters, the r is of interest, being present in two styles, especially as a ligature with e. The letters in the example are about one-third larger than the originals.

The design of these letters should be examined carefully; check them with the textur and fraktur designs; study the chart of style differences accompanying the specimens on this page. One of the most important rules to be followed in using all these letters is: never mix these styles in one alphabet. Each of the designs—textur, schwabacher, and fraktur—represents a separate family; related to the others of course, but under a strict taboo against intermingling. Any attempt to mix these families will produce unsatisfactory results. One should become sensitive to the fitness of employing one letter-design with another; then one will begin to understand letters—not so much from the standpoint of legibility, but as designs.

Letter designers will find a use for the schwabacher in all instances where a Gothic letter is called for, but where a religious feeling is to be avoided; the style is, and always was, straightforward, honest, and popular; it was closely related to the great period of woodcut book-illustration.

Fraktur:

The fraktur is a specific German design; and has maintained itself in Germanic countries until the present, being used for the characteristic literature and advertising of these countries. It is the result of Renaissance influence upon Gothic letters—to be more definite, the influence of the baroque element of the Renaissance. Some writers consider the fraktur to be a continuation of the Gothic textur with Renaissance design changes; it may also be looked upon as a fusion of textur and schwabacher. It is quite simple to connect the general style of the south German area, in the sixteenth century, with the development of the fraktur design. One need but examine some of Albrecht Dürer's title-pages to see the introduction of the baroque flourishes and movement. Again the reader is reminded of the inevitable connection between general style and letter design. There is no doubt that here, again, the type design was based upon a letter made with a broad pen. The first example, from Kaiser Maximilian's prayer book, shows an incompletely evolved fraktur design; it is the same letter that is to be found on one of the pages of the book of styles, started in 1507, by the Benedictine writing-master, Leonhard Wagner. Johann Neudörffer the Elder was the writing-master who worked out the definitive fraktur design, about 1522.

The second example, a type used by Sigmund Feyerabend in the *Thurnierbuch,* in 1566, shows—for all practical purposes—a final fraktur design. These letters should be compared with the transitional style and the Ehmcke fraktur at the end of this chapter. Check the chart of style difference as well; what constitutes a fraktur design should become quite clear; this is a lesson in design that no typographer or letter designer can afford to miss.

Of especial appeal to us as Americans is the fact that it was the fraktur that lent its name to the so-called "fractur work" of Pennsylvania German folk art, although actually the name is somewhat of a misnomer. Much of this remarkable work is simply flat design; and even when—as in birth and baptismal certificates—there is lettering, it is not all fraktur. Among the varieties, one finds textur, schwabacher, fraktur, and also current writing hands. Those who wish to examine these works of folk art may find specimens in many museums or in the book, *Pennsylvania German Illuminated Manuscripts,* by Henry S. Borneman. One must, of course, remember that this is folk art; not the work of gifted professional scribes or designers. There are crudities to be observed; but also a simple grace and loveliness, which is often lacking in highly skilled productions.

Refier oder Kreyß/Nemlich deß Rheinſ
Bayrn vnd Schwaben / ſampt andern
runder zum Heyligen Röm. Reich Teu
hörig/ begriffen/mit ſondern Freyheite
gabet/Bey welchē hernach alle folgende
vnd Könige dieſelben gelaſſen vnd geha
krafft dero ob fünff hundert vnd achtzig
letzten zu Wormbs gehaltnen Thurnier
erhalten worden. Das aber gemeldte T
tzung aller ehrbarn tugenden/Ritterlich

Fraktur used by Sigmund Feyerabend in Frankfurt am Main, 1566 ~ size is about ½ larger than original.
Note florid overall effect ~ the flourishes on the capitals and small letters, h for example, are characteristic.

Fraktur script ~ type used,
in 1545, by Hans Kilian ~
especially for prefaces, etc.

Vorrede.

ſey der Kirchey ſeer dienſtlich/daß Jr' das beſſt/ v
vnnd Zöll zugehöreny. Vnnd wiewol wir wi
auß der heiligey Göttlichey Schrifft etlicher Re
herauß klaubey / dergleichey fürnemey dardurch

57

Certainly, the fraktur design is one of the most interesting developments in the history of letters. The question of readability has been touched upon earlier; it is from this viewpoint that there has been much vehement criticism. Largely, this criticism is due to an ignorance or lack of sympathy with the entire Gothic development. It is a bit difficult, perhaps, to understand chauvinism in typography, but one must realize that it exists. We must all, however, learn to recognize and respect a thoroughgoing job—of course, aberrations or stunts are not included. The fraktur design is just such a thoroughgoing job, whether or not it suits our personal prejudices or traditions. In the workaday world of letter design, where so many men have labored long and faithfully, there is no room for militant prejudice or a narrow viewpoint.

Fraktur is of use to the designer where a definite Germanic effect is desired or where there is a necessity for a Gothic letter that allows for caprice and inventive flourishing.

Gothic Script Types:

The Gothic script types are clearly related to the current-cursive writing hands. Our first example, a fraktur script employed by Hans Kilian, should be compared with both the current hands and the fraktur. It was designed as a sort of italic for use in prefaces—much as italic, or cursive type, is used nowadays.

The elements of the specimen, flourishes, title, and text, have been rearranged a bit; but the general effect is much the same as that of the original page. The flourishes were intended for ornament material; they were probably cut in wood or type metal. It is apparent that this sort of flourishing suits the script and fraktur perfectly.

The second example of Gothic script type is the work of Robert Granjon, one of the distinguished type designers of the period. This is plainly one of the least readable of types. It is of interest, however, that Granjon later became renowned as a designer of italic types. The name "Civilité" was applied to the style from its association with an edition of *Civilité puérile* by Erasmus. Other printers and type designers made use of Civilité; the slightly varying faces were all, however, based upon the French area, Gothic current-cursive—France, as a nation, began, about this time, to produce letters and type designs that manifest, in their details, definite French national characteristics. In fact, this first half of the sixteenth century proved to be the golden age of French letter design.

The modern German type, "Legende," which is shown in the final illustra-

La Mort, Composé en Toscay par
Maistre Innocen Enghicoc
Gentilhomme Bonlongnois .

Civilité ~ a type designed and cut by Robert Granjon, about 1557 ~ reproduced from a title-page.

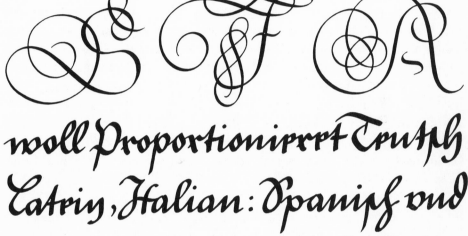

woll Proportionirrt Teutsch
Catein, Italian: Spanish vnd

Initials by Lübeck writing-master, Möller, 1645 ~ two script lines freely copied from a Möller specimen.

und verlor keinen Zoll von der mannhaften Erschei-
nung; aber sie hielt sich so still, daß der Ritter sie nicht
gesehen, wenn nicht das Geräusch des Brunnens sein
Ohr berührt und seine Augen hingelenkt hätte. So-
gleich bog er seitwärts nach dem Quell, stieg vom
Pferd und ließ es trinken, während er die Nonnes

From a page of a manuscript book ~ written by Johannes Boehland, in 1924.

tion in this chapter, is definitely related to Civilité. Compare the two; note the fact that both designs are based on a broad-pen letter. Legende has been much used as a display type; imaginative layout artists have used it often for headlines suggesting the Orient or Mexico—one would not think this possible for a type based upon Gothic everyday writing. The scheme is successful, though, because, for the average person, the style is reminiscent of all oriental broad-pen writing.

The Further Course of Everyday Writing:

The current hands of the fifteenth century developed, throughout the Gothic areas, into the chancery and business hands of the sixteenth century. Some of these are interesting as handwriting but they need not concern us beyond this mention, because they are too often corrupt and full of individual aberrations. Where one of these hands is related to one developed later, however, some explanation will be made. Gradually, the Humanistic cursive became the dominant handwriting style; the early stages of its influence and the attendant development will be discussed in the next chapter. The strictly Gothic handwriting was displaced in one area after another. At the same time came the gradual introduction—from the beginning of the seventeenth century onward—of the pointed pen, which was used to imitate the engraver's rendering of writing. Gothic handwriting, which is inseparable from the use of the broad pen, finally disappeared from everyday use.

The lines copied from the specimen page of the writing-master Arnold Möller show, still, a good use of the broad pen in 1645. There are certain Humanistic cursive influences present here but, on the whole, the writing is still in the Gothic tradition. Clearly in the Gothic style also, are the lines written by Johannes Boehland, one of Germany's foremost lettering artists, in 1924. In choosing these examples, so widely separated in time, the intention is to present— quickly and visibly—the idea that the tradition of Gothic handwriting has been carried along by specialized craftsmen until the present—even though everyday practice has ceased to be influenced by this tradition.

Present-day Textur, Schwabacher, and Fraktur:

The next page of examples brings the design of Gothic letters up to our own times. It is not possible to include the work of all the gifted designers of various countries who have given us fine faces in one or more of these styles; just one specimen of each style has been selected and will be discussed briefly.

ABCDEFGHIJKLMNO
PQRSTUVWXYZ 1234567890
aabcddeefghijklmnopqrrsſstuvwxyzʒʒ

The Wilhelm Klingspor type — a modern textur designed by Rudolf Koch.

ABCDEFGHIJKLMNO
PQRSTUVWXYZ
abcdefghijklmnopqrſs
12345 tuvwxyz 67890

*"Original" schwabacher —
a modern cutting —
based on early designs.*

ABCDEFGOPQRSTUHJKLMN
OWXYZ abcdefghiklmnopqrsſtuvwxyz
1234567890

*Ehmcke fraktur — designed by F. H. Ehmcke —
first used about 1912.*

ABCDEFGHJKLM
NOPQRSTUWX
YZ abcdefghiklmnopq
rsſtuvwxyz 123456789

Fraktur used by Johann Fr. Unger, about 1794 — cut and possibly designed by Johann C. Gubitz.

The textur was designed by Rudolf Koch for the Klingspor type foundry. Letter designers should make a point of observing and learning to recognize the work of this fine type designer. Again, it would be advisable to compare the individual letters in this textur face with those of the schwabacher and fraktur; note the broad-pen quality in the design of all the letters—the Unger frakur is an exception that will be explained at the end of this section. The capitals shown are of initial size; for ordinary use with the minuscules in text matter, a smaller and narrower size would be chosen. There are alternate characters in the minuscule alphabet for the a, d, e, r, s, and z—note how the tone and style of these alternate letters are held to the general design. This is a visible lesson in letter design. The numerals, too, deserve attention; they are quite in keeping with the capitals and small letters of the alphabet.

It is generally recognized that the schwabacher design is best represented by the so-called Nürnberg or Old Schwabacher type. This is an old design revived in the 1870's by the Munich Renaissance movement and since recut by various German type foundries. The specimen shown was produced by the Benjamin Krebs foundry of Frankfurt am Main.

The fraktur specimen was designed by another of the outstanding German craftsmen, F. H. Ehmcke; it was distributed by the Stempel foundry. Ehmcke, in a little essay on its style, mentions a few instances in which he has deviated from the traditional fraktur. The capital U was given more movement in the first stroke, necessitating the closing of the capital A in order to avoid a similarity. He notes the retention of the flourishes as an integral part of the style. Among the minuscules, the first stroke of the w is mentioned; it was given a swing in contrast to the traditional straight stroke. All the letters, insofar as possible, should be compared with the Feyerabend fraktur.

Johann Friedrich Unger, a printer and type designer, was the chief exponent of the Didot and Bodoni influence in Germany. It is interesting to note in his fraktur the attempt to design a type in the same spirit as the so-called "classical" types of these two designers. These types were not based on broad-pen production; their development will be considered in its proper place. As an example of a design problem of this sort, however, the general appearance of these letters should be compared with the Bodoni specimen (see p. 141).

Summary:

This chapter has described, as concisely as possible, the three-hundred-year

Gothic letter development besides a considerable part of the history of letters from Gothic times to the present. The Gothic period was of the greatest importance for the final developments within the alphabet. It has been necessary to untangle a complex knot of influences, developments, and styles. However, it is possible that from this whole evolution the reader will gain a better understanding of designing and styling letters than he would from any other section of letter history. To understand the use and application of the broad pen in making these various styles is alone of great value to the aspiring letter artist. Finally, the basic principle upon which the equal-width type faces of the present day have been designed is to be discerned only in the Gothic letter; it does not matter whether the faces selected for study are roman or sans serif in design.

Hundertjährige Tradition

handwerklicher Arbeit

und ein ewig junger

schöpferischer Geist 1837–1937

Legende ~ designed by F.H.Ernst Schneidler for the Bauer type foundry.

Humanistic Writing and Its Influence on Type

Foreword:

In order to understand—at least sufficiently for our purposes—the times and the scene of this next important development in the history of letters, some explanatory remarks are necessary. We must return to the fifteenth century; the scene is Italy, with all the background and color of the Renaissance. Again, it is wise to avoid a too nationalistic viewpoint; there was no national state as we know it today; and many artists and scholars, especially those concerned with letter design, came from various parts of Europe. Jakob Burckhardt, in his book on the Renaissance, notes that many of the scribes, the "copisti," employed in Rome during the early part of the fifteenth century, were French or German; it will be seen that the first printers and type designers had the same origins. One should bear in mind that there was far more exchange of men and ideas across the Alps than has usually been recorded in our history books.

Italy, as has already been indicated, was the one important western European area in which the definitive, final phases of the Gothic development failed to find expression. Even as the Gothic spirit reached its height in the other areas of western Europe, Italy was slowly evolving what is often considered a revival of the culture of antiquity: a renaissance. The proximity of the seats of ancient Greek and Roman culture is presumed to have prevented the artists and scholars from being too greatly influenced by the drive of northern culture and its art forms. In this respect there did arise a great interest in all the relics and ruins of Roman life; an interest that finally led to the discovery of such works of art as the Apollo of the Belvedere and the Laocoön. The same sort of interest in the realm of literature led to literary sleuthing: all over Europe long-lost manuscripts were located and purchased or copied by literary agents, such as the famous Poggio. Greek antiquity—especially the classic literature—was brought to the Italian scene by an influx of Greek scholars, fleeing the invading Turk; a good deal of our knowledge of Greek literature is to be attributed to this course

of events. There cannot, of course, be a pure revival—the old is always mixed with the new. The revival of antiquity was only one factor in the Renaissance; Burckhardt lists, as equally important: the popular Italian character, political institutions imported from Germany by the Lombards, chivalry and other northern forms of civilization, and the influence of religion and the Church. These, he tells us, were combined to produce the "modern Italian spirit which was destined to serve as the model and ideal for the whole western world."

How Humanistic Writing Started:
Some of the points concerning the period and scene of the Renaissance may now be applied to letters, particularly to the writing style of the Humanist scholars. Under the protection of enthusiastic princes of the Church and the various cities and states, it was not difficult for the Humanists—who were the driving force of the Renaissance—to overcome the last vestiges of Gothic influence. They revived many of the principles of antique culture relating to the arts, especially the horizontal principle in architecture. It follows that, if they built along horizontal lines, they would apply this principle to their manuscript writing. (By now we are accustomed to the consistent relation between general style and letters.) The first steps in this direction were shown by a fresh interest in the incised Roman letter; new studies of the designs were made and treatises were written about them—the first, apparently, was by Felice Feliciano; issued as a manuscript in 1463. At the same time, the Humanist scribes sought to replace the Gothic and half-Gothic minuscules with those of the ancients. In looking about for these ancient minuscules—whose complete lack seems never to have occurred to anyone—they seized upon the Carlovingian writing. This was a natural and even logical procedure. There had, of course, been a lapse of some three hundred years since the widespread use of the style; and the fact that practically all the manuscripts of the classic writers they discovered were written in these letters seemed convincing enough to them. Knowing little, perhaps, of the re-writing of all extant literature following Carl's decree of 789 and of the succeeding two hundred years of copying manuscripts in the Carlovingian hand, the Humanists readily accepted this hand as the genuine writing style of the ancients and called it "lettera antica."

The Humanistic Manuscript Hand:
At first the Carlovingian writing was copied almost exactly. As early as 1425 the Humanist, Niccoló Niccoli was conducting a school in Florence where scribes

65

were trained to write in a precise, round letter, which was really a revival of this long-neglected hand. Vespasiano da Bisticci, the greatest of Florentine booksellers, and Tomaso Parentucelli, later Nicholas V, the founder of the Vatican library, represent other phases of this development. The classic capitals were combined with this letter to form a dual alphabet. Actually, the new alphabet was based on a mistake. It has often been pointed out that the capitals and minuscules were not homogeneous elements; the capitals were unmistakably an incised letter style; the Carlovingian writing was strictly a pen design. One may observe in this entire evolution one of the illogical passages of letter history. It will also be realized that there is not as much estrangement between the Gothic minuscule and roman as there is supposed to be—they were both derived from the Carlovingian letter under the domination of different style periods. Of course, the scribes noticed that the capitals and small letters did not fit together very well; so they performed a styling job of adding serifs and finishing strokes to the latter, in order to suit them to the capitals. By the time the craft of printing was introduced into Italy, the Humanistic writing afforded a fully developed basis for the type style we now call "roman."

The letters in the example should be compared with the specimens of Carlovingian writing (p. 31). The ascenders and descenders are noticeably longer in this new variety. On the whole, ligatures—in the pure Humanistic style—were limited to the t with such letters as the c and long s. It will be seen that the t has not followed the Carlovingian design; it is based on the Gothic letter. In omitting the dots over the i's the Humanists obviously copied the Carlovingian, in which the dot was not present. The addition of some finishing strokes to the minuscules is apparent; when, however, the letters were worked over by the type designers much more styling was done to suit them to the capitals. This example was written several times larger than the original—written with a reed pen; the original was made with a small quill. The reed pen was split off-center, to the left; many of the lighter lines were obtained by lifting the right side of the pen slightly and using the left-hand corner. Much medieval and Renaissance writing was done with this sort of pen; the results are often baffling to those who know nothing of this technique. The initial, which was in color on the original page, has been drawn in a typical black and white style.

The Humanistic manuscripts were among the finest ever produced. It is understandable that when printed books first made their appearance many booklovers, such as Frederick of Urbino, "would have been ashamed to own a printed

Deus inquit Epicurrus
igitur habet potestatem.
cesse est eum qui bt pot
tulis. Ideo inquit incor

fsxy

missa contrabanna: qui
bndo partem: ut de aliys smi
dicta facias obsuari / et in
et tres partes consily rogator

book." These manuscripts were completely different from those of the vanishing medieval period: they had an impressive clearness and precision about their pages; ornament was used sparingly and tastefully; the entire aesthetic effect was often achieved simply through the elegant lettering, arranged neatly in lines that were placed on the page so as to make a delicate overall tone. As a manuscript hand, the Humanistic writing carried on until 1500, being finally displaced by the successful use of roman type for books. In fact, the writing done at the very end of the century was much influenced, in turn, by the type designs.

The Humanistic Current-Cursive:

Just as in all previous letter history, a current variety of the formal writing style made its appearance during the Renaissance; this was called "cursiva humanistica." The Humanistic current-cursive was not just a more rapidly written Humanistic minuscule; it had in it many influences from the Gothic current hands of the Italian area. The example should be compared with the specimens of Gothic everyday writing (p. 47). It may be mentioned that although the severe Gothic never became popular in the Italian area, the Gothic current hands did.

The most striking characteristics of this informal Humanistic hand are the slant and the narrowing of the round letters. From eight to ten degrees is the angle of inclination; the round letters become ovals; and all the letters are written closely together, often connected. The ascenders are extremely tall—twice the height of the body in many cases. Noteworthy letters are the a, which returns to the Gothic current design, and the many ligatures. Unslanted classic capitals were used with these letters. For the student, a close study of the elegant effect and variety of these freely-written designs is imperative. Toward the end of the fifteenth century, "cursiva humanistica" became increasingly important as a manuscript hand. As the Humanistic minuscule was forced out of use by the printed book, this cursive came into favor for all the purposes for which writing was still required. It became the basis for the various styles employed by the sixteenth century writing-masters. The use and later development of these in other countries produced the script styles of the seventeenth and eighteenth centuries. By far its greatest importance to us at this juncture of the history of letters is in its position as the basis for cursive or italic types.

The Development of Roman Type:

Italy, during the early stages of the development of printing, was at the height of

its political and cultural glory; not as a unified state, but as a group of fascinating republics, monarchies, despotisms, duchies, and papal domains. Although the interests of these small political units were largely opposed to one another, there was a certain overall Italian unity achieved by their interlocking rivalries, schemes, commerce, and exchange of ideas. Above all else there was wealth and luxury—the art of the Renaissance is unthinkable if separated from lavish expenditure. It is no accident, therefore, that the first printers to seek their fortunes outside of Germany should have journeyed to Italy; the fact that Venice, queen of the Adriatic, one of the wealthiest of cities, became a great printing center within a few years is quite understandable.

Any study of the start of type design in Italy must be based on the work of some half-dozen men, all of them printers and type designers. It is not necessary to the purposes of this book to give a great deal of information concerning them; their development of the roman type designs, which is our chief interest, may be followed in the illustrations. As a matter of fact, there is a great deal of confusion about many phases of their lives and work. Although Konrad Sweynheim and Arnold Pannartz are usually considered the first known printers to have come into Italy to set up a press, it is quite certain that they were closely followed, possibly accompanied, by the brothers, Johann and Wendelin of Speyer (da Spira), and Nicolas Jenson. The first four were Germans. Jenson was a Frenchman who had apparently learned the new craft at Mainz. All of these men were versatile craftsmen. It is possible that Jenson cut punches for both the Sweynheim and Pannartz firm and the two brothers. These accounts are unconfirmed. He does seem to have maintained some sort of association with the latter pair in Venice.

The examples chosen to illustrate the development of this new type are not sequent according to dates; but, as far as the designs are concerned, the development is clear. Dates, in any case, are extremely doubtful considerations; it is difficult to establish the actual production date of any type face; sometimes it is even more difficult to discover who produced it. All of these early printers designed and used types which ranged from severe Gothic to roman; these were not turned out in a logical succession at all; so, it is obviously not necessary to worry about proper sequence. Much of the early activity was in Rome and these first designs quickly became known as "Roman"; in order to avoid confusion with classic Roman letters it has become customary to apply the name uncapitalized.

In some European countries roman is known as "antiqua" from its affinity with the Humanistic "lettera antica." The names "medieval" and "old-style" are also used to designate a roman type that is in the general style of the late fifteenth century designers—specifically, the roman used by Aldus. Roman faces based on the earlier Jenson and Speyer models are called "venetian."

The first example is really a half-Gothic type; one, however, that represents the transition to roman—this point has already been explained. This style was often called "Gotico-antiqua"—a name that explains its relation to the later antiqua. Compare these letters with the Ratdolt half-Gothic (see p. 53) in the following respects: distance between lines; length of ascenders; treatment of the ends of ascenders, descenders, and all free strokes. It is noteworthy that the Gothic capitals are still used. The influence of the Humanistic minuscule is present, however, particularly in the points mentioned above. These transitional half-Gothics started with the Catholicon type attributed to Gutenberg—a style called "lettre de somme" by the French. The initial in this specimen was drawn in by a scribe.

The second specimen—the second type used by Sweynheim and Pannartz, in Rome—illustrates a very good imitation of the Humanistic minuscule. Check these letters with the example of Humanistic manuscript writing; the use of the classic capitals is excellently shown, as well as the styling of the small letters to suit the capitals. This is by no means a finished roman type; the dots are missing over the i's and it has many other faults, judged by what we now consider a roman type. However, the translation of the Humanistic letter into the new medium represents a highly interesting and instructive achievement. It is to be observed that these letters might easily be made with a broad pen.

Jenson:

The Nicolas Jenson type—first used in 1470—illustrates a completely evolved roman. Johann of Speyer is usually credited with the first truly roman type, which he used in Venice in 1469. Jenson's face, however, is a better one, and has set a standard for authentic roman until the present day. All the characters in this design should be carefully studied; aside from individual letters, the overall effect and the reasons for it are of importance. Note the lengths of the ascenders and descenders compared to the body; study the white areas in and around the letters, including the distance between lines. Slight alterations would change the effect; only a master designer could conceive and hold a design effect

Pⁱßimũ myſteriũ ↄe coïone ↄeclarãdũ ꝺ̃ obligatióis.Obligant̃ ſiqdẽ
bomïes ad cõicandũ ſuſcipiendũꝗ ſáctiſſimũ ſacramentũ ꝺñi noſtri
Ieſu ꝛpi triplici róe.Jꝓimo róe recoꝛdatióis.Secũdo róe ꝑceptióis.Tertio
róe cóminatióis.Cꝙꝓimo róe recoꝛdatióis.Jnſtitutũ ſiquidẽ fuit ſacͬin al
taris a ꝺñ0 Ieſu ꝛꝓ0 ut fideles ſui illud ſumẽtes recoꝛdarent̃ amoꝛis quem
nobis oſtẽdit ꝺum ͛p noſtra ſalute paſſioné acerbiſſimã crudeléꝗ moꝛtẽ pa
tientiſſime rolerauit. Unde (Matͪ.xxvi.ꞇ Luce.xxij.iꝑe ait.Iboc facïte in
meã cómemoꝛatioñé.Et Jꝑau.i.coꝛ.xi.ait.Quotiéſcũꝗ mãducabitis panem
bũc ꞇ calicé bibetis moꝛté ꝺñi anũciabitis ꝯnec ueniat.Et idẽ ponit̃ in ſen
tẽtia ↄe conſeĉ.ꝺi.ij.c.ſcriptura.c.quia paſſus.c. ſemel ꝛpus.c.in ꝛꝓ0.ꞇ.c.ſemel
imolat9.in.c.quia ꝛꝑi coꝛpus.Euſebius ita loquit̃. Quia coꝛpus aſſumptũ

Type used by Wendelin of Speyer (da Spira) in Venice, 1472 ~ "Quadragesimale de poenitentia".

Slightly larger than original ~ note distance between lines, long ascenders and descenders.

Sed plane ípleſtı remeanſ pıe uıctor olympı.
Tartera preſſa ıacent.nec ſua ıura tenent.
Inferuſ inſaturabılıter caua guttura pãdenſ
Quı raperet ſemper:fıt tua preda deuſ.
Erıpıſ ınnumerũ populũ de carcere mortıſ.
Et ſequıtur lıber quo ſuuſ auctor abıſ.
Euomıt abſorptam pauıde fera belua plebẽ.
Et de fauce lupı ſubtrahıt agnuſ oueſ.
Hınc tumulũ repetẽſ poſt tartara carne reſũpta.
Bellıger ad celoſ ampla trophea referſ.
Quoſ babuıt penale chaoſ:ıam reddıdıt ıſte:
Et quoſ morſ peteret:boſ noua uıta tenet.
Rex ſacer ecce tuı radıat parſ magna tropheı:

Type used by Sweynheim and Pannartz in Rome ~ 1468 ~ Lactantius: "Opera" ~ ⅓ larger than original.

of this sort. There is, nevertheless, one fault that has often been pointed out: it concerns the letter h. The Jenson h is considered a bad design; the body is too full for the ascender; actually, it should have been curved as in the manuscript hand and the second type example. There were few type designers who did not follow Jenson; so the bad h has been carried along to the present day. In this specimen the initial was missing; it has been drawn in by the author in a characteristic style—on the page it would have been in color, a bit lighter in effect.

Aldus:

The next type—from Francesco Colonna's *Hypnerotomachia Poliphili*—while it is not as fine a letter as that of Jenson, is important in its later influence, especially on the French designers. Aldus Manutius (Manuzio), a publisher by profession, was primarily a scholar and businessman. He became famous all over Europe for the accuracy of his editions of the classics; and his texts, consequently, were often pirated and copied—usually including the design of the types he used. It is generally believed that Francesco Griffo of Bologna designed the letters and cut the punches for the type of this specimen. The top part shows the definite horizontal effect of lines of classic capitals; the capitals themselves are typical Renaissance renderings of the incised Roman letter. This example, in its entirety, provides a remarkable instance of an even tone over a whole page. Note how the initial is kept in the same tone as the text matter. The illustrations for this book were also designed to suit the type perfectly—the book is an artistic "tour de force." This now offers the only apparent reason for its fame, since everyone seems agreed that the subject matter is fantastic nonsense. Again, one is reminded of the dual nature of letters: of the aesthetic satisfaction they may give, quite apart from what they say. The major defect in this specimen is the lack of compactness in the words; in many places the distance between letters in the words approaches that between words. This may produce a fine overall tone but it causes trouble for the reader; and in this respect it is bad design—compare the Jenson type from this point of view.

Ratdolt:

The sixth man among our pioneers of type design in Italy is Erhard Ratdolt. The specimen of one of his roman types is from the same 1486 sheet from which the example of half-Gothic type was reproduced. Ratdolt probably made the type and printed the sheet in Venice; however, it is dated Augsburg, Ratdolt's native city, and was issued to announce the opening of his printing office there.

Omnibus hic nocuit thebis ut foſſa fuiſſet
 Penderet laqueis ſi bene nota canis.
Quidã eius libros nõ ipſius eſſe ſed Dionyſii &Zophiri co
lophoniorũ tradunt:qui iocãdi cauſa cõſcribentes ei ut diſ
ponere idoneo dederunt.Fuerunt autẽ Menippi ſex. Prïus
qui de lydis ſcripſit:Xanthũqʒ breuiauit.Secũdus hic ipſe.
Tertius ſtratonicus ſophiſta.Quartus ſculptor . Quintus
& ſextus pictores:utroſqʒ memorat apollodorus.Cynici au
tem uolumina tredecï ſunt.Neniæ:teſtamenta:epiſtolæ cõ
poſitæ ex deorum pſona ad phyſicos & mathematicos grã
maticoſqʒ:& epicuri fœtus:& eas quæ ab ipſis religioſe co⁄
luntur imagines:& alia.

Menedemus.

Enedemus Coloti lãpſaceni diſcipulus fuit.Hic ut
ait Hippobotus intantũ ‿pdigioſæ ſupſtiõis uene
rat ut ſumpto hïtu furiæ circũiret:dicens ſpecula⁄
torẽ ſe ex inferno ueniſſe peccantiũ: ut iterato deſcendens
hæc ibi dæmonibus renunciaret quæ uidiſſet.Veſtis hæc e⁄
rat pulla tunica talaris:aſtricta puniceo balteo: pilleus arca
dicus capiti ïpoſitus habens ïtexta elementa .xii. cothurni
tragici barba prolixa:uirga in manu fraxinea.Atqʒ iſtæ qdẽ

Type designed by Nicolas Jenson ~ used in edition of "Laertius", Venice, 1475.

Letters are about 1/3 larger than original ~ initial put in by author.~ original lacks initial.

For Ratdolt, another of the Germans who carried the printing craft into the Italian area, returned to continue his illustrious career in his native land. He is considered the equal of any of the famous Venetian printers and is credited with many innovations in early book production. In the smaller sizes of roman on the specimen sheet it is to be noted that he did not follow the Jenson h, but retained the design of the manuscript letter.

In these examples of type design by Jenson, Griffo, and Ratdolt we have before us the basis of everything that has been done in roman type design from the latter part of the fifteenth century until the present. The designing of roman types was not confined to the Italian area even during this early period; there were one or two good roman types produced independently in Germany—the best, probably, by Lienhard Holle, of Ulm. As a matter of fact, Adolf Rusch seems to have made the first roman type, in Strassburg, by 1464. Many of the later designs that have been turned out over the centuries are little more than workmanlike copies of all the style factors of these early productions, lacking, in many instances, the virility and freshness of the originals. There have been, of course, type designers of great ability throughout this long period of time; and these will be mentioned, in most cases, in the chapters that follow. It is not possible or necessary, though, to pursue the development of letters in minute detail; what should be looked for is the expanding domination of Renaissance letter design in our western culture.

The Development of Cursive or Italic Type:
Aldus Manutius is to be credited with the idea of the first italic type. Of course, cursive writing had become very popular; this fact alone may have forced the demand for a type in this style. The reason usually considered decisive, however, was Aldus's desire to produce inexpensive editions of the Latin classics. He had been able to do this with Greek works through the introduction of a new face of Greek type based on cursive writing, full of ligatures and abbreviations. When he considered a similar device for the Latin classics—a sort of pocket edition—he could not fail to be impressed with the narrow, closely-placed letters of the "cursiva humanistica." Here was a style that would enable him to get much more text on a page than did roman type, that would save paper, and, therefore, money. He commissioned Francesco Griffo to design a type face like it.

A study of the example shows that it is based on the current-cursive writing style; the two examples ought to be compared. This type is full of ligatures—

74

NARRA QVIVI LA DIV·A POLIA LA NOBILE ET
ANTIQVA ORIGINE SVA .ET COMO PER LI PREDE
CESSORI SVI TRIVISIO FVE EDIFICATO.ET DI QVEL
LA GENTE LELIA ORIVNDA. ET PER QVALE MO‑
DO DISAVEDVTA ET INSCIA DISCONCIAMENTE
SE IN AMOR OE DI LEI IL SVO DILECTO POLIPHILO.

E MIE DEBILE VOCE TALE O GRA
tiofe & diue Nymphe abfone perueneráno &
inconcine alla uoftra benigna audiétia .quale
la terrifica raucitate del urinante Efacho al fua‑
ue canto dela piangeuole Philomela. Nondi
meno uolendo io cum tuti gli mei exili cona‑
ti del intellecto,& cum la mia paucula fufficié
tia di fatiffare alle uoftre piaceuole petitione,
non riftaro al potere,Lequale femota qualúque hefitatione epfe piu che
fi congruerebbe altronde,dignamente meritano piu uberrimo fluuio di
eloquentia ,cum troppo piu rotunda elegantia & cum piu exornata poli

Type used by Aldus Manutius for "Hypnerotomachia Poliphili" ~ Venice , 1499.
Designed by Francesco Griffo da Bologna ~ slightly larger than original ~ note design of h , m , n.

Eft homini uirtus fuluo preciofior auro: ænæas
Ingenium quondam fuerat preciofius auro.
Miramurꝗ magis quos munera mentis adornãt:
Quam qui corporeis emicuere bonis.
Si qua uirtute nites ne defpice quenquam
Ex alia quadam forfitan ipfe nitet

The largest size roman type from Erhard Ratdoldt's specimen sheet ~ 1486.
About 1/3 larger than original.

very similar to those found in the writing hand. As a type, it proves to be a careful translation of the pen letter into the new medium. The use of roman capitals is well shown in the specimen; they are about the height of the lower-case t. One of the general rules for designing roman and italic types is to hold the capitals a trifle shorter than the lower-case ascenders—not, of course, as small as these capitals. The term "lower-case"—the printer's name for minuscules—comes, simply, from the use of a lower case to hold these characters; the majuscules were in the upper case and are sometimes called upper-case letters.

Aldus's first editions using the new type were immediately pirated, particularly by the printers of Lyons. Griffo actually cut another set of punches for the type, which he sold to a rival printer. Although the style was first called "Aldino" it soon acquired the name "italic"—perhaps because it came from Italy. The Germanic countries call these types "cursive," which, it must be said, is a better name—and the proper one. Names are a vexing problem in any matter such as this; to add to the vexation in this instance, some writers call these faces "chancery" types, which seems to be the least suitable name of all. The Aldine italic had, for a short period, great influence on type design, although it was not the best of the italic types. For the reasons listed above—having to do with the fame of Aldus and his editions—his type was widely copied or used as a model.

In recent times it has been pointed out by Mr. Stanley Morison that the italic of Ludovico Arrighi, also called Vicentino, was a much better design which had been entirely neglected by all typographic historians. It is to Arrighi that we owe much of our present italic style, through the influence he had upon French designers. Arrighi was a scribe in the Vatican chancellery, one of the gifted writing-masters. He based his italic on the "cancellaresca" style of writing, which was nothing but a later variety of the cursiva humanistica. The sixteenth-century writing-masters' styles will be considered in the next chapter. It is apparent from what has been said whence the idea of using the name "chancery" was derived. Arrighi's punch-cutter was Lauticio di Bartolomeo dei Rotelli, who seems also to have been a famous medalist.

A comparison of the two examples is all that is needed to instruct the reader in the differences between the types. The later design avoided almost all ligatures; used a slightly taller capital; and was really worked out in the type medium—it was not a copy of the pen letter. This is an elegant letter, with long ascenders and descenders; in this elegance it has the effect of the written style. Study the totally

AENE·

P abula parua legens, nidis'q; loquacibus escas,

E t nunc porticibus uacuis, nunc humida circum

S tagna sonat, similis medios Iuturna per hostes

F ertur equis, rapido'q; uolans obit omnia curru.

I am'q; hic germanum, iam'q; hic ostendit ouantem

N ec conferre manum patitur, uolat auia longe.

The first italic type ~ cut for Aldus Manutius by Francesco Griffo da Bologna.

This example is from a page of the "Virgil" printed in 1501 ~ a bit more than twice larger than original.

 V dimus effigiem belli, simulataque ueris

P rælia, buxo acies fictas, et ludicra regna.

V t gemini inter se reges albusque, nigerque

P ro laude oppositi certent bicoloribus armis.

D icite Seriades Nymphæ certamina tanta

C arminibus prorsus uatum illibata priorum.

N ulla uia est. tamen ire iuuat, quo me rapit ardor,

Arrighi's second italic type ~ 1527 ~ about twice larger than original ~ initial by the author.
Original lacks initial.

different aspect produced by the greater distance here between the lines and words. The inclination of both types is about the same, between eight and ten degrees. It was Stanley Morison who suggested that letter designers might still develop the Arrighi italic, particularly as a self-sufficient type. To him, the manner in which most of the italic faces were evolved and used was not exactly the best thing that could have happened. This point will be more fully developed in the chapters that follow.

The majority of sixteenth-century Italian books were apparently printed in italic types; those printed at Rome by Arrighi were among the finest productions of the Italian presses. By 1550, however, italic began to be abandoned as a book type. This process continued until it came to be used only for preliminary matter, citation in the line, emphasis, etc.

Other Renaissance Influences:

Arrighi was, for a time, associated with Gian Giorgio Trissino, who wrote extensively concerning reforms in spelling and writing the Italian language. He printed several of Trissino's books. The final separation of the vowels i and u from the consonants j and v—the separation of the designs, that is, which was begun in pre-Gothic times—was one of Trissino's favorite projects. It was carried out at this time, although a mixed usage continued in Europe until the eighteenth century. The Italian language itself engendered another process that finally resulted in the dropping of the long s. Centuries of development, especially during Gothic times, had produced the two distinct s designs; the long s, for the initial and medial positions in a word, and the round s, for word endings. The Italian language lacks s endings; so, gradually the custom became confused, the tendency being to use the round s in the initial and medial positions indiscriminately with the long s. After this careless usage had been transferred to Latin texts the damage was done. Other European countries, France particularly, copied Italian practice—regardless of the fact that all their languages had plenty of s endings. Even countries such as England, whose language is decidedly Germanic, gradually ceased using the long s; although it was still found during the eighteenth century. Some Germanic countries still have the two designs. Many philologists consider the dropping of the long s a distinct cultural loss; they tell us that it gave the reader and writer an immediate insight into the structure of the word—helped make the word picture clear. Insofar as letter design is concerned, a definite aesthetic loss is to be recorded in the dropping of the

long s. Such fine points as these should be carefully studied; they help to sharpen the eye and refine the taste.

"The Model and Ideal for the Whole Western World":
Burckhardt's words concerning Renaissance influence are truer, perhaps, in the field of letter design than in any other. It is not possible to have studied the examples, and looked at current books and newspapers, without realizing the dominance of Renaissance letter-designs. They became, indeed, the "model and ideal for the whole western world." It must be remarked, however, that in the process of conquering the western world, for various reasons the letters lost much of their nobility and effectiveness. They have been revived several times, following periods of corruption and bad taste; but after each revival they seem a bit less vital than before. This is comprehensible when one remembers that, during their development in the Renaissance, they were living designs, subject to the blunders as well as to the creative efforts of the master-craftsmen—happily, the blunders were few and the results of great and lasting aesthetic value. On the other hand, in most instances, nowadays, these letters—the revivals, etc.—have ceased to be regarded as living designs; and they are but rarely in the hands of master craftsmen. Considering this state of affairs, the one important point to remember is that the letters originated in a broad-pen style of writing. They should be studied first as a broad-pen product and then as a type design. Much space in the following chapters will be devoted to the varying aspects of Renaissance letters, or the types derived from them, under the impact of later style periods.

The Sixteenth Century

Foreword:

The dominant phases of sixteenth-century letter design are to be found in the writing-masters' copy-books and in the further development of roman and italic types. The strange detachment of writing from type design having set in, the material of this chapter may be divided into two parts, which have little relation to one another. Insofar as writing is concerned, detailed discussion will include the styles of men from the German, Italian, and Spanish areas; the consideration of roman-italic type design may well be concentrated on France, the scene of the greatest importance in this respect. In these discussions the intent is, as always, to make the developments clear with the least possible digression or ramification. A large part of sixteenth-century activity has already been explained in the chapter on Gothic letters; the Gothic and roman-italic evolutions were simultaneous, of course, but they are being described separately for reasons already mentioned; points at which the influences merge have been noted. To study the intricate tapestry of any historical development one must first learn the various major design elements; then it is easier to understand the overall pattern as it has worked out on the loom of time—one is not misled or distracted by non-essential details.

Part 1. Writing-Masters.

General Considerations:

The practices of manuscript writing and illuminating declined steadily during the sixteenth century; the printing-press, as has been indicated in the preceding chapter, gradually displaced the scribe and the illuminator. These men were forced to seek employment in the chancelleries or as teachers of writing. Although some monasteries continued manuscript book-making on into the seventeenth century, here, at the beginning of the sixteenth, we may take our leave of the manuscript book. It is still, however, a factor to be reckoned with, having

influenced book production from the start of printing to the present.

The practice of everyday writing, though, became ever more widespread. A tremendous increase in the number of those, among all classes, who were interested in writing led naturally to the development of the copy- or instruction-book. From the beginning of the century onward, there was a constantly enlarged output of these writing-masters' copy-books. In Italy they all have a strong resemblance to one another; the Spanish writing-masters quite clearly copied the Italians, but added their own measure of genius; in the German area there was a preoccupation with Gothic letters, or some sort of merging of the Gothic and Renaissance styles—the latter tendency has been partially explained in Chapter V, in the section on fraktur. Practically all of these books—most of them small in format—were printed from woodcut renderings of the writing-masters' styles. The exceptions are the *Proba centum scripturarum* of Leonhard Wagner, which was a manuscript book of one hundred styles started in 1507, and the engraved books by Hercolani and De Beaulieu, published in 1571 and 1599, respectively. For memory purposes the manuscript may be considered the first, the De Beaulieu book the last, of the sixteenth century copy-books. Many of these little books, of course, went through numerous editions.

This entire writing development was one of semi-formal and everyday hands. From what has been said about the decline of manuscript writing it is apparent that the formal book hand, which for so long held the dominant position in all consideration of writing, had lost that dominance to printing—to type letters; it was gradually disappearing as a factor in writing history. A separation of writing from printing began: writing became faster, freer, and more corrupt; while type letters were more and more controlled by factors of mechanics and design inherent in the printing process. The two lost their previous relation to one another, so that, at the present time, it is difficult to realize that all type was originally based on written letters. Actually, the hands shown in this chapter represent the start of our usual writing styles. These, for various reasons, have become always more corrupt. In our own time most handwriting has lost all resemblance to the writing-masters' styles of the sixteenth century. To most of us the "cancellaresca" or "bastarda" look like "lettering"; regardless of the fact that they were, in practice, quickly and freely written.

Leading Masters and Their Books:
To give the reader any detailed information about the writing-masters would re-

quire all the pages of a rather large book; this information would not in any way change the rather simple, general picture of the writing development during the century. The evident interchange between areas and the cosmopolitan character of all the arts at this time should deter anyone from accepting any narrow, nationalistic view of writing activity. In general, one may speak of a slow "italianization" of writing styles throughout western Europe; this was due to the expanding influence of the Renaissance. For those who may wish to follow the work of certain individuals further it seems best to list some of the well-known writing-masters and their books, with the place and date of publication.

Leonhard Wagner. *Proba centum scripturarum*. Augsburg, started 1507.

Luca Pacioli. *De Divina Proportione*. Venice, 1509. Pacioli was not a writing-master; a section of his book was devoted to the construction of Roman capitals; the theories of Leonardo da Vinci, with whom Pacioli worked in Milan, are presumed to be the basis for these constructions.

Sigismondo Fanti. *Theorica et Practica de Modo Scribendi*. Venice, 1514. This work also is thought to have been based on the ideas of Leonardo da Vinci.

Johann Neudörffer, the Elder. *Six folio pages with printed styles*. Nürnberg, 1519. *Anweysung einer gemeinen hanndschrift*, 1538. *Gesprechbüchlein zweyer schüler*, 1549.

Ludovico Arrighi (Vicentino). *Il modo et regola de scrivere littera corsiva over cancellarescha*. Rome, 1522. This is the book that was imitated by most of the Italian writing-masters when preparing their own material.

Giovanni Antonio Tagliente. *La vera arte dello exellente scrivere de diverse varie sorti de litere*. Venice, 1524.

Albrecht Dürer. *Underweysung der messung mit dem zirckel und richtscheyt*, Nürnberg, 1525. Dürer was not a writing-master, of course. This book of art theory contains a fine section concerning the construction of Roman capitals and Gothic letters. First book printed in a developed Fraktur.

Geoffroy Tory. *Champ Fleury*. Paris, 1529. Tory, while not exactly a writing-master, was a designer of type and fine initials; he had traveled in Italy and was an enthusiastic supporter of Renaissance culture—this support appeared largely in the printing and publishing of books. Only the last section of his book is of interest: a set of capitals with constructions, similar to those of Pacioli and Dürer.

Johannes Baptista Palatinus (Palatino). *Libro nel qual s'insegna a scrivere.* Rome, 1540. This was without doubt the most widely used of all the 16th Century Italian copy-books.

Gerhard Mercator (Kremer). *Literarum latinarum, quas Italicus, cursoriasque vocant scribendarum ratio.* Antwerp, 1540. The author was the famous cartographer; he deals here entirely with the Italian cursive style.

Juan de Yciar. *Recopilacion subtilissima.* Saragossa, 1548.

Christoph Stimmer. *Kunstrych Fundamentbüchle.* Zürich, 1549.

Urban Wyss. *Libellus valde doctus, elegans et utilis.* Zürich, 1549.

Kaspar Neff. *Köstliche Schatzkammer der schreibkunst.* Köln, 1549.

Wolfgang Fugger. *Nutzlich und wolgerundt Formular.* Nürnberg, 1553.

Ferdinand Ruano. *Sette Alphabeti.* Rome, 1554. Ruano extended constructions to include cursive letters.

Fra Vespasiano Amphiareo. *Opera nella quale sinsegna a scrivere.* Venice, 1554.

Giovanni Francesco Cresci. *Essemplare di pui sorti Lettere.* Rome, 1560. Both this book and that of Palatino were printed by the famous Antonio Blado.

Pieter Heyns. *A B C, offt exemplen om de kinderen bequamelick te leeren schryven.* Antwerp, 1568. Heyns designed initials for Christopher Plantin.

Jacques de la Rue. *Exemplaires de plusieurs sortes de Lettres.* Paris, 1569. This is not the first of the French copy-books; small books in the Italian manner were produced in Paris and Lyons as early as 1561. France was the first Gothic area to abandon the Gothic writing hands; the process was gradual—not until the mid-seventeenth-century were the Gothic cursives discontinued in the state offices.

Jehan de Beauchesne and John Baildon. *A Book Containing Diverse Sortes of Handes.* London, 1571. This was the first English copy-book showing the Italian cursive; it is evident, however, from the writing of Elizabeth and her advisers, that Italian style had exerted an influence before the appearance of this book.

Guilantonio Hercolani. *Essemplare utile.* Bologna, 1571. Hercolani's book differed from those of his predecessors in that it was printed from engraved copper plates.

Francisco Lucas. *Art de escrevir.* Madrid, 1577. It is quite apparent that the Spanish writing-masters knew the Italian copy-books thoroughly.

Jacobus Houthusius. *Exemplaria sive Formulae Scripturae Ornatioris XXXIV.* Antwerp, 1591.

Giacomo Franco . . . *modo di scrivere.* Venice, 1595. This book contained the first

examples of written flourishes; these became, from this time onward, the particular pride of the virtuoso writing-master.

Sieur de Beaulieu. *Exemplaires*. Montpellier, 1599. Of greatest interest is the fact that the engraving process was used to reproduce the examples in this book; this was the start of the seventeenth and eighteenth century engraved copy-books —a technique that ushered in the use of the pointed pen.

The Dürer Variety of Classic Capitals:

In most of the sixteenth century writing-books there was a page of Roman capitals, usually accompanied by constructions and notes concerning proper proportion and design. This is manifestly owing to the influence of the Renaissance, with its enthusiasm for all things classic. Perhaps the most interesting set of such capitals is that in Albrecht Dürer's *Underweysung der messung*. While they may not be the best letters produced during the sixteenth century, they certainly offer a most reasonable and workmanlike alphabet—with, moreover, a number of alternate designs. Dürer was, above all, a practical artist, free from illusions concerning the value of theories. His constructions, which need not occupy us beyond a slight examination of the illustrated method, were workable and did not distort the letters in order to make them fit the system. They are chiefly valuable for working out very large letters; the ratio of the heavy stroke to the height of the letter is 1 : 10, approximately that of the Trajan alphabet—although Dürer believed that 1 : 9 or 1 : 12 were equally good ratios. As may be observed, all the letters are related to a square, the usual method of construction. The little circles that delineate the serifs mostly have a radius equal to the heavy stroke of the letter. In his notes, however, Dürer emphasizes that there are certain faults in the constructions which can only be properly adjusted by the trained hand and eye— curves, for instance, that need more fullness, flattening, or other adjustment.

As an exercise in eye-training one should compare these capitals with the Trajan letters (p. 11). The noteworthy differences are in the finer design features. Dürer's V, W, M, N, and Z show no sign of the "entasis"; the inside oval of the O is at a much greater tilt, affecting the C, D, G, and Q—although there are alternate letters that are closer to the Trajan design. The narrow letters check quite well—with the exception of the bottom cross-bar of the E and L, and the middle cross-bar of the E and F. Most of the remaining letters compare well enough. It must be remembered that Dürer—like the majority of the other Renaissance designers—did not base his letters on the sole authority of one inscrip-

AAVMM A M

OCCCGGD

DDQQQ D Q

EEFLLBBB B

PPPRRSS S

KKKXXYY K

HITTT

Capitals from "Underweysung der messung"
Albrecht Dürer, Nürnberg, 1525.
Compare proportions with Trajan capitals.

NNNZZ N

tion; nor was there any good reason for doing so—the inscriptions on the various arches and tablets were all equally Roman and impressive.

The Cancellaresca:

The foreword and general discussion of sixteenth century writing have described the broad conditions upon which styles were developed and spread. Along with the usual page of classic capitals, the one constant element—and the most important one—in practically all copy-books was the series of pages devoted to variant designs of the "cancellaresca." This style, as has been noted in the preceding chapter, was a development from "cursiva humanistica." Ludovico Arrighi, who published the first of the Italian copy-books, called it "cancellaresca"; it is essentially the same letter that was used in the papal chancellery under the name of "lettera di brevi." Palatino, who copied Arrighi in certain instances, gave the style the name of "cancellaresca romana"; in his book, however, was included a "cancellaresca bastarda," a style without turned-over tops on the ascenders. Directly from this bastarda there evolved a so-called "cancellaresca formata," which shows a decided typographic influence. The Spanish writing-masters, especially Juan de Yciar, copied Palatino almost letter for letter, including the term "bastarda," which they used as the definitive name for the style. When the Italian current-cursives began to take hold in France the name bâtarde was transferred from the Gothic hand and type to this new style; the indiscriminate use of the word bâtarde make it a questionable name for this writing, even in France. English writers have used the name "chancery hand"; but here too there is a confusion with Gothic current styles. Cancellaresca is by far the most fully descriptive name; bastarda may be used as an alternate or to describe the style of the Spanish masters.

One should now compare the examples illustrated with the cursiva humanistica (see p. 67), and with each other. Fra Vespasiano Amphiareo's cancellaresca bastarda is typical of the cancellaresca style—on the whole, a narrower and sharper letter than the earlier Humanistic current-cursive. Again, the examples were done with a reed pen, much larger than the originals. The entire effect is that of a highly stylized writing, containing many self-conscious mannerisms; it is definitely the product of the professional writing-master. Only ʄ, long s, and the turned-over ascenders relieve the sharpness of the overall pattern. The variant letters b, h, and p are from Palatino's cancellaresca bastarda; this sort of letter created a still more prickly appearance. It is not difficult to perceive how

Frate' vespasiano Amphyareo
di lettra che' quella Bastarda
habbi alla mia Cancellarescav
Giouan Battista ciardj

bhp

Tal, ch'a noia et disdeg

Et se non fusse che mag

g

the cancellaresca formata evolved from these styles plus the influence of the italic types. Of course, the production of Arrighi's italic fits into the early sixteenth century; it is the work of a writing-master—writing and type design were still, in this instance, quite close together.

The decorative element at the end of the first example gives a visible idea of the use of the pen—typical of contemporary copy-book ornament. It is not always possible to indicate accurately how a particular writing-master held the pen; the little diagrams show two different pens and positions that may be used. In general, the pen with an edge cut straight across will do anything the skewed, or slant-cut pen can do; it is simply a matter of working with the pen-holder at a slightly different angle—the choice depending on personal taste. The writing-masters, of course, were pen virtuosi—they used it in any number of positions and with varying skews.

The cancellaresca, as has been indicated, is a professional, or virtuoso style; and one should try to understand all its brilliant and effective characteristics. Lines are kept quite far apart; ligatures are few; and elegance, which was in the Humanistic cursive, is still present. All the letters ought to be familiar enough, except for the narrow and sharp treatment; the swing of the ʃ, long s, and the ascenders afford an elegant relief; the angle of slant is about eight degrees. This is a style that may be used for a polite and cultured informality.

Cursive Capitals; Legal and Mercantile Hands:
Palatino's "majuscole cancellaresche," or cancellaresca capitals, represent another page to be found in the copy-books. The caption under the illustration describes them as initials and this is, largely, what they are—being too florid for insertion in the middle of a line. For ordinary purposes they are kept shorter than the ascenders of the minuscules; the example of Amphiareo's cancellaresca in the preceding illustration shows their use as initials and display capitals perfectly. Where they were apt to cause trouble in the line the writing-master always substituted a plain, unslanted Roman capital. From this point onward in the history of letters, we shall come across cancellaresca capitals in combination with italic or cursive letters; these are the ancestors of the "swash" italic capitals of today. The sixteenth-century scribe never employed them together—to form a word or words—and this is a good rule to observe. Of course, in making them the pen is held exactly as for the cancellaresca. The last five symbols are varieties of the ampersand; this symbol always represents e and t joined as a ligature. One of

AAABCDDEE
FFGHHHJJKK
LLMMNNOOPPQQQ
RRSSTJTVVVXX
YXZZEE&&&

Cursive initials for use with cancellaresca ~ freely copied from Johannes Baptistus Palatinus (Palatino).

Vn. Giouanetto ama Vna

Lettera Napolitana

Et la penna, Vuol esser

Mercantile Milanese

The influence of the Gothic current hands should be noted ~ both examples freely copied from Palatino.

the early writing abbreviations that has come down to us, this sign for et, or and, is now a part of our alphabet.

Another feature of the Italian writing-books was an assortment of legal and mercantile hands. These were influenced either by the cursive styles or the Gothic current hands. The "lettera Napolitana" belongs to the first category; the initial u of the illustration and that in "una," however, are Gothic. A more slanted variety of this style was known as "lettera notaresca." Most of the mercantile hands lean toward the Gothic current writing; the "mercantile Milanese," "mercantile Fiorentino," etc. are all fairly similar. The peculiar, hooked ending to the words is typical Milanese. A page of "majuscole mercantile," for use with these hands, was included in Palatino's copy-book. These capitals are a bit on the eccentric side, being strongly influenced by Gothic capitals; the cursive capitals may be substituted for them. Lettering artists will find these legal and mercantile hands—as well as the Gothic currents—are inspirational material for freely-written headlines, captions, etc.

The Spanish Writing-Masters:

In the sixteenth century Spain was reaching the fullness of her political and economic power as a nation; her cultural achievements kept pace. This is the period of colonization and great wealth; it is also the time of Cervantes and Lope de Vega. Although the Spanish tended to follow the art of the Low Countries, which they controlled, and although their first printers were Germans, their writing-masters copied the Italians with meticulous closeness. One need but examine the page of antiqua and Griffo italic to be aware of this fact. In all things concerning letters, however—in Spanish books and in the work of its writing-masters—there is a certain grace and individual approach that is typical only of Spain.

The chief difference between the bastarda of Francisco Lucas and the Italian cancellaresca is in the greater degree of slant of the former. Lucas wrote at a slant of about twelve degrees and used quite a variety of joined letters; in fact, one feels that his example is nearer to "handwriting" than is the cancellaresca. In general, individual letters are similar; the lines are a bit closer together; but the weight of the stroke is lighter, so that the overall effect is more delicate. One of the pages of Lucas's copy-book was devoted to an analysis of the strokes used for each letter; a and b have been written in the example to illustrate this idea. The pen was held at a considerable angle to the perpendicular and the strokes

Obsecrote domina sancta Maria
mater Dei pietate pleniſsima, ſu⁼ᵐ
mi regis filia, mater gloriosiſſima,
mater orphanorum, conſolatio·ꝯ

Bastarda – freely copied from a facsimile page of Francisco Lucas' "Arte de escrevir."
Slant is about 12 degrees – compare with Italian cancellaresca.
The Lucas stroke system ꝯoa ſſʄʙ

O señoꝛ con Summa ꝺeůocion,
con abꝛasaꝺo amoꝛ, con toꝺo
mi afecto te ꝺessco yo recebiꝛ:
como muiᵍꝗos Santos y ꝺeů⁼
tas peꝛsonas te ꝺessca ᵈꝛon

Redondilla – copied from a Lucas facsimile – note the Gothic influence, especially in d and r.

were made approximately as the arrows indicate; the order of the strokes may have varied slightly. This example was written with a reed pen; the light connecting strokes were made by using the left corner of the pen, as explained in the previous chapter. The initial O was written with a broader pen.

Redondilla was a style peculiar to the Spanish masters; Humanistic cursive has been strongly influenced by the rotonda—called "letra de redondo" in Spain —and the Gothic current hands; this may be called a retrogressive style. Gothic influence is apparent in the b, d, r, and y. For this letter the pen was held at a rather acute angle from the perpendicular; it is even possible that the pen was skewed a bit to the left, as shown in the diagram—the usual skew is always to the right. The letter had a considerable influence in France and England. Largely, its effect in the French area was to corrupt the Gothic current hands that were being used during the sixteenth century; (the Civilité type was based on one of these, a secretarial hand). A further development of these hands will be discussed in the next chapter. Redondilla is a quiet and quaint sort of style and should be treated accordingly. The letters d and r need restyling for present-day use.

The "letra antigua" and "letra del Grifo" of Francisco Lucas show perfectly the fact that the Spanish writing-masters copied the Italians; of more importance, however, is the clearly indicated spread of the Humanistic minuscule and cursive. It is apparent that Lucas wrote his letters from type examples. These alphabets are useful as a guide for written lower-case and italic letters. Of especial interest is the well-illustrated incorporation of the cursive initials or swash capitals into the italic alphabet.

Part 2. Type Designers.

Background of Type Design in France:
Type design was started in France, as in most other western European countries, by German printers. Michael Freyburger, Ulrich Gering, and Martin Crantz set up a press in Paris in 1470, within one of the buildings of the Sorbonne. They were induced to come by Johann Heynlin, who was the rector of that institution; associated with him in the project was the learned Guillaume Fichet. The first type was copied from that of Sweynheim and Pannartz; it is, however, not as good as the original. French type design before the sixteenth century resembles that of the German area: severe and current Gothic types predominated—slowly giving way, though, to roman type.

92

Aaa bb cc dd ee ff ſſ gg hh ii j ll m
m nn oo pp qq rr ſſ ſſ s s ſt tt ſt vv
u u xx yy zz. & ct æ æ ę ę & & & & :

A B C D E F G H I L :
M N O P Q R S T V :
: X Y Z Z :

Letra antigua que eſcreuia Fran͠ Lu-
cas en Madrid. Año de. m.d.lxxvii.

Aaa bb cc dd ee ff gg hh ii j ll mm nn oo p
p qq rr ſſ ſſ ſſ ſt ss ſt vv vu u xx yy zz ſp :
A A B B C C D D E E F F G
G H H I S L L M M M N
N O O P P P Q Q R R S S :
T T V V X X Y Y Z Z &&

Letra del Grifo que eſcreuia Fran͠, Lucas En
Madrid. Año De. M. D. LXXVII.

Antiqua "type" and the Griffo "italic" as written by Francisco Lucas, Madrid, 1577.

Before considering the examples of type design illustrated, certain background factors must be made clear. The end of the Renaissance in Italy was heralded by the sack of Rome in 1527. Ludovico Arrighi, who was working there at the time, appears to have been one of the victims of this tragic occurrence; there is no record of him after this date. Further development of Renaissance ideas and influence was carried on, to a large extent, outside of Italy. The French, who had their first good look at Renaissance culture during the invasion of 1494, were greatly influenced by it; later, François I and many of the leaders of French affairs set about "italianizing" practically everything—the language, customs, literature, etc. Writing, as has been remarked, remained Gothic for a long time; type, however, and the general appearance of books, followed the Italian style closely.

In 1503, Jodocus Badius Ascensius (Josse Bade) of Ghent set up a press in Paris, which issued, during its existence, some seven hundred works; these had a continuing effect in the dissemination of Humanistic ideas, which, as we have seen, were the motivating force of the Renaissance. Geoffroy Tory, after his return from Italy in 1518, was an enthusiastic promoter of Renaissance culture. Three of the most important Paris printers were Bade's sons-in-law: Robert Estienne, Michel Vascosan, and Jean de Roigny. Bade and Henri Estienne (Stephanus), Robert's father, were far too busy satisfying the demand for classic and Humanistic texts to do much about type design; both used utilitarian roman faces reminiscent of Gothic types. The elder Estienne died in 1520; and in the following year his assistant, Simon de Colines, married his widow and carried on the business. When Robert came of age, five years later, he took over his father's establishment and devoted himself to pocket editions of the classics—using roman type and the Aldine format. De Colines started his own press and continued publishing the authors introduced by the first Estienne. The fine development of roman type design in France is intimately connected with the activities of these two men—including, of course, the work of the unidentified punch-cutters employed by them.

Up to this time typographic evolution had been hampered by the italianization of the French language, with the attending orthographic and phonetic changes—there were at least some sixteen experimental phonetic types cut, with the purpose of more accurately conveying the new spellings and sounds. It is at the close of this disturbing period that both De Colines and Robert Estienne seem to have decided to try to improve the design of the roman type used in their

Ioannis Ruellij Canonici Parifienfis

ET MEDICI, DE NATVRA STIRPIVM LIBER SECVNDVS.

¶Iris. Cap. I.

Aximum hinc naturæ opus, arboribus iam expofitis, aggrediemur, dicemúfq; rerum furdarum ac fenfu carentium ingenia, pacé, bellum, odia amicitiáfq;: item appellationes, quibus officinæ, rura, medici nunc vtantur, ne quis vilitate nominum deceptus in his hallucinetur: tantum venia fit. A frumentis, oleribus, hortenfibúfq; rem ipfam aufpicabimur, fi prius tamen de falutaribus aliquot odoramentis, quæ pretiofis vnguentis iaciunt fundamenta, ab iride exorfi differamus. Iris radice tantum cómendatur, vnguentis & medicinæ nafcens. æftate floret, folio arundinaceo. caulem emittit cubitalem, rectum, albucum prorfus æmulanté, fed minorem duriorémque. E'rebus in vnguéta venientibus aliquid inueniri in Europa præter irin ne-

This roman was used by Simon de Colines in 1536 ~ the initial is by Tory ~ "De Natura Stirpium" by Ruel.

110 MEDIOL. PRINC.
ACTIVS.

Ctius vigore bellico & præalto conftã tis ingenii fpiritu patri Galeacio facilè par , efficaci verò prudentia & longa infracti animi fortitudine auo Mathæo perfimilis, collapfam familiæ fortunam admirabili virtute reftituit: tanta quoque felicitate, vt recuperato dominatu, imperii fines paucis

Middle size of Robert Estienne's 1532 roman ~ specimen from Giovio's "Vitae," 1549 ~ ⅓ larger than original.

books. Between the years 1531–32 each of them published with new faces that have been the basis of "old-style" type design ever since.

The De Colines Roman:

The first example shows one of the new faces used by De Colines. This is a re-cutting of a somewhat better 1531 font—a font is a complete assortment of type of one size and style. However, the specimen displays De Colines's taste at its best; and it illustrates the trend of type design quite clearly. A comparison with the specimen from the *Hypnerotomachia Poliphili* (see p. 75), which was so much admired in France, will give some idea of the derivation; although, in general, the design does not copy any former font closely. Tradition states that De Colines himself was a designer of types; but nothing certain is known concerning the actual production of his roman faces. On the whole, the lower-case is a bit narrow in its proportions. The capitals, however, are full and served as an influence in the final working-out of French style. Noteworthy individual letters are the a, with its low, flattened bowl, and the g, with its relatively large top circle. In the larger type of the title the high, slightly tilted cross-stroke of the e and the high, scooped-out top serif of the n are points of interest; this line resembles the pioneer 1531 type, which had carefully modeled serifs. An interesting comparison is provided by the large "Garamond" of the Egenolff specimen sheet.

Robert Estienne's Roman:

The pioneer face of De Colines was followed closely, in 1532, by the new roman of Robert Estienne. It was the lower-case of this design that was copied by French book-printers for the next two centuries. From the capitals especially, it is plain that the punch-cutter took the Aldus trial font used in Pietro Bembo's *de Aetna* as a basis for his design. This was the same face in which the *Hypnerotomachia* was later printed, except for changed capitals and some redesigning. Peculiar to the de Aetna font were the square-topped A, the G with a turned-in cross-stroke, and the one-eared M—all of which may be studied in this example of the Estienne type. Among the lower-case letters the following are noteworthy: a, with its shallow, angular bowl; e, with its cross-stroke tilted slightly forward; g, with its top circle only half the height of the body letters, allowing for a graceful tail; the condensed h, r, and u; the well-defined serifs at the top of the ascending letters b, d, h, and l. Other noteworthy letters are among the capitals: B, whose top and bottom curves do not join the upright in a horizontal line; C, which is not

Quid magis aduerſum bello eſt ? bellíque tumultu
 Quàm Venus ? ad teneros aptior illa iocos .
Et tamen armatam hanc magni pinxere Lacones ,
 Imbellíque data eſt bellica parma deæ .
Quippe erat id ſignum forti Lacedæmone natum :
 Sæpe & fœmineum bella decere genus .
Sic quoque non quod ſim pugna uerſatus in ulla,
 Hæc humeris pictor induit arma meis :

NTONIVS Perrenotus, S.R.C.Tit. Sancti Petri
ter, Cardinalis de Granuela, præfatæ Regiæ & C
à conſiliis ſtatus, & in hoc Regno locum tenens
neralis, &c. Magco viro Chriſtophoro Plantino
ſi , & præfatæ Catholicæ Maieſtatis Prototyp
gio, dilecto, gratiam Regiam & bonam voluntat

E natura ſtirpiũ opus, Chriſtianiſſime ſimul & Inuictiſſime Rex
Franciſce, iandiu liberalibus auſpiciis tuis ſuſceptum, eiſdem bene
fauentibus, nuper ad vmbilicum perduxi: veterémcȝ ſequutus au-
thorum morem, tuæ nunc ſereniſſimæ maieſtati nũcupo. Quando
ea ſemper literarum dignitas fuit, ea excellentia, ea deniȝ autho-
ritas, vt eas ſibi naſci, apud ſe foueri, ſibíȝ dicari, principes & ho-
neſtum & glorioſum putarent: quanto tu magis mira rerum cele-

part of a full circle; and the quite narrow E, F, and L. The punch-cutter of this type is generally assumed to have been Claude Garamont, although there is no proof beyond conjecture and a certain similarily between this letter and some of the earlier Garamont types.

Antoine Augereau:

Of great interest in all this guesswork concerning the punch-cutter or cutters employed by De Colines and Robert Estienne is the designer of the third example, Antoine Augereau. The design illustrated was first used for printing Augereau's edition of Navagero's *Orationes duae,* in 1532; Augereau cut the punches for this type. Striking resemblances between this face and the Estienne roman have led to the belief that Augereau also may have been the master who cut the punches for Estienne. Augereau was one of the martyrs of the Reformation, a victim of the suspect beliefs of the king's sister; he was hanged and burned in 1534. Since Robert Estienne was already suspect because of his publishing policy, some writers feel that there may well have been a furtive but intimate connection between the punch-cutter and the great publisher; no relation to De Colines has ever been established. It seems quite possible that in all this muddle some of the achievements of Augereau have been attributed to the orthodox Garamont, who survived him by seventeen years. In any event one may come to as good a conclusion as the experts simply by studying the examples carefully.

Plantin of Antwerp:

Christopher Plantin fits into the puzzle of the Garamont (also spelled Garamond) types as the purchaser of some of the master type-founder's punches and matrices. The famous Antwerp printer was in Paris in 1561, having been forced to leave Antwerp temporarily because of suspected heresy. While there he attended the sale of Garamont's effects; the noted punch-cutter having died in somewhat impoverished circumstances, his wife tried to realize something by the sale of his equipment. The executor of the estate was André Wechel, the printer-publisher, who seems to have purchased some punches and matrices, which he sent to Frankfurt am Main; these apparently found their way to the Egenolff foundry. Guillaume Le Bé (Lebé), who cut Hebrew fonts for Garamont and prepared part of the inventory of his estate, is the man who is said finally to have acquired some of Garamont's stock. Plantin's *Index Characterum* of 1567 shows two large sizes of roman which seem identical with the "Garamond" of the Egenolff sheet; nothing that has come down through the Le Bé family seems

to be authentically Garamont. This example of Plantin's work illustrates his style; although it does not appear to be a Garamont face, the type is certainly based upon the French area designs which have already been discussed. Plantin, who was a Frenchman by birth, provides an example of the scholar-printer leaving France for the Netherlands; the rise, in turn, of this area as the chief center of European printing is thus foreshadowed. The restrictions and censorship placed upon the printers by the Church and the State in France did much to stifle the wonderful flourishing of printing that had taken place during the first half of the sixteenth century. It is only necessary to point out that both Robert Estienne and André Wechel had to flee for their lives, to suggest what happened to the greatness of French book production. The influence of the roman type designs developed in France continued on, however, until the eighteenth century.

Italic:

It is generally acknowledged that Garamont did not cut a good italic; he does not seem to have been interested in this type form. The two italics he cut for his own venture into the publishing field were poor imitations of the Aldine letter. The De Colines italic, however, is a fine design—it is clearly based on the italic of Arrighi or of the Italian printers who followed him. Compare the specimen with the Arrighi and Aldus examples. The use of this italic in the *De Natura Stirpium* suited the roman very well indeed, in tone and in general style.

The "Garamond" of the Egenolff Sheet:

In examining the specimens from the Egenolff or Berner sheet, we must again consider the somewhat hazy typographic activities of Claude Garamont; and try to round out and finish the presentation of sixteenth-century type design in France. There seems to be enough information of a general sort about Garamont: but his actual accomplishments as a designer of roman types are not accurately known. His best known work is the series of Greek fonts done for François I, the famous "grecs du roi"; there is apparently no confusion here; in fact Garamont bore the title "tailleur de caractères du roi." Robert Estienne, who was king's printer, was his sponsor in obtaining the commissions to execute these Greek fonts; this was in 1541—and it is assumed from this fact and the date that Estienne must have known and trusted Garamont as the result of an earlier relationship, the 1532 Estienne roman design, for instance. This, however, is again conjecture. One point of importance, though, is that eleven capitals of the middle size "grecs du roi" of 1544 are identical with the corresponding capitals

of the Estienne design; in the large size, of 1550, the capitals have been rede-
signed—the M, for instance, displays the fine design of the Egenolff sheet. As an
outcome of his venture into publishing, a number of early roman faces can be
ascribed to Garamont with certainty; and it is from the appearance of these early
fonts, their similarity to such romans as those of Estienne and Wechel, and the
attributions of the Plantin and Egenolff-Berner specimens, that we must fill in
the rest of his activity. It needs to be remarked here, for the sake of clarification,
that Conrad Berner was the owner of the Egenolff foundry in 1592. The names
Christian Egenolff, Jacques Sabon, a partner who had died twelve years earlier,
and Conrad Berner are mentioned on the specimen; Berner was simply giving
credit to the two other men, long deceased, who had helped to make possible this
fine showing of types. There seems every reason to believe that the roman of
these last two specimens is really of Garamont design. Up until quite recent
times, due to an unfounded set of suppositions, the seventeenth-century punches
of Jean Jannon found in the Imprimerie Nationale in Paris were reverently
considered to be those of Garamont. (For further details, see the section on Jan-
non in Chapter VIII.) The specimens should be carefully studied and compared
with the De Colines, Estienne, and Augereau examples, as well as with the mod-
ern revival described in Chapter X. This is the style that dominated all roman
type design for the next century and a half, and was finally revived as a book face
in the early 1920's, after the mistake concerning Jannon's type had given us
several revived faces that were not really Garamont at all. Such letters as the M
have been executed in a brilliant fashion; the study of this letter alone will tell
all one needs to know about the ability of this punch-cutter. Actually, the bril-
liance of this design hindered the craft of type design generally; craftsmen de-
generated, largely, into repairers of punches for the various cuttings of the Gara-
mont letter. The Egenolff-Berner Foundry became the Luther Foundry in
1676; it was this Frankfurt firm that supplied the German, Dutch, and English
printers with types cut by Garamont and Granjon.

Other Punch-Cutters:

There were two other gifted punch-cutters in France during the first half of the
sixteenth century: Pierre Haultin and Robert Granjon, whose name was origi-
nally GranJon and is often spelled that way. Haultin was noted for his music
types—he was easily capable, however, of having contributed to the development
of roman type design during this active period. Granjon was a bit later in his

ro:& brachium Iehouæ cui Re-
ltum CORAM eo,& velut
ma ei, neque decor. 🖌 Æ.Œ.

Generally accepted as the final roman of Claude Garamont ~ "Canon de Garamond" from the Egenolff sheet ~

s, & Non desiderauimus eum videre. Despe
expertus Infirmitatem, & veluti absconsio
mus eum. Verè languores nostros ipse tulit,
auimus Eum plagis affectum, Percussum à
🌿 W. H. S. G. 🌿

"Petit Canon de Garamond" from the same specimen sheet ~ issued by Konrad Berner, Frankfurt a.M. 1592.

Nec aperuit os suum. A carcere & iudicio sublatus est: & Gene
ν ἡ λέγων, Κυϱιε ο παις μ8βέβλη) ῶϱα. Ἴπ ☞ 🖐] *rationem eius*
Quis enarrabit, Quia abcissus est è terra viuentium, propter præ
uaricationem populi Mei plaga fuit ei. Et dedit cum impijs sepul
turam eius, & cum diuite in Morte sua: Quamuis iniquitatem
non fecerit, Nec dolus fuerit in ore eius. Jehouah Autem voluit
conterere eum & ægrotare fecit eum: Quum posuerit seipsum sa
crificium pro delicto Anima eius. 🌿

"Parangon de Granson" with a line of Greek ~ all specimens on this page are about ¼ larger than originals.

activities than the others and consequently was at work until the latter part of the century, chiefly in Lyons; although he is known to have been in Paris, Rome, and Antwerp also. His main contribution seems to have been in the italic style. In the last illustration may be seen the sort of italic that had a great influence on the designers of the seventeenth century—particularly Jean Jannon and Christoffel Van Dyck. It is apparent that the conception of an italic had strayed far from the Aldine and Arrighi models; the slant, here, is much greater; the roman capitals are now set at the same slant corrupting their design; and the contrasted thick and thin gives the letters a dazzling appearance that makes them hard to read. There is a relation to an italic that may have been a Basel design, a letter that was used by Sebastian Gryphius in Lyons and found wide favor throughout France and Italy. Plainly, italic was losing its position as a text face for books and was gradually becoming a mere appendage to the customary roman font of type. This letter should be compared with the De Colines italic; the loss of strength and severity are immediately visible. Nevertheless, this was the style that influenced the further course of the italic letter.

Summary:

For those interested in fundamental concepts it should be evident that all this activity was part of the general European culture and only in its details and superficial aspects was it typically French. We have only touched on the printing centers of Antwerp, Frankfurt, Basel, etc.; in Basel Johann Froben employed many gifted punch-cutters and artists, including the famous Hans Holbein the Younger. France, though, during this busy first half of the sixteenth century, affords the best example of the development of roman and italic type design; and the example that had the most widespread influence, through the drive of French nationalism. In general, there was a change from the fine, severe quality of Renaissance type design to an exaggerated concern with neatness of detail and execution; there was a loss of simplicity and strength, replaced by a certain delicacy and grace that are typically French.

The Influence of Engraving and the Pointed Pen

The Condition of Europe:

The next development in the history of letters began about 1600 and reached its final phases in the first quarter of the nineteenth century. From the standpoint of technique, it may be briefly and quite completely described as the gradual influence of engraving and the pointed, flexible pen upon writing and type design—the pen in some instances following, in others leading, the engraving tool. The change, therefore, from the use of the broad, square-cut pen to the pointed writing-tool—a quill or, toward the end of the period, steel—is the dominant fact to be considered when examining seventeenth and eighteenth-century writing and letters. Extreme contrast is the most striking effect of this technique: hair-lines opposed to heavy strokes. It is also necessary to consider the effect of the baroque, rococo, and classic revival styles upon the writing-masters and type designers. Baroque and rococo influence introduced rounds and complicated flourishes; the classic revival, a strange stiffness and pseudoseverity—the latter the result of a sterile, mathematical approach to letters. These technique and style innovations produced many changes in the Italian writing hand (to be discussed later in this chapter) and the design of roman and italic types as we left them at the end of the sixteenth century. De Beaulieu's engraved copy-book, of 1599, may be regarded as the start of this long development, the close of which may be marked by the death, in 1813, of the Italian printer and type designer, Giambattista Bodoni.

Some slight consideration must be given to the cultural and commercial situation in the western European areas during these two centuries. It is only through some knowledge of conditions that the shift of the center of importance in letter design from one area to another can be properly understood. In explaining the various examples of letters and types, therefore, some of the pertinent facts concerning each area or country will be added to round out the picture. Sketched in an extremely broad fashion, the history of the western European areas within

the date limits set for this chapter was about as follows: France dominated the continent until the defeat of Napoleon; The Netherlands emerged from the partial break-up of the Holy Roman Empire to become, for a short time, an important colonial and sea power; England, after the defeat of Napoleon and the conquest of India, became, through the results of the Industrial Revolution, a world power; Italy and Spain gradually declined to comparative unimportance from their positions of strength in the fifteenth and sixteenth centuries; the German states, after the Thirty Years' War, lost their cultural and commercial position for about a century. It may be said that writing served more and more the interests of commerce rather than culture; English roundhand (to be described in a later section of this chapter) became, at the end of this time, the commercial writing style of the trade centers of Europe and America; the so-called "classical" and "modern" types (explained in the *Foreword* under Part 2 of this chapter) dominated type design until the revival, in the mid-nineteenth century, of the old-style faces.

Part 1. Seventeenth- and Eighteenth-Century Writing-Masters.

Foreword:
The same arrangement will be followed in this chapter as in the preceding one: the writing-masters and their work will be reviewed first, the type designers and theirs second. Writing, as affected by the engravers' techniques and the use of the pointed, flexible pen, had a great influence on the type designer; but it seems better to hold the two media apart for the sake of clarity; this influence should, however, be constantly borne in mind. A partial listing of the important writing-masters, their books, and the place and date of publication, is again inserted for the benefit of those who may wish to follow certain aspects of style or design further. In some instances, where the writing-master published several books, it has been considered sufficient to mention one with its date, etc.; this may not, in every case, be the first book written or the earliest date of its publication; but the references will adequately serve for all practical purposes. From among the great number of writing-masters active during these two centuries only those are included who seem, for one reason or another, especially noteworthy; the endeavor has been to make a representative and useful selection without becoming too all-inclusive. Books concerning letters and type, written after the end of this period, are to be found in the bibliography.

Anton Neudörffer. *Schreibkunst*. Nürnberg, 1601.

Paulus Franck. *Schatzkammer*. Nürnberg, 1601. This is a collection of decorative initials.

Jan van den Velde. *Deliciae*. Amsterdam, 1605. This is the first of this master's exceptional writing-books. Van den Velde had a great influence in England, Germany and Scandinavia.

Antonio Sacchi. *Libro di Lettere Cancellaresche*. Rome, 1605.

Maria Strick. *Tooneel der loflijcke Schrijfpen*. Delft, 1607. The book is noteworthy as the work of a writing-mistress.

Lucas Materot. *Oeuvres*. Avignon, 1608. The author was a scribe in the papal office at Avignon. His manual was important in the popularization of the lettre italienne bastarde; his elaborate calligraphic borders seem to have set the style for the later English decorations known as "command of hand."

Christoph Fabius Buchtel. *Soli Deo Gloria, Schöne zierliche Schrifften*. Nürnberg, 1610.

Peter Stoy. *Schreibformular-Büchlein*. Leipzig, 1614.

Martin Billingsley. *The Pen's Excellency or Secretary's Delight*. London, 1618.

François Desmoulins. *Le Paranimphe*. Lyons, 1625. A writing-book in which, perhaps for the first time, the ecriture ronde financiere was taught; this was the typical ronde developed by the scribes in the French Ministry of Finance.

Pedro Diaz Morante. *Nueva Arte de Escrevir*. Madrid, 1626.

Lucas Kilian. *Newes A B C Büchlein*. Augsburg, 1627. A set of decorative initials.

Gio Battista Pisani. *Tratteggiato da Penna*. Genoa, 1640. A collection of penflourishes provides the basis of this book.

Arnold Möller. *Schriftkunstspiegel*. Lübeck, 1645.

Louis Barbedor. *Traité de l'art d'escrire*. Paris, 1655. Barbedor and his contemporaries in France spread a new kind of initial decoration, with extended strokes and exaggerated swells.

Ambrosius Perlingh. *Groote en kleene voorbeelden van Latynse Italiaensche getalletteren*. Amsterdam. 1660.

Louis Senault. *Livre d'Écriture*. Paris, 1668. This book was dedicated to the French Minister of Finance, Jean Baptiste Colbert, who was a patron of the writing-masters. It was Colbert who was chiefly responsible for replacing the

Gothic current hands, used in the French state offices, with the italianate styles.

Edward Cocker. *Magnum in parvo or the Pen's perfection*. London, 1672.

Jean-Baptiste Allais. *L'Art d'Écrire*. Paris, 1680.

Joseph Moxon. *Mechanick Exercises*. London, 1683. Moxon was not a writing-master; but his book has a great deal to say about letter-proportion, printing, punch-cutting, and the founding of type.

Joseph Friedrich Leopold. *Anmuthige Schau-Bühne*. Augsburg, 1696.

John Ayres. *A Tutor to Penmanship*. London, 1698. Ayres had a marvelously flexible writing hand, which used the pen arbitrarily placing the pressure in any direction.

Jacob Harrewyn. *De XXV letteren van het A B C*. Antwerp, 1698.

Johann Leonhard Buggel. *Schreibkünstler*. Nürnberg, 1708.

George Shelley. *Natural Writing*. London, 1709. Shelley used the pen almost without system—played with it—never, though, lost track of the balance of black and white; his ornamental flourishes are freer than those of any other English writing-master.

Charles Snell. *The Art of Writing in Theory and Practice*. London, 1712.

Michael Baurenfeind. *Vollkommene Wiederherstellung der bisher sehr in Verfall gekommenen grund—und zierlichen Schreibkunst*. Nürnberg, 1716.

Juan Claudio Aznar de Polanco. *Arte Nueva de Escribir por preceptos geometricos*. Madrid, 1719.

Manoel de Andrade de Figueiredo. *Nova escola para aprender a ler, escrever, e contar*. Lisbon, 1722.

Jan Pas. *Mathematische of Wiskundige Behandeling der Schryfkonst*. Amsterdam, 1737.

George Bickham. *The Universal Penman*. London, 1743.

Joseph Champion. *The Parallel*. London, 1750.

Etienne de Blegny. *Les Elemens, ou Premières Instructiones de la Jeunesse*. Paris, 1751.

Johann Georg Schwandner. *Dissertatio de Calligraphiae Nomenclatione, Cultu, Praestantia, Utilitate*. Vienna, 1756.

André Franc Roland. *Le grand Art d'Ecrire*. Paris, 1758.

P. D. F. Decaroli. *J Ammaestramenti teoricopratici*. Turin, 1772.

F. X. de Santiago Palomares. *Arte nueva de escribir*. Madrid, 1776.

Jean Braun. *Anweisung zur Schreibkunst*. Mühlhausen, 1784.

Domingo Maria de Servidori. *Reflexiones sobre la verdadera arte de escribir*. Madrid, 1789.

P. Paillason. *L'arte di scrivere*. Padua, 1796.

Torquato Torio. *Arte de Escribir*. Madrid, 1798. Both Torio and Servidori attempted some review of the work of earlier scribes and writing-masters.

France.

Three Basic Styles:

The writing that was being done in France during the early part of the period with which we are here concerned holds our first interest. Hands that were to serve as models for the other European areas and for later script types were developed rapidly, after the opening of the seventeenth century. France, as a nation, was on the threshold of a period of great power and influence; it is quite understandable that French style affected neighboring countries. The names of Cardinals Richelieu and Mazarin recall for us the consolidation of French national power and, of course, the "age of grandeur" under Louis XIV—when French armies and policies controlled most of western Europe. The absolute monarch, Louis, and his fabulous court were imitated by the nobility of all Europe. This copying of clothes, manners, general style, etc. included, as might be expected, the writing hands; there are three basic styles that concern us.

Ronde:

The first example of the three basic French writing hands brings us once more into contact with Gothic style—in fact, the "ronde" has much more of Gothic in it than the Spanish redondilla, to which it owes some characteristics. It was a direct outgrowth of the Gothic current writing of the preceding century and was closely related to Civilité type. By some writers it is considered to be a French Renaissance style; much the way fraktur type was looked upon as a German Renaissance design, each containing a large measure of baroque influence. The example should be compared with all the styles that have been mentioned.

Since the ronde seems to have been developed largely by the scribes in the Ministry of Finance, it has often been called "ecriture ronde financiere." To

avoid confusion it is well not to use the term "financiere" as the definitive name. This term has been used indiscriminately. For instance, "financiere" was also used to describe the "coulée" hand when that, in turn, was developed by the scribes in the same, aforementioned ministry. It should be apparent that the only proper use of this term is as above: as a descriptive adjective. Some of the English writing-masters used the name "secretary" for their varieties of the ronde; this term shows the relation to the earlier Gothic secretary hands, but is also easily confused with them. For this round, upright, typical French style there is no better name than just ronde.

The specimen was written with a pen that might still be classed as square-cut; it was copied from examples in the books of Barbedor and Senault, books issued between 1628–1650. As yet, the pointed pen had not displaced the older, square-cut writing tool to any great extent—the final dominance of the pointed pen did not come about until after the Thirty Years' War. The letters that are peculiar to our eyes have been marked; these are the c, e, r, and s; they require altering for present-day usage. Ronde is a formal script, an admirable hand for ceremonial use; it is the forerunner of all the round, upright script styles used by writing-masters, engravers, and type designers up to the present. The notable characteristics of a page of ronde are deep interlinear separations, long ascenders and descenders that are often flourished, and the large, flourished capitals. These capitals are not all suitable for present use; the flavor of them is adequately conveyed by the A, B, and C of the specimen. Any showing of Civilité or ronde type capitals will provide a basis for them.

Lettre Italienne—Italian Hand:
The second basic style is usually known as the "lettre italienne bastarde." This has often been called "bâtarde," a name that, as has been previously suggested, should be restricted to the earlier Gothic current-cursive hand and type. Since this second example is a French adaptation of the Italian hand, it might well be called simply "lettre italienne." Early in the seventeenth century the style was popularized by Lucas Materot and other masters; and, because of its joined letters and the rapidity with which it could be written, gained favor as a business hand, to the gradual exclusion of the Gothic current hands. This example of the lettre italienne was copied from a page written about 1647 by Louis Barbedor. It is a development from the cancellaresca, which was gradually given more cursiveness and written with a finer and more deeply-cut pen—compare it with

Coutrollaw general dea
R R S

Bastimena payé auxs
E

finanaa donnca aduia
C E S E R

bbhjkqrrStvz Alphabet

Plaise AMonsieur
Conseiller du Roy en sa Cour
R
de parlement auoir pour recomman

the Francisco Lucas bastarda (see p. 91). Of course, the use of engraving as the reproduction method for the writing-masters' examples most certainly was a contributing factor in the development of the style. The use of flourishes as decoration was nothing new; but as employed by the seventeenth- and eighteenth-century scribes they were given an importance far exceeding their decorative value. It is evident that rococo style, with its profusion of ornament, was exerting its influence. This sort of flourishing was carried over to the cursive capitals with results as shown in the initial P. In order to accomplish the strokes, hair lines, and swells of this type of decoration and letters, it was necessary to take up techniques of writing that are unnatural for the hand and at odds with the organic design of letters as we have known them up to this juncture. For this reason there will be no indication of pen position, etc. accompanying these illustrations of pointed-pen writing. In the next chapter several of the odd methods of holding the pen will be illustrated.

Pages of lettre italienne writing show the following noteworthy characteristics: deep separations between lines, long ascenders and descenders, an angle of slant of somewhere between twenty and thirty degrees from the perpendicular, capitals that are a bit taller than the ascenders, initials that are elaborately flourished, and flourishes that decorate the top, right side, and bottom of the page. The effect is semi-formal.

From its early, narrow treatment, the lettre italienne developed roundness, especially as written by the later Dutch and English masters. Obviously, it was this design from which evolved the later roundhand.

Coulée:
The third basic style is shown in the example of the "bâtarde coulée." It is best to call this hand simply "coulée"; the reason, of course, is the indiscriminate use of the names "bâtarde" and "financiere," which has been sufficiently explained. This design is plainly the result of combining the ronde and the lettre italienne. Apparently, when Colbert assumed the post of finance-minister and introduced the italian hand, the clerks were unable to drop the ronde immediately and devised this compromise style. The specimen should be compared with both the ronde and the lettre italienne.

Coulée was written with about the same slant as the italienne but is a rounder letter. It was easier to write than the ronde and, therefore, more useful in the business world. In comparison to the ronde, coulée is a semi-formal hand; the

Le present Caractere

Imprimeura curieux ,

Epitre dedicatoirex , &c.

Billets d Commerce d'

b ff f g h j k q v fs v w y z

The "bâtarde coulée" was a combination of "ronde" and the "italienne bastarde" – also called "financiere".
It was developed from 1650 onward by the clerks in the Ministry of Finance .

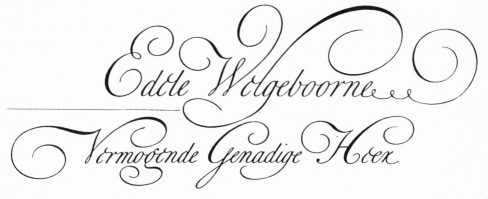

Edele Welgeboorne

Vermogende Genadige Heer

The "italian" hand as used by Ambrosius Perlingh – Amsterdam, about 1660.

line separations are deep; the capitals are not as tall as are those of the first two basic designs.

Engravers and engrossers still use the coulée style for what are now considered formal announcements, etc. Coulée is more formal that the later roundhand and should be used where a script letter with not too great a slant is required.

The Netherlands.

French Influence upon the Netherlands:
The fourth example shows the Italian hand as used by Ambrosius Perlingh—reproduced from his engraved copy-book. A comparison with Barbedor's lettre italienne will establish that this is a similar design, except that the Dutch master wrote at a greater slant and treated the initials in a different way. The Dutch, so independent in most matters of craft and artistry, continued using Gothic letters long after the French had abandoned them; apparently, in considering the new scripts, they felt it best to follow the French.

Script Capitals:
The fifth specimen shows characteristic script capitals. These letters should be compared with the cancellaresca capitals of Palatino and the cursive capitals that Lucas copied from Griffo's type—both illustrated in the preceding chapter. The difference between pointed-pen letters and those written with a broad pen reveals precisely the trend of the time in letter design.

The German writing-master, Michael Baurenfeind, called these capitals "Holländische letteren," or Dutch letters. They are, however, typical capitals for use with script—they may be combined with either the lettre italienne or the coulée. It is even possible, by keeping the designs upright and expanding them, to have suitable capitals for the ronde.

The monogram illustrated is of importance in showing the system of spiral ornament used by Van den Velde. It represents the beginning of a monogram technique that became popular in the eighteenth century, a technique to which script capitals evidently lent themselves. This Dutch master devised interlinear and surrounding flourishes for script—he set a new field of endeavor for the writing-masters. His effect upon writing in northern Europe and England was considerable. The initials by Arnold Möller in Chapter V show the influence of Van den Velde's style; it is also visible in Shelley's flourishes.

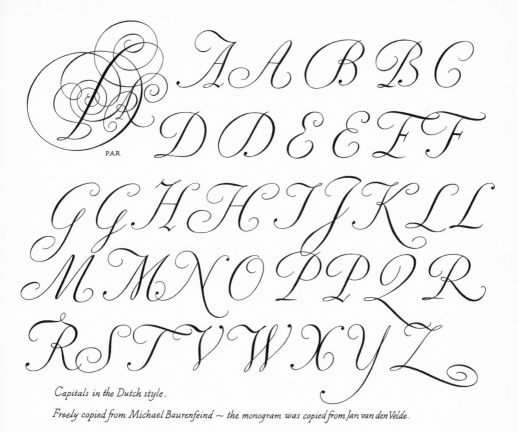

PAR

A A B B C
D D E E F F
G G H H I J K L L
M M N O P P Q R
R S T V W X Y Z

Capitals in the Dutch style.

Freely copied from Michael Baurenfeind ~ the monogram was copied from Jan van den Velde.

Literis tamquam rei immortalitati proxi
-mæ hoc debemus, quod consulere alijs pos=
-sumus ceterisque tam prudentiæ quam
sapientiæ muneribus uti et posteritati pros=
picere

An example of John Ayres' "italian" hand ~ from "A Tutor to Penmanship" London, 1698.

England.

The Development of Roundhand:

England clung to Gothic letters even longer than the Dutch; but during the seventeenth century the Italian hand became more and more important in the books of the writing-masters—largely through French and Dutch influence. The English style was rounder than the French italienne and gradually acquired a greater slant. As used by John Ayres it was a bit rounder and more slanted; in Shelley's specimen this roundness and slant are quite marked—the examples were reproduced from copy-book pages. The reason for the name roundhand is obvious. In its final, standardized style, roundhand has a slant of thirty-six degrees from the perpendicular; this is a considerable angle—one that does not contribute to readability.

The English writing-masters developed a great virtuosity in the technique of flourishing and in the use of the roundhand. With the end of Dutch maritime supremacy, after 1658, and Cromwell's success in increasing England's commerce, interest in writing was directed toward developing a standard English practice of penmanship that would suit commercial ends. One need but examine some of the writing-books produced in the early part of the eighteenth century to see the results of this tendency—they are largely collections of sample invoices, receipts, orders, bills of lading, etc. The roundhand is the writing style of most of these specimens. It was only natural that when England became the foremost commercial nation other countries copied not only her manufacturing methods and trade practices but also her business hand.

Italy.

Writing in the Italian Area:

The writing done in the Italian area during the two centuries under discussion did not have any merit or influence beyond the ordinary. The term "italian hand," as it was then applied throughout western Europe, meant simply the general style that had developed from cancellaresca or bastarda, as used by the great sixteenth-century writing-masters of the Italian area or Spain. The seventeenth- and eighteenth-century pointed-pen hands, and their reproductions in engravers' techniques, show many changes from sixteenth-century designs; but, essentially, are based upon them. The term *italian* is best left uncapitalized.

114

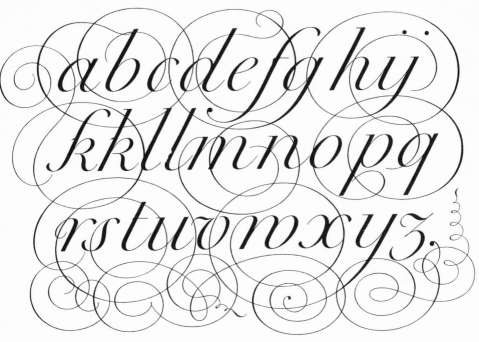

"Italian" hand with flourishes ~ from George Shelley's "Natural Writing" ~ 1709.

Melior est sapientia
cunctis pretiosissimis,—
et omne desiderabile, ei

"Italian" hand as used by P.D.F. Decaroli — 1776.

The example, by Decaroli, shows that the general style was about the same in the Italian area as in France, Holland, and England; this, also, was reproduced from a copy-book page. There is a slight difference in the method of turning the strokes, which should be studied; in script styles the turn is of great importance.

Spain and Portugal.

The Preference for the Broad Pen:
The most striking characteristic of the writing-masters of this area during the seventeenth and eighteenth centuries is their continuance of broad-pen style. Despite the practice of the rest of Europe and the influence of the engraver's technique, which they also used to produce their books, the examples show a preference for broad-pen design. Bastarda and redondilla remained favorite hands until the eighteenth century. Even when all Europe had accepted the domination of the pointed pen, the Spanish and Portuguese writing-masters were consistently true to broad-pen tradition. One need but look casually at these lovely writing-books to see this. It is apparent in the example by Servidori —through all the copperplate engraving technique. This continuation of what has been called "sound pen practice" had little contemporary effect, however, outside of Spain or Portugal. The letter designer of the present, though, will find all of this work extremely interesting and useful.

Germany.

General Survey:
The Thirty Years' War, 1618–1648, which left France dominant in western Europe, so devastated the area of the German states that they lost their cultural and commercial importance for a century. Their part in the history of letters during this century was, of course, small. From the time of the Renaissance on-ward, German letters and writing had acquired a dual character; the average German had to be more or less familiar with two alphabets, the "Latin" and the Gothic. Both type and writing underwent separate developments along one or the other of these paths, which, as we have seen, touched at times. The Gothic evolution has been reviewed in Chapter V; it is evident that German designers always enjoyed working in the Gothic tradition and did excellent work in all the Gothic letter styles. Here, however, we are concerned chiefly with the italian hand and its development in the German area. It was not until the mid-eight-

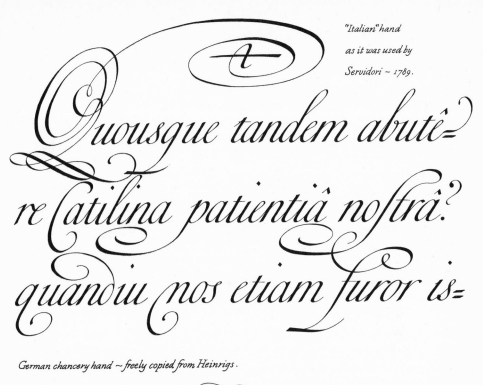

Quousque tandem abutē=
re Catilina patientiā nostrā?
quandiu nos etiam furor is=

German chancery hand ~ freely copied from Heinrigs.

Deutsche Kanzleischrift

Engravers' variety of "italian" hand ~ freely copied from Heinrigs.

Italian hand as it was used
by the engravers during the
early nineteenth century

eenth century that the German writing-masters adopted a standardized round-hand, which they called "latin cursive" or "English current." It is obvious, from the latter name, that the major influence was English; there was also a considerable admixture of French style. This roundhand was used by the engravers, schoolmasters and clerks. A German current script was developed and used in the same way; it would, however, lead us astray to discuss that. "Kanzleischrift," which shows Gothic derivation, is of interest and will be described briefly.

Kanzleischrift:

The German chancery hand, as first used, was related to the French ronde. In the course of development, however, it tended to become more like the fraktur letter. The example, copied from Johann Heinrigs's style book, shows the letter as it was employed by the early nineteenth century engravers. The capitals are of interest; they are still valuable as initials for a certain type of engraved and printed matter, to achieve an effect of pomp and ceremony. They are to be had in a type design called "Dutch" initials. A comparison with the capitals of the Unger fraktur at the end of Chapter V will show their relation to fraktur.

The Italian Hand:

Most of the nineteenth century writing-books show the italian hand about as it has been copied in the next example, from the Heinrigs book. The most striking quality of this writing is the retention of the original narrowness of italian hand, as used by Lucas Materot and other early French designers. Peculiar to this later design is the placing of the weight at the top or bottom of the straight strokes; a page of this italian hand has quite a different "color"—that is overall, general effect—from a page of roundhand. The roundhand capitals are, on the whole, suitable for use with the small letters of the italian style; they should, though, be written a trifle narrower; and the weight of the letter placed in the swells of the flourishes while the major organic strokes remain light—look at the initial L in the Ayres specimen.

Roundhand:

The final specimen is a fine example of roundhand from the engraved book of Johann Heinrigs, who was active in Cologne during the early nineteenth century. By observing the diagram letter and the dots in the margins, the construction of the letters may be readily understood. The angle of slant is thirty-six degrees. It must be emphasized once more that the turns in script are important;

m abcdefghiklmnoſst

A pqrtuvnxyz B

C D E F G H

I K L M N O

P Q R S T U

V W X Y Z Z

Aabbcdefghhijkllmnopqrſstuvnyz

B C D E F G H I J

K L M N O P Q R S

T U V W W X Y Z x

"Great Latin" or "English Roundhand" as used by Johann Heinrigs ~"Alphabete"~Köln, 1834.

in the roundhand, it will be observed that when the stroke turns at the waist- or base-lines it has thinned out to a hair-line before it continues, either upward or downward into the next stroke. (For a clarification of these terms, see the third illustration in Chapter XII.) All the hair-lines in this specimen have been carefully weighted for the purposes of reproduction; in the engraved original these light strokes are extremely delicate.

It is apparent from this German specimen that the use of roundhand spread. As a matter of fact, the style is generally the major example in any of the writing-books of the nineteenth century, either in western Europe or America; and most of the examples resemble one another closely. Roundhand became the basis for all business penmanship training, continuing to recent times in such systems as the Spencerian and Palmer methods of penmanship. The style grew always more corrupt and sterile. At the present time there is no longer any teaching of hand-writing that could be called roundhand: specifically, the pointed-pen writing done in the style of this specimen by varying the pressure on the pen to achieve the thicks and thins of the design. The typewriter has made business penmanship almost unnecessary.

Revival of Script Hands:

There has been a revival of script hands for use in advertising; the roundhand, particularly, has received much attention although it is not the most interesting of them. Most of the built-up, freely-written, or brush scripts that have been employed are derived from the writing and engraving styles developed during the period reviewed in this chapter. However, for anyone who studies this period of the development of letters and writing there are certain inescapable conclusions: the cursive scripts became, during the entire evolution, always more impersonal; what emerged, finally. was a definite type, the roundhand, which represents the ultimate in painstaking neatness and studied elegance; in the fashioning of these letters, though, all severity, which is the hallmark of truly fine design, was forfeited.

Part 2. Seventeenth- and Eighteenth-Century Type Designers.

Foreword:

To understand the developments in type design during the period reviewed in this chapter, one must study the gradual changes made in the old-style designs—

changes that produce the classical or modern types at the end of the eighteenth century. These changes were largely the result of pointed-pen influence, the engravers' techniques, and the various style tendencies—all of which have been commented upon. Of course, no phase of design can be arbitrarily confined to a given time sequence; changes are gradual; there are transitions, anachronisms, revivals, and retrogressions—illogical development was mentioned early in this book. The pattern of development during these two centuries displays all these characteristics. At best, these time periods are memory aids; and help to break the long, endless evolution into more convenient sections. The conditions and influences that acted upon the designers existed before the seventeenth century and continued after the eighteenth; but the focal point of the pertinent conditions and influences, whether technical or stylistic, certainly fell within these two hundred-odd years.

This evolution from old-style to classical or modern types is marked by gradual alterations in letter widths, serifs, in the relation of the thin and thick strokes, and in the color of the printed page. The full circles of the old-style rounds became, in the late eighteenth-century types, compressed; this compression, of course, was carried through the entire alphabet. Serifs, which had been bracketed, and often blunt, became pointed and more delicate; finally, they were nothing but fine, straight, finishing lines. As in the writing styles, the relation between the thin and thick became a contrast between hair-lines and heavy strokes. The weight of the round letters was placed so as to be in the same position on each side, instead of being noticeably tilted as in many of the old-style faces. There is a horizontal-vertical balance of the hair-lines and thick strokes. A comparison of the sixteenth-century types with the Bodoni types in this chapter will show exactly what happened. The page color became much lighter, even a bit bare-looking at times; this whole effect of the final classical or modern types is one of compression, contrast, and verticality, plus a high degree of exactitude and finish.

The names, "classical" and "modern," require some slight explanation. One needs to know that the artists and designers of the eighteenth century became, as the century advanced, always more enthusiastic about antique or classic style. This enthusiasm was brought about by the discoveries—at Rome, Herculaneum and, later, Pompeii—of Roman antiquities and the popularization of these treasures by writers and artists such as Johann Winckelmann and Giambattista

Piranesi. An increasing public interest led, finally, to a "classic revival." Since letters always reflect general style, it is not surprising that type styles were affected. However, this entire movement was not very well founded: it was intellectual and a bit artificial. The tendency was to approach all design problems with a fixed set of proportions and measurements; the result was a highly finished, careful production in what must necessarily be called a pseudo-classical style. Insofar as type faces are concerned, the Didot types represent the final development of the so-called "classical" style; France, perhaps, was most affected by the classic influence and gave it the most logical development. England was affected similarly. Here, too, the arrival of art treasures from Italy—such as the collection of Sir William Hamilton—plus the effect of general European interest in the revival of classic art principles, led to results much like those in France. English type designers, however, came to call their type style "modern"—not a good name, considering that what was modern then is not so now; it has, though, remained in use as the definitive name for this entire category of type design. (All further references to "modern" type design will apply to this style; not to that of the twentieth century.)

It is difficult to illustrate this long period of type development with a limited number of examples. However, by avoiding many of the ramifications, repetitions, and purely nationalistic interpretations that crowd the pages of typographic history, it is possible to present a visual record of the major developments without becoming too involved. Certain phases of letter design, of course, may seem a bit neglected: script types, for instance, and the work of many famous type designers. Some explanation of this seeming neglect will be made in the proper place. The main directions of type design during the seventeenth and eighteenth centuries are clear enough—despite the reduction of literally hundreds of possible examples to these few.

It seems best to consider the examples chosen as a sequence, without excessive concern for their nationality. Each specimen will be discussed as a step in the overall development, which has been described in this foreword. The intention is to show the general western European trend; this general, or composite, trend is important to the understanding of the design of our letters and types. Any change of the center of activity from one area to another must, of course, be explained briefly. To a large extent, the history of type design during the seventeenth and eighteenth centuries is to be viewed in the work of the outstanding

type designers. However, their relations to their times and to one another are of some importance and will be mentioned during the consideration of each specimen. To this examination of the specimens will be added whatever seems pertinent from the historical or economic viewpoints.

Elzevir:

The house of Elzevir represents another sign of the passing of the center of typographic activity from France to the Netherlands. From its establishment by Louis Elzevir at Leyden in 1583, until its dissolution after the death of Daniel Elzevir in 1680, this publishing firm dominated the book markets of Europe at various intervals. Nor was it the only Dutch house of importance. The first illustration evidences an unmistakable relation to the French sixteenth-century style; the capitals are almost identical with those of Antoine Augereau, particularly the one-eared M; the lower-case letters resemble his design also, except for the somewhat greater contrast between the thick and thin strokes and the width of certain letters, such as s and x. Thus, in the early part of the seventeenth century one may record, besides the continuation of French area design, a slight increase in contrast, affecting the color of the page. Compare the specimen with and Augereau and Garamont types in Chapter VII (see pp. 97 and 101). As for the italic: this style is related to a type used by Plantin, a design that is based on a cancellaresca writing hand.

Later in the century, especially after 1647, the Elzevir types were almost always cut by Christoffel van Dyck, who was the master craftsman of the century in this field. His types were also based on French designs; but were of a more precise cut; by some experts these types are considered better than the Garamont designs, which Van Dyck undoubtedly followed. They were the types used in the famous Elzevir pocket editions; present-day revivals are known as Elzevir. All of the original Van Dyck material, with the exception of one size of italic, has been destroyed.

Jean Jannon:

Typographically, the seventeenth century has usually been considered a period of poor quality and workmanship. That such was not altogether the case we have already seen. This viewpoint of seventeenth-century books and type, although partly justified, seems, curiously, based in part upon the idea that, if French quality declined, the quality everywhere else must have done so too. Nowhere, perhaps, are the reasons for the decline of French craftsmanship in book

production more clearly implied than in the rather strange story of Jean Jannon and his types—a story leading up to the immediate past, affecting American typography of the present.

Jean Jannon served his apprenticeship in Paris; he was a master printer there until 1610. In that year, due to his Protestant leanings, he left for Sedan, where he printed for the Calvinist Academy. Apparently, a lack of satisfactory type material compelled him to try his skill as a punch-cutter and type-founder; one of the finest and earliest of French specimen books was issued by him in 1621. The Jannon types were used at Sedan, solely for the Academy and the Prince of Sedan, for the next twenty years. At the end of this period Jannon returned to Paris to set up a business. Political and religious troubles, however, plus the launching of the Imprimerie Royale by Cardinal Richelieu, made operations almost impossible for the ordinary printer. Jannon was saved from destitution through the employment offered him by Pierre Cardonnel, a merchant of Caen, who had the desire to publish learned books. A versatile craftsman such as Jannon was invaluable to his project. The engagement at Caen, however, did not turn out very well; spies reported Cardonnel's activity and his workroom was raided, the type-founding materials sealed, and the room padlocked. It happened that the book in preparation was of a scientific nature—not in any way propagandistic—so permission was finally granted to complete it; but Jannon's punches and some matrices were seized and evidently transported to the Imprimerie Royale. Cardonnel was allowed no further publishing and Jannon returned to Sedan where, with his son, he again printed for the Academy.

Jannon's misfortune was not an isolated instance of the censorship and repression that were exercised in France at this time. Nothing could have been more discouraging to the members of a craft than conditions of this sort. It is not at all strange that typography did not flourish. Despite Richelieu's interest and powerful patronage, book publishing in seventeenth-century France fell far short of the achievements of the first half of the sixteenth century. The continuance of these repressive conditions into the eighteenth century explains why so many books in French, which were prohibited or liable to suppression in France, were issued by Dutch printers— a situation contributing greatly to their economic advantage.

Jannon never recovered his confiscated punches. They lay in obscurity, in what, after the revolution, became the Imprimerie Nationale, until 1898. Then they were revived and the types used for various de luxe editions published by

AVX TRES-PVISSANTS
SEIGNEVRS LES ESTATS GENERAVX DES PROVINCES VNIES.

COMME plusieurs Autheurs tant modernes qu'anciens ayent beaucoup & bien escrit de la *Castrametation*, comme d'vne des principales parties de l'Art militaire, dont les principaux Officiers du Camp des Romains (à sçavoir les Tribuns) avoyent l'administration, son *Excellence* les a diligemment leuz, non seulement comme Theoricien, ou par speculation, mais là dessus s'en est servi en la practique, y adjoustant ses propres inventions & ordonnances, selon

Type used by Matthieu and Bonaventure Elzevir at Leyden, 1618 ~ from "Castrametation, etc." by Symon Stevin.

ABCDEFGHIJKLMNOPQRSTUVW XYZ& *ABCDEFGHIJKLMNOPQRS TUVWXYZ& ABDGIMNPQ RTU*

abcdefghijklmnopqrstuvxyz& *abcdefghijklmnopqrstuvwxyz&*

Officinæ meæ librariæ primitias, Reuerende in *Christo pater, quur uni tibi hactenus mihi non cognito,*

The Jean Jannon type ~ cut about 1615 ~ these are the "caractères de l'Université."
Arranged from a specimen sheet of the Imprimerie Nationale, Paris.

this national printing establishment. In the intervening centuries a legend grew up around them: the designs were given the name "caractères de l'Université" and declared to be the work of Claude Garamont. The origin of the name is doubtful, unless it came from their use at the Sedan Academy, which was really a university, although forbidden to use the name. Since the Imprimerie Nationale proudly and reverently wrote about and used these letters as Claude Garamont type, designers in both England and the United States, charmed by the superficially acceptable story of their origin and their position in typographic history, made new cuttings of the designs intended to fit into the revival of sixteenth century types. These productions were called Garamont, or the variant, Garamond. This structure of fancy was demolished about 1926 by the researches of Mrs. Beatrice Warde, who issued her material under the pen-name of Paul Beaujon. The story related in this and the preceding chapter concerning Garamont and Jannon type has been drawn largely from her material.

A comparison of Jannon's roman with the Garamont designs of the Egenolff sheet, or with the letters of the Elzevir example, will reveal the characteristics of seventeenth-century type design. The striking differences between Jannon's letters and those of Garamont, whose style he undoubtedly used as a basis for his work, are in the top serifs of the i, m, n, p, and r. They are at a steeper angle and a bit scooped out in the seventeenth century design—note the dotted lines on the specimen. All serifs are sharper and a bit elongated; the contrast between thick and thin strokes is pronounced enough to create a slightly brilliant effect. Those who wish to study individual letter differences should note, in both examples, the bowl of the a, the tail of the g, and the design of the s; the differences among the capitals are noticeable in the E, M, R, and W. Jannon never cut a J; this was added when the types were first used by the Imprimerie Nationale; small sizes were also cut to give the face a greater flexibility for book purposes. The italic should, of course, be compared with that of Granjon. The Jannon design is quite erratic in its differing slants; the capitals are less slanted than the lower-case; and even among these there is no set slant. Letters such as the k, w, and z are most peculiar. Definite Dutch influence is to be observed in the swash capitals, especially in the spiral endings.

Jannon's types seem to have had a definite influence, despite their long obscurity; after all, he printed for many years at Sedan and was renowned for his Sedanoise, the smallest size type of its time. Certainly he had an effect on our own times, which has already been sufficiently explained.

The Fell Types:

The third specimen is a showing of the Fell roman and italic, named after Dr. John Fell, who became Bishop of Oxford. Interested in the "cause of learning," he purchased punches and matrices for these and other types to augment the equipment of the University Press at Oxford. An agent was dispatched to Holland to negotiate the purchase; the transaction took place between 1670 and 1672. Dirck Voskens is considered to have been the designer of this type face; he and his father, Bartholomew, were among the gifted Dutch punch-cutters of the last half of the seventeenth century. It has often been deplored that Dr. Fell's emissary did not get the better Christoffel van Dyck type; the benefit to English type design would have been somewhat greater; for there is no denying that the Caslon face, so important in the next century, was inspired by Dutch design, particularly the Fell type.

It has been stated many times that there was, at the end of the seventeenth century, more Dutch type in England than English. There is no reason to doubt this. In the first half of the sixteenth century there were a few men, trained on the continent, who did punch-cutting. John Day is the most noteworthy of these; his fine roman and italic are amazingly similar to Dutch and French types. For a century and a half after this period the Crown interfered so seriously with printing that its attendant craft of type-founding had no chance to develop a school of punch-cutters. The craft of type-founding was officially separated from that of printing by a decree of 1637; on the continent it had become a separate craft, with Garamont. During the seventeenth century, however, English printers were forced to import most of their types, and these were largely Dutch in origin.

The specimens, issued by the Oxford University Press, were printed from types cast with the original type-founding material, which is still in its possession. These letters should be compared with the Jannon designs. In the roman, a definite narrowing of the round letters is to be observed and a greater degree of contrast. The serifs on the capitals are similar to those of Jannon but among the lower-case letters a flat serif is to be found at the base of f, h, i, k, l, m, n, r, and on the descenders of p and q. This thin, flat serif is one of the distinguishing features of the later classical and modern types. Ascenders and descenders are notably short in the Fell designs, giving the largest size a squat appearance. In the separation of the design of the U from that of the V there was some difference of opinion about the design of the U: Jannon used a V with a rounded bottom and Voskens

retained the uncial style of the letter—either is correct if properly designed to fit the alphabet in which it is used. Other noteworthy differences between the two faces are in the Q, the tail and ear of the g, and in the design of s and the ampersand.

The italic design has the same lack of a uniform slant as Jannon's italic, but there the similarity ends. All the capitals show slight differences, the \mathcal{J} and Q of the Fell design are really swash letters; these are typical of the seventeenth century and the differences between the two sets of swash characters is interesting. The small letters vary considerably from these of Jannon: the ovals are wider, the contrast is greater, ascenders and descenders are shorter. Great difference is to be seen in the design of v, w, and z; the branching of the m, n, and r, in the Fell design, splits the stem instead of growing from it. Throughout both the roman and italic there is an irregularity that is considered old-fashioned and naive; this quality has been used to advantage by the Oxford University Press in reissues of seventeenth and eighteenth-century books.

Before leaving the third quarter of the seventeenth century it seems best to mention another of the Dutch punch-cutters, Anton Janson. His name has come down to us attached to revivals of his types. The original punches are in the possession of the Stempel Type Foundry of Frankfurt am Main; they passed through the hands of several German and Dutch type-founding firms and were long thought to be of strictly Dutch origin. Later research has disclosed that they were actually cut in Leipzig, where Janson conducted a type-foundry for some twenty-seven years after 1660. This is another of the many disturbing facts for those who wish to attempt a nationalistic explanation of typographic history. The Janson designs are more regular in setting and of a more precise cut than the Fell types; and fall in between these and the work of Caslon and Fleischman in typographic development.

William Caslon:
Caslon learned the trade of engraver in London; he was apprenticed to a maker of ornamental gun-locks and barrels. As an independent master he began also to do silver-chasing and cut stamps for bookbinders. Gradually, he became interested in cutting punches for type-founders. The printer, William Bowyer the elder, finally persuaded him to enter the business of type-founding and helped in raising the necessary capital. Caslon's first specimen sheet was issued in 1734 and shows the results of fourteen years' work—some forty sizes of various faces:

to complain of in the pro-gress of his profession.

Scarcely eleven works out of twelve are sent properly prepared to the press; either the manuscript is illegible, the spelling incorrect, or the punctuation

is defective. The compositor has very often to read sentences from his copy more than once before he can ascertain what he conceives the meaning of the author, that he may not

Three-line Pica, Double Pica, and Great Primer specimens of the Fell roman and italic — lines below are reduced.

ABCDEFGHIJKLMNOPQ
RSTUVWXYZ &
abcdefghijklmnopqrstuvwz

ABCDEFGHIJKLMNO
PQRSTZ ADMPTÆ
abcdefghijklmnopqrz as &

The examples on this page were arranged from specimens of the Oxford University Press.

roman, italic, textur, Arabic, Greek, Hebrew, etc. Our interest is entirely in the roman and italic.

Practically speaking, Caslon was the first important English punch-cutter. Almost single-handed, he ended the Dutch type-founders' dominance in supplying the English printer with type. With the consideration of Caslon type we enter the period of the eighteenth century. This type is a retrogressive style to a great extent, being based largely on the Dutch types of the last half of the seventeenth century; in the precision of the cutting and a certain perpendicularity, however, there are eighteenth-century factors present. The best answer to the oft-repeated statement that the Caslon face is typically English is a comparison with the Fell and Janson types. No claim to great originality can be made for Caslon. Taken as a whole, though, his output is remarkable and presents an imposing achievement.

The world-wide use of Caslon type, its imitations, and derivatives among the English-speaking populations, came about mostly through the expansion and influence of the British Empire; its virtues as a type design did not justify this. English type followed the colonizer. There is a certain justifiable nationalistic pride that the average Englishman may take in the accomplishments of William Caslon; but if one also takes a broad view of the general western European pattern of development, it is difficult to describe this accomplishment as "thoroughly English." In this connection it is interesting to note that Caslon's father came to England from Spain. The important indication in the appearance of Caslon is the rise of the English area as a center of publishing activity, with an accompanying typographic industry. Practically all the type used during the last half of the eighteenth century in the American colonies was English, types of the Caslon family predominating; the notable exceptions were the German types used in the Pennsylvania German area. A brief study of Benjamin Franklin's career as a printer will bring one into contact with most phases of colonial typography.

The examples of Caslon Old Style are from specimens printed in 1923–24 with types produced from the original punches and matrices of the eighteenth-century firm of William Caslon and Son. In England this roman and italic are known as Caslon Old Face. Of course, the most interesting comparison is with the Fell type. Not much need be said, for the lesson is entirely in the examination of the specimens. Caslon improved the alignment and, in general, the design of

AT the beginning of the 18th century the great James Foundry, which contained material produced by De Worde, Day, the London Polyglot Founders, Moxon, and many others, was procuring types from Holland, and an account of Thomas James's negotiations there in 1710, when he went to procure a supply of material for his foundry, is given in a series of interesting and unconsciously humorous letters in Rowe Mores' *Dissertation*.

IT was a lover and his lass,
With a hey, and a ho, and a hey nonino,
That o'er the green corn-field did pass
In the spring time, the only pretty ring time,
When birds do sing, hey ding a ding, ding;
Sweet lovers love the spring.

ABCDEFGHIJKLMNOP

ABCDEFGHIJKLMNOP

abcdefghijklmnopqrstuvwx

abcdefghijklmnopqrstuvwxyz &

Caslon Old Face roman and italic reproduced from specimens of H.W. Caslon & Co., London.

the Dutch type. The roman capitals are a bit wider, have a tendency to be even-width, and the swells in the rounds are not tilted. The lower-case letters have slightly bracketed serifs throughout, a return to an earlier style; but the contrast between thick and thin is maintained. Ascenders and descenders are short; Caslon kept the rather homely quality of the Fell type. One or more of the characters in each font of the larger sizes are not well related to the rest of the alphabet; this, rather than being distracting, gives a page of Caslon a certain irregularity that is interesting to the eye. It is especially noticeable in the italic, in which some of the erratic slants of the seventeenth century styles have been continued. Caslon's italic is obviously a narrower design than the Fell face, but with the wide setting. The long s that was an accepted form when Caslon cut his punches is not shown; it began to disappear in England after 1750; the original Caslon *h* appears only in the bottom line; *h* was cut to suit the taste of a later period.

The Caslon roman and italic, which had considerable renown and use during their designer's lifetime, were eclipsed between the years 1780 and 1840 by the classical and modern types. A revival after 1840 gave to Caslon Old Style a wider market by far than any William Caslon could ever have imagined. Its popularity has continued; but revivals of other early types, some of much finer design, have greatly encroached upon the once dominant position of the Caslon face. It makes a fine design for books or text matter that require a certain old-fashioned look; it has, also, enough characteristics of the "modern" types to work well with much present-day matter.

Johann Michael Fleischman:
Johann Fleischman, the punch-cutter of the type illustrated in the next specimen, was born in Nürnberg in 1701. His training in the craft was obtained in his native city. After working for some time in Frankfurt am Main, the famous German printing center, he settled in Holland, about 1728, and began employment under Dutch type-founders. In a way, the career of Fleischman indicates the return of the German area to normal typographic activity after approximately a century of effort to overcome the calamitous effects of the Thirty Years' War. It has been apparent that the Dutch were spared, and prospered during this period. By 1743 Fleischman had a position at the Enschedé foundry of Haarlem. Over the course of twenty years he did an enormous amount of work for this famous firm—cutting punches for romans, italics, scripts, texturs, orientals, and music types. When he died in 1768 the Enschedés issued a type specimen

in his honor, in which he is called the "greatest and most artistic punch-cutter who had ever existed or was possible." This eulogy may be accepted with some moderation, considering the occasion; but it is an indication of the esteem in which Fleischman was held by his contemporaries, Unquestionably, his influence during the third quarter of the eighteenth century was immense. His punches and matrices are still in the possession of the Enschedé establishment, whose collection of ancient punches, matrices, types, etc., is probably the most extensive in private ownership.

In contrast to Caslon, Fleischman cut an entirely new series of designs. He was influenced, to some extent undoubtedly, by the famous "romain du roi" that Louis XIV had ordered for the Imprimerie Royale in 1692. A comparison shows, however, that Fleischman by no means imitated Phillipe Grandjean, who cut the punches for the "king's roman," any more than Grandjean followed the designs prepared by Nicolas Jaugeon and other members of the French Academy, who had been charged with developing the new type. This French design is usually considered the beginning of the classical and modern types; but, as we have seen, the process started earlier. Even the characteristic thin, flat serif had been used at various previous periods. The first printing from Grandjean's type was in 1702; the many fonts of the face were not completed until 1745, being finished by Jean Alexandre, Grandjean's pupil and assistant, and finally by Louis Luce. It was forbidden to copy this type in France; but Luce did something similar for his own customers; the Dutch founders, noting the style trend, followed in their own way.

The Fleischman specimen should be compared with the four already illustrated; it is related to all of them, besides showing new departures. In the even widths of most of the capitals there is a resemblance to Caslon—the rounds, however, are compressed and the weight is placed perpendicularly with very little modeling to join it to the hair line. The beak endings on the top or bottom cross-strokes of E, F, L, T, and Z are noteworthy. Top and bottom serifs have the general appearance of being flat and thin, except where they are bracketed to end a light stroke. These capitals strike one immediately as designs in a new style. This is also true of the lower-case letters, although they are held somewhat closely to old-style models, especially in the serifs. Fleischman may have adopted the general tone of Grandjean, but he compressed his letters more, gave them more perpendicularity and an exact finish; the serifs, of course, are not like those

of Grandjean. Ascenders and descenders are short. Although the contrast be-tween thick and thin is considerable, the Fleischman types have a rather light, even effect; modern specimens sometimes seem a bit colorless; but when printed on the paper of Fleischman's time the tone of the page becomes much more in-teresting to the eye. The ball endings on the a, c, f, g, j, r, and y should be noted; this ending is to be found on some of the italic letters also. In the italics, as-cenders and descenders are longer, there is more resemblance to Grandjean, ex-cept in the *h*, where Grandjean introduced a new style, and in the *v* and *w*, where Fleischman followed Dutch patterns.

The influence of the Fleischman types was recorded in at least one instance by Pierre Simon Fournier, the renowned French punch-cutter, who admitted hav-ing copied them. Fournier *le jeune*, as he was known, was the first to call the "contrast" types "modern." He published, in 1764—66, a two-volume work called *Manuel Typographique*, into the first volume of which he put much valu-able information concerning typography in western Europe during his lifetime. Included in this work is the final plan of a system of type measurement by which he sought to overcome the wholly arbitrary traditional relations of type sizes to one another. He was the first to use the word "point" to describe his unit of measurement. Fournier, by his own admission, tried to make his types conform to the writing of the time; his work reflects much of the rococo style, and this factor is to be found in Fleischman also.

Before turning to the next specimen it may be well to explain that the number of characters in a font of type may vary, from about eighty to almost two hun-dred and fifty, according to the number of accents, tied letters, punctuation marks, numerals, small capitals, symbols, etc., included. All of these additional characters must be styled to suit the capitals and lower-case of the design. In this respect it is well to examine numerals, punctuation marks, and various other symbols, not only in this Fleischman specimen but in all places where they ap-pear.

John Baskerville:

In the early part of his career John Baskerville was a writing-master. He made a fortune in the manufacture of japanned-ware—trays, boxes, etc.—and retired to an estate, Easy Hill, near Birmingham, England. His activity as a printer of fine books began there about 1750; the term "amateur," which has often been ap-plied to him, is largely an expression of the jealousy of professional printers—

*Non inchoantibus præmium,
ſed perſeverantibus datur. Het
loon word niet aan den begin-
nende belooft, maar het word
aan de volhardende gegeeven.
acefgklopqrstwxyz.cfghjkprætuw.*

Lors qu' Aspaſie étoit concubi-
ne d'Artaxerxès: On ne ſauroit
lui donner moins de vingt ans à la
mort de Cyrus: elle avoit donc
ſoixante - quinze ans lors qu'un
nouveau Roi la demande comme
une grace particuliere. PLTGA
ABCDEFHIJKMNOQSU
VWXYZÆ ÆABCDEFGHIJKL
1234567891o†([ʃ§!?áọʃúm̃ñ

Italic and roman cut by Johann Fleischman for the Enschedé foundry at Haarlem.

there is nothing amateurish about his work. There is also much reference to his eccentricity, vanity, etc., which indicates to not a little extent that Baskerville was a victim of the scorn of his inferiors, both during his lifetime and afterwards. He had the qualities of a great artist who wishes to control all phases of his production; he is the forerunner of William Morris in this respect. His experiments with presses, paper, ink, and type design proceeded through years of purposeful effort. It is with his type design alone that we are here concerned.

Baskerville's roman and italic are products of his own time, plus his experience and knowledge as a writing-master. His design is original in the sense that he did not too obviously copy an earlier type style as did Caslon. He employed a punch-cutter named John Handy; and William Martin, who later became celebrated as a designer of types for William Bulmer, worked as an apprentice in his establishment. In his own words, Baskerville says that he was "desirous of contributing to the perfection" of letters; and had "formed to myself Ideas of greater accuracy than had yet appeared, and have endeavored to produce a Set of Types according to what I conceived to be their true proportion." This is all that need be said about these types; the rest of the story lies in examination and comparison. Perhaps the best comparison is with the Caslon specimen, the type that Baskerville called "a fairer copy for my emulation than any other master." Baskerville is regarded as a transition type between old-style and modern; it is a little later than the work of Fleischman. The capitals are of a decidedly different cut from those of Caslon; there is an elegance that is quite foreign to the earlier design. A, R, Q, and W—the latter two not shown—are the letters that differ greatly from Caslon's; the tail of the Baskerville R is similar to Grandjean's design. Serifs are carefully modeled and the letters seem most accurate. In the lower-case the letters are superficially similar to those of Caslon with the exception of the g, h, and w; the open tail of the g goes all the way back to Carlovingian style; this definitely reflects a writing-master's conception. It is in the italic design, however, that the technique and style of the eighteenth-century writing-master are most visible. This portion of the specimen should be checked with the lettre italienne throughout the first part of this chapter. Here, again, is an elegance and fragility that is new to type design; this italic is typical of the eighteenth century and is related to the script types that will be discussed a bit later.

It is Baskerville who exerted the greatest influence upon English printing and

P. TERENTII
ANDRIA.

PROLOGUS.

POETA cum primum animum ad fcribendum ap-
 Id fibi negoti credidit folum dari, [pulit,
Populo ut placerent, quas feciffet fabulas.
Verum aliter evenire multo intelligit.
Nam in prologis fcribundis operam abutitur,
Non qui argumentum narret, fed qui malevoli
Veteris poetæ maledictis refpondeat.
Nunc, quam rem vitio dent, quæfo, animum advortite.

*S*OROREM *falfo creditam meretriculæ,*
 Genere Andriæ, Glycerium vitiat Pamphilus:
Gravidaque facta, dat fidem, uxorem fibi
Fore hanc: nam aliam pater ei defponderat
Gnatam Chremetis: atque ut amorem comperit,
Simulat futuras nuptias; cupiens, fuus
Quid haberet animi filius, cognofcere.

The roman and italic used by John Baskerville in his "P. Terentii" Birmingham, 1772.

type design during the last half of the eighteenth century; the types of Alexander Wilson, Joseph Fry, and John Bell followed Baskerville closely. Through his correspondence with continental type-founders and printers and their interest in his work, this influence was extended to most of western Europe. The results may be seen in the work of Bodoni, Ibarra, and the Didots. Baskerville's punches and type-founding materials were mostly lost to English typography through complete indifference on the part of everyone who should have been concerned. Most of his equipment went to France; it was used in the Kehl edition of Voltaire; and that material was largely scattered or destroyed during the French revolution. New cuttings of Baskerville designs have been introduced gradually until, at present, it has become popular for books and advertising. The text type in this book is a modern rendering of the Baskerville Face.

Giambattista Bodoni:

Bodoni, the son of a printer, was born at Saluzzo in the Piedmont in 1740. While still a youth he journeyed to Rome and worked at the press of the Propaganda Fide. Apparently he liked his environment and occupation; he began cutting types for the establishment. The suicide of the director of the press, a scholarly man who had been kind and helpful, shocked him and made it impossible to continue working in Rome. With the idea of trying his fortune in England, he traveled northward, stopping at his parents' home in Saluzzo for what was to have been a farewell visit. An illness prevented him from leaving immediately. During his recovery—in 1767—he was asked to take charge of the newly furnished Stamperia Reale at Parma. He accepted the post and remained there for the rest of his life, becoming always more famous and influential in the realm of printing and typography.

At first Bodoni's position was that of a private printer who had a certain amount of official work to do for the court of Ferdinand, Duke of Parma. However, he soon began to take up other projects and his reputation grew. His editions attracted wide attention, and book-lovers from all over Europe made pilgrimages to the press at Parma, establishing this Italian city as a center of important typographic activity. An enticing offer of a new position, which would have taken Bodoni to the Papal Court in Rome, was countered by Ferdinand when he granted his master-printer a much larger press and a more independent position. Bodoni now printed for anyone who wished to use his services. Books in English, French, German, Greek, Italian, Latin, and Russian issued from his

138

presses. He became a distinguished personage: he was honorary printer to Carlos III of Spain, the uncle of the Duke of Parma; the Papacy bestowed its compliments upon him; Parma issued a medal in his honor; Paris also gave him a medal; pensions were granted him—by Carlos IV of Spain, by the Viceroy of Italy, and by Napoleon. Last, but not least, he corresponded with Benjamin Franklin concerning typographic matters. When he died, in 1813, he was at the height of his fame.

Baskerville, Fournier, and, perhaps, Fleischman were the strongest influences upon Bodoni's typographic production. The first types used at Parma were from the Paris foundry of Fournier *le jeune*. Soon, however, Bodoni cut his own rendering of these designs; and, finally, under the immediate impact of the classic revival, he designed his "classical" types—the first truly "modern" faces. Bodoni moved typographically from the rococo period into the position of unrivaled master of a new type style. His prestige was the determining factor in the change from old-style to modern types. This final phase of Bodoni's enormous output falls into the last decade of the eighteenth century; it is this phase that had a continuing effect upon letter design until our own times.

The specimens are modern, printed, however, with authentic Bodoni types from this latter period. Compare the capitals with those of Baskerville and Fleischman. For brilliance, the lower-case is not to be matched by any earlier type style; a comparison with the preceding specimens in this chapter will reveal all there is to know about Bodoni's originality in developing this design. The letters answer completely the description of the classical or modern types given in the foreword; here are compression, contrast, verticality, hair line serifs, and a most meticulous finish. Bodoni separated his lines widely, achieving a light page effect; he compensated somewhat for the separations by lengthening the ascenders and descenders of his types.

Types of the Bodoni family, in present-day cuttings, still have wide and continuing favor, despite the effective old-style revival and much adverse criticism. Their use in mode journals, advertising, and for a definite type of book work is based upon their brilliant, sparkling effect, which is not as unreadable as some people have pretended. The development of these types represents a thoroughgoing design job; Bodoni was a consummate artist in both the manufacture of types and their use on the printed page. Some of Bodoni's types were cut by Andrea Amoretti. A type specimen book issued by Bodoni's widow in 1818 is probably the most elaborate ever produced; it was called the *Manuale Tipo-*

grafico and contained examples of 373 types, including 34 Greek faces and 48 orientals.

Script Types:

The seventeenth- and eighteenth-century type designers cut many varieties of the basic script styles and their derivatives. These are remarkably similar to the examples of writing shown in the first part of this chapter and bear, in many instances, the same names. Since we are here concerned entirely with letter design it is hardly necessary to show them. Some of the noteworthy designers who produced script types during these two centuries were Pierre Moreau, Fournier *le jeune,* Jacques Rosart, J. Gillé, Gillé *jeune,* Molé *jeune,* and Firmin Didot.

The example of Bodoni's French Cursive was printed with one of his numerous script fonts—this, too, is a modern specimen. It was chosen instead of the italic in order to illustrate a class of script that falls between the joined style and the italic. The Baskerville italic is very close to that of Bodoni, even to the open tail of the g; its relation to this script is also evident. Fleischman cut an earlier design that may well have been the inspiration for this face. All the scripts of the late eighteenth century reflect the rococo style.

Joaquin Ibarra:

The specimen of Ibarra's work has been included to illustrate the effect of Baskerville, Bodoni, and the Didots upon Spanish typography. Ibarra held a post, under Carlos III in Madrid, similar to that held by Bodoni in Parma; and since the court of Spain and the duchy were intimately connected by family ties, it is obvious that the work of the Italian master must have been known to him. The edition of Don Quixote, of which part of the opening page is reproduced, was splendidly illustrated with engravings; the books printed during this entire period—1740 to 1770 particularly—made elaborate use of engravings. Men such as Gravelot, Cochin, Eisen, and Moreau were among the best of the engraver-illustrators; and with them engraved book-illustration reached a pinnacle of use and perfection.

Compare the specimen with those representing Baskerville and Bodoni. Ibarra's type is held close to old-style; but the manner in which it is used, the widely separated lines and letter-spaced capitals, show their influences—Didot influence is present also. Spanish attachment to broad-pen writing has been mentioned; the italic should be studied in this respect. It is quite different from the designs of Baskerville and Bodoni; it might almost be classed as a script type and could

FRÉDÉRIC LE GRAND
AU MARQUIS D'ARGENS

Nove fiate già appresso lo mio nascimento era tornato lo cielo de la luce quasi a uno medesimo punto, quanto a la sua propria girazione, quando a li miei occhi apparve prima la gloriosa donna de la mia mente, la quale fu chiamata da molti Beatrice li quali non sapeano che si chiamare. Ella era in questa vita già stata tanto, che ne lo suo tempo lo cielo stellato era mosso verso la parte d'oriente de le dodici parti l'una

ASCHERMITTWOCH

So ist denn ein ausschweifendes Fest wie ein Traum, wie ein Mährchen vorüber, und es bleibt dem Theilnehmer vielleicht weniger davon in der Seele zurück als unsern Lesern, vor deren Einbildungskraft und Verstand wir das Ganze in seinem Zusammenhange gebracht haben.

be written with a broad pen. The initial was engraved, but has been rendered in a line technique for the purposes of reproduction.

The Didots:

This family of French printers and type-founders produced many splendid books during the last quarter of the eighteenth century. The branches of the Didot family and their interests exceeded even those of the famous Fourniers; interests aside from printing and typography included invention, paper-making, publishing, and writing. François Ambroise Didot and his son Firmin were the members who specialized in type design, the former in conjunction with the punch-cutter Waflard. In 1775 François Ambroise issued the first type in the "Didot manner"; actually it presented no great deviation from the general style of the period. From this time onward, however, there were changes noticeable in the design of the succeeding Didot types, especially the later designs produced by Firmin. Whether the Didots or Bodoni designed the first modern type is somewhat controversial; it seems fairly certain, though, that Bodoni was the more original craftsman. The influence exerted by the Didots was strongest in the German area; that of Bodoni in England, perhaps, and Spain.

The revolution in France, the "period of enlightenment," and the succeeding imperial interval under Napoleon all had their effect upon type design. All rococo design disappeared; the later Didot types showed this "enlightenment" and the classic revival in their mathematical exactness and pseudo-severity. As in the case of Bodoni, it is the latter phase of the Didots' work that had an effect upon type design until recent times—particularly in France, where the Didot tradition is still manifest. François Ambroise brought out "maigre" and "gras" fonts, which correspond to the condensed and expanded types of today. These were the products of much experiment; a more important result of continuous experiment on the part of the Didot foundry, however, was the revision, about 1785, of the Fournier system of type measurement. In this new system the points were made to conform to French linear measurement and types were named according to their point sizes for the first time—10 point, 12 point, etc. The Didot system was adopted in the German area; it was revised about 1879 by Hermann Berthold, to suit the metric system; the Didot-Berthold system became standard for Germany, much of eastern Europe, and Russia. American type-founders accepted the standard point system about 1886, suiting it to the inch, which is divided into 72 points; England did not adopt the point system until 1898. It

PRIMERA PARTE
DEL INGENIOSO HIDALGO
DON QUIXOTE
DE LA MANCHA.

CAPÍTULO PRIMERO.

Que trata de la condicion , y exercicio del famoso hidalgo Don Quixote de la Mancha.

En un Lugar de la Mancha, de cuyo nombre no quiero acordarme , no ha mucho tiempo que vivia un hidalgo de los de lanza en astillero , adarga antigua , rocin flaco, y galgo corredor. Una olla de algo mas vaca que carnero , salpicon las mas noches , duelos y quebrantos

Roman and italic used in "Don Quixote" ~ printed by Joaquin Ibarra , Madrid 1780.

FRANÇOIS - AMBROISE DIDOT

born in Paris in 1720, was the most renowned printer of his day. He died in 1804. He started his activities as a printer in 1757,

The Didot type, like the Bodoni, shows a striking contrast between the heavy main-strokes and the thin serifs and

Didot roman and italic ~ reproduced from a specimen of the Deberny ~ Peignot foundry , Paris.

is the Didot point system that may well be considered the most important contribution of the family to the development of type design.

The specimen is modern, but the capitals, lower-case, and italics show the typical Didot type of the final period. Characteristic of the extent to which the "Didot manner" was exaggerated by subsequent designers, are the large initials. Comparison of the capitals and lower-case with the Bodoni specimen ought to be instructive in revealing Bodoni's somewhat superior ability as a type designer. The italics are interesting in that they illustrate, to some extent, an idea put forward by Stanley Morison. His feeling was that italic design should be, as much as possible, a slanted variant of the roman; its use to be only that to which italic has been limited: citation in the line, emphasis, sub-headings, etc. This, he believed, would free the script types from their unfortunate relation to italics and, perhaps, permit their use for small books, etc. as a text face—such a use as the Bodoni French Cursive illustrates. Noteworthy characters in this Didot italic are the w, which is derived from Jannon, the v, and y; none of which suit the remainder of the alphabet very well.

Firmin Didot was on friendly terms with the Berlin printer and type-founder, Johann Friedrich Unger. Through him, the use of types in Didot style became popular in the German area during the early nineteenth century. Other German type-founders, who adopted some of the "Didot manner," were Johann Gottlob Breitkopf in Leipzig and J. G. Justus Walbaum of Goslar. At the present time Didot types are used mostly in their exaggerated, derived styles, for headlines or initials.

William Martin:

The first modern faces in England were the work of the punch-cutter William Martin. His apprenticeship to Baskerville has been mentioned; naturally, the influence of this master is apparent in his designs; the other major influence upon him was Bodoni. These modern types were cut for William Bulmer and his associates, who founded the Shakespeare Press about 1786. A story to the effect that their first production was compared unfavorably to the work of Bodoni by connoisseurs is interesting, in that it provides an understandable reason for the Bodoni-like effect that Martin achieved.

Thomas Frognall Dibdin's *Library Companion,* from which the next example was taken, was printed by the Shakespeare Press. Although this press used Martin types almost exclusively, this roman may not be his. However, except

PREFACE.

IT will be obvious, from the slightest glance at the ensuing pages, that it has been the object of their author to present a great quantity of useful information within a reasonable compass. A work which, like the present, aspires to be a *Guide to Youth* and a *Comfort to Old Age*, should be rendered at once commodious in form and moderate in price ; and considering the extent and variety of the subjects here treated, it is presumed that both these points will be found to have been accomplished in the volume now in the hands of the Public.

The roman used in Dibdin's "Library Companion" 1824 ~ a type in the English "modern" style.

Cursus ventorum inter tropicos spirantium solvitur ab Hadleio?

Projectilia, amota medii resistentia, describunt parabolas?

Phænomena terræ motuum solvi possint ab ignibus subterraneis?

Vibrationes ejusdem penduli in cycloide sunt Isochronæ?

A "modern" italic type —from Richard Watson's "Anecdotes"~ printed by J.M'Creery, London 1818.

for details, it does resemble a Martin design. Moreover, it is a fully developed modern face, illustrating very well indeed the general style in England at the end of the period under discussion. A comparison with the Baskerville and Bodoni examples reveals that this is a fatter face, evidence of a trend that soon led to the "fat faces" of Thorne and Thorowgood. Among the capitals the "curly-tailed" R is noteworthy—it is a typical Martin design—the tail has a double curve with a curled ending; serifs on the capitals are sharp and somewhat modeled. The lower-case letters have flat serifs that are slightly bracketed. Besides a letter by letter comparison with the Baskerville and Bodoni pages one should study the differences in general effect, or color. An understanding of page color is most important when letters or type are to be chosen for a specific purpose. The example of italic also is taken from the work of a printer who used Martin types. Again it is possible that the design is not Martin's; but what was said about the roman in this connection is just as true of this italic. Baskerville's influence is apparent in the open tail of the g.

William Martin's type designs have been carefully studied and revived in a type called Bulmer, named after the printer instead of the designer. It is used for books and matter for which Bodoni might be an alternate choice; but its effect is a bit less severe.

Eighteenth-Century Decorative Types:

The final page of specimens shows some of the ornamented or decorative types of the eighteenth century. In the first group there is a marked influence of the rococo style. These letters were much used for title-pages, headings, and initials during the last half of the century. They are display types, not very readable; but have a charm and interest that is typical of the time and the books in which they were used. Fournier *le jeune* and Jacques François Rosart designed such types. Rosart is notable for having made the first use, in a Brussels newspaper of 1769, of an advertisement to sell his types.

The open face titling type is certainly characteristic of the end of the century, of the classic revival, the chasteness and severity of the "period of enlightenment," etc. It is the prototype of many such designs. All these faces, florid or severe, were useful in suiting the color of a heading or title to that of the text, introducing, at the same time, a larger size of type and adding a bit of interest or variety.

FRANÇOIS JACQU
ES ROSART.
MATTHIAS ROSAR
BOEKDRUKKERS.
VOOR-BERICHT
HENDRIK VAN STAD
PLOOS VAN AMSTEL

Typical 18th century decorative types ~ much used for headings and initials.

ABCDEFGHIJK
LMNOPQRSTU
VWXYZÆŒ&

Open Face Titling ~ originally cast by Fry & Steele, 1795.

Summary:

We have now finished with a long and involved section of typographic history, from the period of dominant old-style type design to the advent of the classical or modern types. This development was gradual and not always consistent. Both visually and descriptively the process has been explained as clearly and concisely as possible. It must be mentioned that many authorities consider the trend brought about by Bodoni and the Didots to have been bad, a "wrong direction," a "blind alley." This may be partly true; but it must also be pointed out that authorities often believe in a fixed and unalterable status quo, which is an immobile conception, lacking both life and direction. A moment's reflection upon the history of letters up to this point should convince anyone that change has been a constant factor in letter design, to suit the style, whim, or studied inclination of the changing times. Tradition cannot, of course, be ignored; but nowhere in nature or art is it possible to stand still; one must come to grips with the needs of one's own time and solve problems with as much taste and ingenuity as can be brought to bear. Bodoni was a product of the tastes and techniques of his own time and environment; usually, revivalists and traditionalists are not. The course of letter design during the period just concluded did not necessarily follow reason, sentiment, or good design; but it was remarkably well-suited to the general taste at any given date. The classical and modern types have survived much severe criticism and seem destined to have a definite use for some time to come.

The Effects of the Industrial Revolution

Foreword:

The time range of this chapter is from 1810 to 1896, the year of William Morris's death. It includes the Victorian period; and is a section of letter-design history best illustrated by examples of the activity in the English area. The main interest will be centered there; but certain phases of American and Continental design must, of course, be included. There is some overlapping with the last part of the period examined in the preceding chapter. To understand these times one needs to consider the effects of the industrial revolution upon England, which became—economically and politically—the dominant world power. English material success with the new system of machine production astounded Europe and led to imitation in all fields—if English machines were bought and their methods copied it is not strange that their writing and types should have seemed desirable also. The fact that English roundhand became the prevailing business hand of America and Europe has been mentioned already. A novel part of the picture is the circumstance of France, Germany, and Spain using types purchased from English foundries or copied from the English. A partial listing of the inventions of the century having to do with printing and reproduction is the first requisite in sketching the background of the scene. The second is to outline the revivals and trends that affected art in general. With these factors in mind it will be possible to understand all phases of nineteenth-century letter design.

Inventions and improvements, which revolutionized reproduction methods and the entire craft of printing, made their appearance at regular intervals throughout the century. At its start the process of lithography had been discovered by Alois Senefelder of Munich and, in France, Louis Robert had built the first machine to produce paper in endless rolls. Soon after 1840 the photographic discoveries of Louis Daguerre and others were applied to the problems of reproduction; the processes of photo-lithography, photogravure, line and halftone reproduction, and three-color halftone reproduction were in use before the

end of the century—often in conjunction with the older woodcut process. The first high-speed, power-driven, cylinder press was operating in London by 1814, the invention of Friedrich König. All sorts of developments followed the high-speed press; stereotyping, an old process, was improved to meet the new requirements of book and newspaper publishers; a type-casting machine supplanted the method of casting characters by hand; various attempts to build a typesetting machine resulted, finally, in the linotype machine constructed by Ottmar Mergenthaler; a punch-cutting machine based upon the pantograph was invented by Linn Boyd Benton; at the end of the century another machine, which set and cast type in individual characters instead of lines, the monotype, was invented by Tolbert Lanston—these four machines were produced in the United States. The typewriter, which was to have such an adverse effect upon handwriting, was a reality by the last quarter of the century. These developments, so greatly changing the pace and quality of writing and printing, were a necessity of the times; it was essential to produce a tremendous volume of writing and printing in order to conduct business, to advertise and find markets for the enormous output of goods that were being produced by all kinds of new machines. Commercial and advertising printing, which had always been a minor factor, now assumed a trade importance far exceeding the printing of books. That artistry and craftsmanship were sadly neglected during the period of great expansion is a fact which may not be overlooked.

The revivals and trends of the nineteenth century were complicated but not too numerous. Of first importance in the English area was the Gothic revival—continuous in its effect throughout the whole of the century. Augustus Welby Pugin and his son A. W. Northmore Pugin are the chief figures to be associated with it; the latter's book, *Glossary of Ecclesiastical Ornament,* published in 1846 in London, is typical of their work. William Morris was also a devotee of Gothic letters and design. The second revival, which started toward the middle of the century, represented a renewed Renaissance influence. To most people, then, the Gothic and Renaissance periods seemed like one continuous development, which could be described with the name medieval. Revived old-style types, therefore, were often called "medieval." The writers to be connected with this second manifestation are Jakob Burckhardt, Walter Pater, and John Addington Symonds. Functionalism, which was started by the Pugins, is of enough importance to be mentioned. It grew out of the conviction that the Gothic was the

150

only truly "functional European style." Transferred by other men to the prob-lem growing out of the clash between art and the machine, it ended as revival-ism—either Gothic or Renaissance. The attempt to resolve this clash may be seen in the work and writings of such men as John Ruskin, William Morris, and Emery Walker. One could almost disregard functionalism except for the fact that it has played such a prominent part in two efforts to reconcile art and the ma-chine. Without becoming too involved in the subject, it is necessary to note that functionalism failed in each instance: due to a misunderstanding of the nature of the machine in the nineteenth century; and, recently, due to a faulty under-standing of the nature of creative art. The machine baffled the first efforts of functionalism because the artists and designers failed to see that industrialism had destroyed the foundation upon which the earlier cultures were built. Func-tionalism held that the purpose of an object must be used as the basis from which to judge it as a work of art; its further concern was with new techniques and ma-terials, simplification, and mass production. Similar theories were put forward in the German area by Gottfried Semper. To the influences already mentioned a whole range of Oriental trends must be added. The expansion of the British Empire and closer European contacts with the East introduced many Oriental motifs and designs—most of them badly or inappropriately assimilated. There can be no doubt that this entire period was imitative and eclectic; the very worst of it lay in the constant attempts to combine elements having no possible relation to one another. One must remember, however, that the artists and designers were bewidered by the visible results of the first accurate examination into the achievements of the great cultural periods of the past.

What has been said, in this broad fashion, concerning art in the nineteenth century, is completely applicable to the letters and types. Since we are not inter-ested in aberrations, much of what was done cannot be shown; however, the major contributions will be explained; and just enough other material will be included to illustrate the general characteristics of nineteenth-century letter design.

Part One. Nineteenth-Century Writing and Letters.

Roundhand and Flourishing:
As has been indicated already, roundhand became the major accomplishment

151

of the writing-master. The first illustration shows the typical roundhand used during the latter part of the 1800's. The letters were drawn from examples written by C. P. Zaner, an American writing-master and engrosser, who was active at the end of the century. Compare this page of roundhand with the Heinrigs specimen in the preceding chapter. A considerable loss of elegance and charm is to be noted; as a matter of fact, the loss of character, the final emergence of an impersonal, sterile letter, could hardly be more clearly shown. Insofar as design is concerned, what was said in Chapter VIII applies to these letters, the angle of slant, the turns, etc. are the same; the differences are in the styling of the letters and in the degree of contrast. It is this rather heavy, matter-of-fact letter that was taken as a basis for numerous script types of the period—types still in use.

Essentially, these were written letters; but for engrossing work—testimonials, diplomas, and the like—the letters were carefully planned and more drawn than written. Scripts used for advertising at the present time are, to a large extent, of the carefully-drawn and built-up variety. This is caused by the necessity of following carefully designed layouts, in which the size, tone, and style of the letters have been expertly worked out; it would be next to impossible to write a line or word that would fit; the lettering artist must draw and render his letters to suit this definite design conception. To be able to draw them, though, it is necessary to understand how they are properly written. An examination of these pointed-pen techniques was purposely left for this final discussion of roundhand and flourishing. The pen, as far as we are now concerned, is of steel. Pointed-pen technique is simple enough: it is impossible to put pressure upon such a pen during an upstroke because it will dig into the paper or spatter; all upstrokes, therefore, are hair-lines; downstrokes of all sorts, however, will take all the pressure that the writer wishes to give or that the pen will stand. The pressure may be varied to achieve wedge-strokes, even-thickness strokes, or the swelling strokes called "shades." The basic pen position for roundhand was that in which the pen pointed to the right; it is an unnatural position, which was usually achieved by bending the wrist awkwardly or using an oblique penholder. These two techniques are shown on page 157. Elaborately flourished initials and flourishes in general were the result of another technique explained by the illustration on page 155. All of the writing-masters, from the time of Van den Velde and Materot onward, employed combinations of these techniques to produce their bewildering and highly flourished initials and pages. Besides the use of various

Roundhand,

abcdefghijklmnopqrstu

vwxyz. 1 2 3 4 5 6 7 8 9 0 .

A N M M N N W Z Z Y

H K I J T F P B

R 2 X Y U S L

G C E O D A N Z

P F F

The typical roundhand used by the writing-masters
and engrossers of the nineteenth century – the breaks
were left to indicate a lifting of the pen.

techniques there must be much reversing or canting of the paper in order to have the sharp pen turn out clean hair lines and shades. All this sort of pen work must be done on smooth, highly-finished paper. Those who wish to understand flourishing and roundhand thoroughly must experiment with the flourishing exercises and the letters, using the techniques illustrated. The intent of such experiments should be a genuine understanding of style; it is not necessary or even advisable to become an expert penman or flourisher of this sort.

The Italian Letter:

This example was based on the Italian Print in the engraved specimen book, *Ornamental Penmanship,* by George J. Becker, published about 1854. In the competition that arose between lithographic artists and the type designers, ornamented letters of every possible sort were put forth; the varieties that are of interest to us being, for the most part, best shown in type designs. As a reminder, however, that many of these styles originated with the lithographic artists, this example of Italian is shown under the heading of writing and letters. It is simply a letter in which the weight has been placed exactly where it should not be according to tradition: horizontally. With the pen held as for the Roman rustica, to which it has some slight resemblance, this letter could be written freely. As used by the lithographers, though, Italian was a stiff, built-up design. As for the name: there was possibly some feeling that in the placement of weight at top and bottom there was some relation to the italian style of script. This letter is difficult to read, a good example of nineteenth-century perversity in letters; it should never be used for more than a word or two to suggest the period.

Round Script:

With the final dominance of roundhand, writing became a sterile as well as a standardized procedure. All sense of the organic design of letters, as they had developed from work with the broad pen, was lost; even the Gothic alphabets to be found in the writing-books of this time show little understanding of the broad pen. About 1875, however, the use of the broad pen was reintroduced in Germany by F. Soennecken. This man was probably more interested in the manufacture of pens than in the return of broad-pen writing—this revival was to come later through Edward Johnston and Rudolf von Larisch. Nevertheless, Soennecken did make a start in this direction; the alphabet that he devised was called "Rundschrift"; it was based upon the French ronde, as a comparison will show (see page 109). Despite the fact that it was not a really good style, it found favor

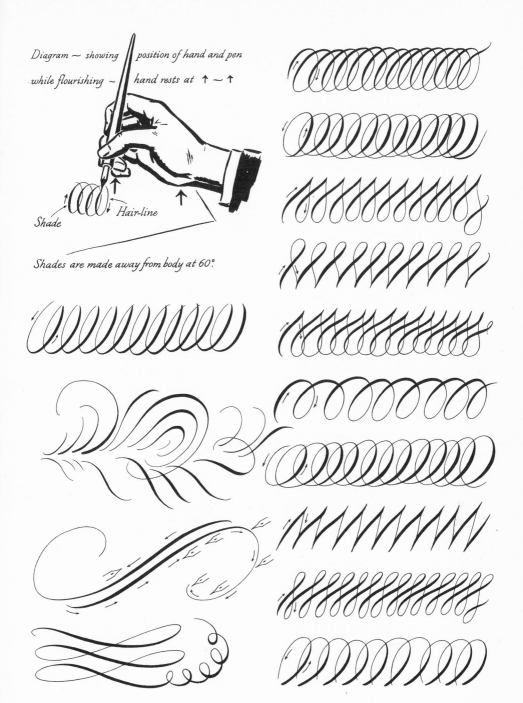

Diagram — showing position of hand and pen
while flourishing — hand rests at ↑ ~ ↑

Shade Hair-line

Shades are made away from body at 60°.

with engrossers, writing-masters, sign-writers, etc. throughout Europe and the United States. It is still in use and affords an example of the manner in which the seventeenth-century ronde may be utilized. The example was freely copied from the work of C. P. Zaner.

There is little that need be added to this brief story of nineteenth-century writing. The craft of the writing-master, or letter artist, had reached a condition that may properly be considered its worst. Under the influence of the Pugins a school of manuscript writers and illuminators was started in England; but it had little effect in raising the level of achievement. It was not until the latter part of the century that the followers of William Morris, Edward Johnston particularly, revived traditional pen styles and sound writing procedure. Although this activity began within the limits of the period under consideration, its effects were not apparent until the early 1900's. It is, therefore, rightly a part of the next chapter.

Part Two. Type Design in the Nineteenth Century.

General Survey:

It has been suggested often that most of the types produced during the nineteenth century were the worst ever designed and cut. Like most general condemnations, this is only partly true. What the critics habitually overlook, as Stanley Morison has pointed out, is that two new categories of type design were to be reckoned with: "job" faces, including display and ornamented type for commercial use; and newspaper type, which does not concern us—being a matter involving the specialized requirements of newspaper production. The manufacture of display and ornamented types, however,—to compete with the fantastic letter designs of the lithographic artists—became a major part of the business of the type foundries. Most of these peculiar creations were made to catch the fickle fancy of the public for but a short time; they were, generally, soon displaced by new varieties. That the designers showed a complete lack of understanding for the aesthetics of the printed page and of letters is unquestionable; the production of types that resembled branches of trees, icicles, flowers, human figures, monumental inscriptions, lettering on ribbons, tablets, grillwork, etc. was a tasteless and stupid enterprise. Nevertheless, ornamented types were produced that are still highly interesting; it is impossible to show more than a few of the hundreds of designs that were made on the Continent, in England, and in the United States. Out of the welter of bad taste and short-lived concoctions there

Pen at angle ~
pointing to right.

Hand turned
unnaturally on
wrist.

Pen also points
to right.

Oblique penholder
allows hand to retain
normal position.

Two peculiar roundhand techniques ~ in order to achieve shades, etc. properly pen must point to right.

A B C D E F G H I J K L M
a b c d e f g h i j k l m n o p q r s t u v w x y z
N O P Q R S T U V W X Y Z

The "Italian Print" — weight is placed horizontally ~ there is a relation to engravers' "italian" script.

abcdefghijklmnopqrstuvwxyz

ABCDEFGHIJKLMN

OPQRSTUVWXYZ:

Round script used by engrossers and writing-masters during latter part of nineteenth century.

emerged several display types that have become, in the hands of better designers, the mainstay of present display typography.

In England, the Gothic revival brought a flood of types based upon all the Gothic styles; they were often badly designed and cut, and overloaded with flourishes, ornament, outlines, and shadows. Most of them were ornamented letters, of course, for use as display types. Few of them were pure styles. The fact that Gothic letters had a great influence upon the production of nineteenth-century ornamented types has been mentioned; a part of this influence may be attributed to the cordial relations that existed between England and Germany at this time. Some of these types, both in England and the United States, were of German origin.

Book types, of course, were affected by the general decline in taste and, beyond one or two examples, the nineteenth-century production is not of great interest. The revival of old-style types is the important fact of the century, insofar as book types are concerned. This type revival was started by the publication, in 1844, by the Chiswick Press of London, of *The Diary of Lady Willoughby,* which was set in Caslon Old Face. Interest in reviving this face had been started as early as 1840 by the Charles Whittinghams—uncle and nephew—owners of the Chiswick Press, and by William Pickering, the publisher. From 1844 onward, however, there was a constant increase in the use, not only of Caslon, but of other old-style faces. The dominance of the fat-faces was broken; various modern types, though, held their position. This type revival affected both the Continent and the United States, reaching its greatest extent in the latter area during the first quarter of the next century.

The last decade of the century saw the results of William Morris's activity as a type designer. Although he was unmistakably more attracted by Gothic style, his type production reflects the two major style revivals of the century, Gothic and Renaissance; the Troy type was based upon the Gothic types of Peter Schoeffer, Günther Zainer, and others; while the Golden type followed Nicolas Jenson's roman face quite closely. Morris's career in the applied arts began about 1870; he designed wallpapers, rugs, hangings, stained glass, etc., and worked at manuscript books and illumination. It is in this latter field that he developed his interest in book production, of which his type design was merely one factor. His conception of the book as a unified design still exerts a great influence upon the designers of books—this, in spite of the general admission that his types are

158

not especially good, nor his books very readable. Morris was the prophet of a new gospel of applied art; and it is in this capacity that he has had his greatest influence.

During his own time, the effect of his work was but slightly felt; but after his death, a whole generation of teachers and craftsmen—especially in Germany—carried on his gospel. This called for the revival of the handicrafts and the restoration of honest and workmanlike practices. William Morris was the prophet of hope for all who loved handicraft and disliked the tyranny of the machine; his teachings have been elaborated and extended by many later writers on these subjects. Morris believed that his goal could be attained by having the craftsman voluntarily limit himself to a small circle of activity. This idea inspired the private presses, specializing in fine editions; and it is the basis upon which many free-lance designers conduct their affairs. However, the clash between the artist and the machine continues, with no sensible solution in sight. Although our interest is specifically in letters and types, it seemed necessary to explain the position of William Morris in relation to the entire field of the arts and crafts. All of the important work that was done in the early part of the next century in letter design was performed by men who, in one way or another, owed a great debt to the inspiration of William Morris.

Fat-Face:

The first page of type specimens shows the major innovations of the nineteenth-century type designers. These three styles have retained their position in display typography; and various new cuttings or varieties are to be found in present-day type design. Fat-face, the first of these styles, was not really a new conception, but resulted from a further increase of the contrast between thick and thin strokes—a logical development of the modern face. The important distinction to remember is that this fat-face was a display type. Robert Thorne is considered to be the designer who developed the fat-face types; the name explains itself. There had been the tendency, from the latter part of the eighteenth century on, to increase the element of contrast; this started with designs by Thomas Cottrell—a type designer who had been apprenticed to William Caslon and who was later Thorne's master—and continued until the ratio of the thick stroke to the height of the capitals was practically 1:2. Thorne took over Cottrell's foundry after his death and became prosperous and renowned in the production of fat-face romans; he even cut one for the French Imprimerie Nationale. To assign accurate

159

dates to Thorne's types is difficult, because the first complete specimens of his stock were issued in 1820–21, after his death, by William Thorowgood, his successor.

Characteristic of fat-face capitals are the following designs: the short J, ending in a round blob; the curly-tailed R; Q, with a tail that loops through the counter; and C, G, and S with their barbed terminals. These blobs and spurs appear on the lower-case terminals also; roundness is emphasized; the serifs of fat-face may be unbracketed or slightly bracketed. Compare the specimen with present-day types of the ultra-Bodoni family. The use of such letters is restricted to headlines and displayed words. Fat-face has been the object of the most violent criticism; but it and its derivatives are still widely favored to achieve definite graphic effects upon the printed page, effects that may be called, properly, "blackletter."

Egyptian:
The second major innovation has been described as the most brilliant typographic invention of the nineteenth century. This letter seems first to have been named Antique, then Egyptian; surely, the great interest in Egyptian culture, which began about the time of the first appearance of this type design, had something to do with its title. There is, moreover, a certain quality reminiscent of Egyptian architecture to be found in the capital letters. Vincent Figgins is credited with creating this style, about 1815. He served his apprenticeship with Joseph Jackson, another of the masters produced by the original William Caslon foundry. The specimen is a Thorne design, but it is representative of the style; it is of interest to note that an italic was developed to accompany the roman of this style. This Egyptian italic was produced by the Caslon firm about 1825.

The notable characteristics of the style are the thick, slab serifs and the general evenness of weight. Again, it must be understood that this is a display, or job type. The manner in which the serifs were solved may be studied in the E and T. In designing the lower-case the evenness of stroke had to be abandoned in such letters as the a, b, d, e, h, m, n, etc. At the joint of the stem and bowls, at the branchings, the rounded stroke was lightened. These letters should be compared with the example of Memphis in the next chapter.

Sans Serif:
Sans serif type was the third major nineteenth-century innovation. Unlike the other two styles, it remained comparatively undeveloped for some time after its first appearance. This first font, produced by the Caslon firm as a display type,

Quousque tandem abutere, Catilina, patientia nostra? quamdiu nos etiam furor is te tuus eludet? quem after
CONSTANTINOPLE
£1234567890

Robert Thorne's Fat-face Roman — from an 1821 specimen issued by William Thorowgood.

Quosque tandem abutere Catilina patientia
FURNITURE 1820

Quosque tandem abutere Catilina patientia nostra? quamdiu nos
W. THOROWGOOD.

Robert Thorne's Egyptian types ~from same specimen as above.

W CASLON JUNR LETTERFOUNDER

William Caslon IV's "Egyptian"~ really the first sans serif type ~from an 1816 specimen.

161

had no lower-case; later, Vincent Figgins seems to have popularized the sans serif style; but it never achieved the fine design that is associated with such types as Futura or Kabel at the present time. By sans serif type one usually means an even thickness letter without serifs, in which the design and relative widths of the capitals are based on the classic Roman alphabet, those of the lower-case more or less on traditional type. There are other types without serifs, but they do not fit within the limits of this description. Compare these letters with the example of Futura in the next chapter; and then examine the gothics (described under Part 2 of Chapter X) to see the difference. Sans serif seems to have been the expression of modernity and functionalism in the 1850's—just as it was in the 1920's.

Lyons Capitals:

In 1846, Louis Perrin, of Lyons, published *Inscriptions Antiques de Lyon,* a collection of Roman inscriptions by De Boissieu. For printing this work he used a set of capitals that derived, largely, from the classic Roman letter, plus a lower-case of his own design; the face, called Caractères Augustaux, was, rightly, much admired. Following Perrin, Théophile Beaudoire, a Parisian type-founder, cut the capitals shown at the head of the second page of type specimens about 1858; appropriately, they are called Lyons Capitals. A medieval, or old-style, face produced by Beaudoire became famous under the name of Elzevir.

These capitals should be compared with those of Albrecht Dürer, in Chapter VII, and with the classic Roman letters, in Chapter II. The Beaudoire capitals have a somewhat greater contrast between thick and thin strokes; Bodoni-Didot influence makes itself felt despite the effort to achieve classic proportions. Perhaps the only letters that one might criticize are the narrow M and the rather weak U. There is a fine severity in the design of this alphabet; it is not just copied from the Roman inscriptional letters, but is a good translation of them into a type design that suited the period.

A Revived Old Style:

Although the Caslon revival may be considered the important event of the nineteenth century insofar as books are concerned, it is not the only event. Both on the continent and in America types were produced that had a decided influence upon the text faces used at the present time. The old-style revival was furthered by the general European interest in the Renaissance. Such letters as the Lyons Capitals are the result of new studies of Roman inscriptions, which was an at-

ABCDEFGH
IJKLMNOP
QRSTUVWX
YZ&

Capitals designed by Théophile Beaudoire about 1858.
They were based on similar inscriptional letters produced
by Louis Perrin of Lyons about 1844.

ABCDEFGHIJKLP
ABCDEFGHKLMNOPRTW
XYZ ABCDEFGHIJKLMNOPQ
RSTUVWXYZ ABCDEFGHIJKLM

ABCDEFGHIJKLMNOPQRSTUVWXYZ A
ABCDEFGHIJKLMNOPQRSTUVWXYZ
abcdefghijklmnopqrstuvwxyz abcdefghijklmnopq
abcdefghijklmnopqrstuvwxyz ab SMALL CAPITALS

The "Revived Old Style" produced by Miller & Richard — Edinburgh, 1850.

tendant factor in the Renaissance revival. The type shown at the bottom of the same page, which was called simply Old Style, is really a modernized Old Style: the old-style elements dominate the design, but they are modified by the introduction of many characteristics of the modern types. A. C. Phemister, who later migrated to America, cut the punches for this face. The style was widely imitated.

This example of Revived Old Style, as it was known in England, should be compared with some of the pages showing the change from old-style to modern types—the specimens of Caslon, Baskerville, Bodoni, for example. It is a light face, but well designed throughout. There is some tendency toward making the capitals even-width; the serifs on the top or bottom cross-strokes of E, F, L, T, and Z are at an angle, as are those of the C, G, and S; a unique feature is the rounded upper-left-hand corner of the B, D, E, F, P, and R, where the bowl or cross-stroke joins the stem; the joint of the T is also rounded; Q is a Baskerville design; and, in some sizes, the arms of the Y meet quite low on the stem. With this letter the Aldine design reached a sort of final state of development in Scotland and England.

Another face produced about 1808 by the same foundry is an ultimate variety of the modern letter. This was a Scotch roman, a type still in wide use today in its original and derived styles. On the whole, it is a modern face with just enough individuality of design to soften some of the perpendicularity and contrast. The noted American type designer, William A. Dwiggins, has combined Scotch roman and the Martin type in an interesting linotype face known as Caledonia.

The Morris Types:
The third page of type examples shows two William Morris faces. A comparison of the specimen of the Golden type with that of Nicolas Jenson in Chapter VI will be the most instructive means of considering this contribution to nineteenth-century type design. Morris disliked the classical and modern types, with their contrast; when, therefore, he decided to design his own type for the Kelmscott Press, he went as far as possible in the opposite direction. Though he based his letters upon those of Nicolas Jenson—using photographic enlargements to study a type like Jenson's and his own—a quality was added that gave his page a darker and different appearance. Some part of this quality was, by his own admission, Gothic; but the main difference lies in the effect of even weight and the slab serifs—factors that make the type look like a variety of Egyptian. Edward Prince

THE ARTS AND CRAFTS OF TODAY. BEING AN ADDRESS DELIVERED IN EDINBURGH IN OCTOBER, 1889. BY WILLIAM MORRIS.

'Applied Art' is the title which the Society has chosen for that portion of the arts which I have to speak to you about. What are we to understand by that title? I should answer that what the Society means by applied art is the ornamental quality which men choose to add to articles of utility. Theoretically this ornament can be done without, and art would then cease to be 'applied'... would exist as a kind of abstraction, I suppose. But though this ornament to articles of utility may be done without, man up to the present time has never done without it, and perhaps never will; at any rate he does not propose to do so at present, although, as we shall

William Morris's "Golden" type ~ about 1/3 larger than original.

From "Art and Its Producers, etc." ~ Longmans & Co., London, 1901.

In his fen-hold had laid down the last of his life,
His soul of the heathen, and hell gat hold on him.
THENCE back again far'd they those fellows of old,
With many a young one, from their wayfaring merry,
full proud from the mere-side on mares there a-riding
The warriors on white steeds. There then was of Beowulf
Set forth the might mighty; oft quoth it a many
That nor northward nor southward beside the twin sea-floods,
Over all the huge earth's face now never another,
Never under the heaven's breadth, was there a better,
Nor of wielders of war-shields a worthier of kingship;

The "Troy" type — from "Beowulf" — printed by the Kelmscott Press, 1895.

165

cut the punches for the Morris types. The Golden type, finished in 1890, was named after the book that was to have been the first from the Kelmscott Press, Caxton's *Golden Legend.*

The effect of this type was to introduce a whole series of romans based upon early Venetian or Roman models. Hitherto, all romans had been either old-style developments—based, fundamentally, upon the Aldus type, which had served as the model for the French designers of the sixteenth century—or classical-modern in design—following the Bodoni-Didot tradition, which was the culmination of a gradual break with Renaissance style, with increased contrast and perpendicularity, hair-line serifs, etc. Of the many types that might be mentioned, Cloister Oldstyle is, perhaps, the best example of a face inspired by Jenson's letter; the example in the next chapter should be studied.

The Troy font was the second of Morris's types—a smaller size of the Troy type is known as Chaucer. The example is included to illustrate Morris's use of initials, his customary way of working—the example of Golden type is not from a Morris-designed book. This Gothic letter was preferred by Morris to his roman; actually it is a half-Gothic style with a certain admixture of schwabacher—one of the reasons for its failure as a good Gothic type design. A comparison with the half-Gothic and schwabacher specimens in Chapter V will provide a good lesson in styling.

Ornamented Types:
One of the best sources of information concerning American typography during the latter part of the nineteenth century is *The Practice of Typography,* by Theodore Low De Vinne, published in 1899; this book was published again in 1914 under the title *Plain Printing Types.* De Vinne is, as the second title indicates, not at all concerned with ornamented types; but he does write, "The excess of display letter shows that job printers buy more than book printers, and that their wants are more cared for." This statement should be a sufficient emphasis of the economic importance of nineteenth-century job types, of which the majority were ornamented, and serve as a dollars and cents reason for the great volume of ornamented type production. English foundries led this production until the latter part of the century; the type-founders of America and the continent were not far behind, however. A recently revived interest in ornamented types in the United States has appeared under the name "Americana"; here, again, is the nationalistic element in the history of letters. A note from the above-mentioned

166

book by De Vinne should serve as a further reminder that nationalism is a poor basis for the history of letters. In commenting upon fourteen men working in the United States about 1899 who, in his estimation, were masters of the type designer's craft, he points out that five were from Scotland, four from Germany, one from England, and four were native Americans. In general, the American and European varieties of ornamented letters were similar; the names, however, differed. Further information about this entire type category is available in *Nineteenth Century Ornamented Types and Title Pages,* by Nicolette Gray— a book that attempts a complete analysis of English ornamented types.

The blocks of specimens at the top of both pages of ornamented types illustrate two important aspects of them: the first set of examples shows types based on the Gothic practice of filling the counters and open areas of the letters with some sort of linear ornament, extension of strokes, etc.; the second set typifies the use of outline or shadow treatment, which was a new and not always successful scheme, particularly when the shadow disturbed the flat design effect of the surface or page. These specimens are representative of the type-specimen books used by American printers of the time; the Hildreth and Fales' Job Printing Establishment exists today as The Hildreth Press, Inc., of Bristol, Connecticut.

A study of the two rows of individual letters along the bottom of both pages will give one an understanding of the basic kinds of nineteenth-century ornamented types. The fat-faces went into many variations, including italic styles and fat-Gothics—the latter almost unreadable, even in large display sizes. Following closely upon these were a number of shadowed and decorated combinations, in which open-face letters were given every conceivable shadow or decorative treatment. About 1830, fat-faces, usually capitals, were ornamented with linear designs, floral motifs, etc., which appeared as white effects when the type was printed. Compressed types, an important class, were really fat-faces reduced in breadth by eliminating the light strokes to a certain extent; terminal serifs became either large, triangular elements, attached directly to the stems or were hair lines. Sans Serif Open is merely an open-face letter of this new variety. Elongated types were related to the Compressed styles, but the width of the heavy stroke, as well as that of the entire letter, was much narrower in relation to the height of the letter. In the Tuscan style we have another dominant variety of nineteenth-century ornamented types. Its main characteristic, in any of its myriad forms, is the splayed or forked terminal. The style known as Grecian is an even-weight, rectangular Elongated, with rectangular counters, slab serifs,

167

A MOST BEAUT
PIGEONS 23
}Circlet

The Way of the wicked
Old King Kowl was
}Maltese

→GREAT✛PRIMER✛GLYPTIC∴NO.✛8←

→✛89✛JOHN ✛ MORISSEY∴
}Glyptic

Arbor Day in Vermont
Ohe Paper King
}Arbor

From "Specimens of Printing Types in Hildreth & Fales' Job Printing Establishment."

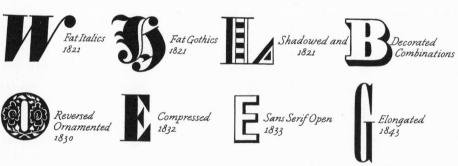

W	*Fat Italics* 1821
H	*Fat Gothics* 1821
L	*Shadowed and* 1821
B	*Decorated Combinations*
O	*Reversed Ornamented* 1830
E	*Compressed* 1832
E	*Sans Serif Open* 1833
G	*Elongated* 1843

Basic English ornamented type styles of the nineteenth century ~ date is that of first use.

SHADED - - 55

Ornamented Extended

THURSDAY EVENING, APRIL 12.

MARY ANN JAWBREAKER 5

}*Ornamented*

GEORGIANNA 12

FANTASY 9

}*Ornamented*

Bean Pot 1

Additional examples from the Hildreth & Fales book — issued 1888 at Brattleboro, Vermont.

 Tuscan 1824
 D *Grecian 1843*
 Ornamented Roman 1843
 R *Rounded 1844*

 Ornamented Tuscan 1846
 N *French Antique 1865*
 Ornamented 1874
 Rubens 1890

Additional basic English ornamented type styles.

and beveled outside corners. All the compressed or elongated styles show, in their perpendicularity, Gothic inspiration. Grecian is a forerunner of the even-weight, sans serif, angular styles known as gothics. The Ornamented Roman represents a whole order of half-and-half types, combining not only Roman and ornament but Roman and Gothic as well. Even lower-case designs were done in this fashion. The capitals are of some interest and use; the lower-case is usually mongrel, in the worst sense of the word. Rounded styles appeared in a great many varieties—squat, tall, shadowed, outlined, etc. The so-called French Antique letter is a cross between Italian and Egyptian. Rubens is another of the condensed letters suggesting Gothic inspiration; it stands for a whole group of types with uncial and half-uncial characteristics. Although this arrangement does not record the multifarious styles completely, it will be found quite inclusive enough for all ordinary purposes.

With the end of this chapter, all the important basic letter and type designs that were ever used within the reaches of western European culture have been recorded or illustrated. Any examination of present-day display type, for instance—aside from the actual revival of ornamented faces—will show that they are based on the nineteenth-century styles to a very great extent. In the final chapter of this history, which follows, it will be apparent that most of the examples, whether of book or display types, are either revivals, copies, or redesigned variations of some earlier style.

The Twentieth Century

Foreword:

The business of this chapter is to explain and illustrate the important develop-ments in letters which lead from the revivals, following William Morris, to the lettering and types in use today. Before proceeding it is necessary to consider style briefly—style, in the sense of the major style periods; not in the highly super-ficial mode sense. Repeatedly, it has been pointed out in this history that the letters used during any given period were characteristic of the general style of that period. The relation to architecture, for instance, is especially obvious throughout all the early history of letters. In the nineteenth century, however, this relation to architecture or general style changed somewhat. For, with the final disruption of the handiwork and craftsmanship culture of western Europe by the machine, style, in its earlier sense, was no longer possible. Now, the de-signs of the merchandise, produced blindly and in ever-increasing volume by the machine, were simply pilfered from all the earlier styles; the design of these products was no longer the result of the artistic creative process, which had been the basis of the work of all earlier craftsmen. Architecture and letter design suf-fered a similar fate—buildings were erected, and types were cut in every con-ceivable style. When one considers, though, that most nineteenth-century design was hybrid—the result of every possible mixture of styles—it may still be said that the letters reflect the general style of the period. Attempts to escape from this state of affairs led to the revivals and the ideas of functionalism already dis-cussed. The revivals provided a certain relief from bad taste; but they were anachronisms at best; and, for all the furore about functionalism, there was little that was really functional. In fact, it was not until the 1920's that some semblance of a style was discernible that seemed again to be general as well as functional. This style grew out of certain aesthetic ideas and art experiments that had been developing from the early part of the century onward; it has pro-foundly affected all the arts and crafts. Our concern, of course, is with the new approach to letters, which is most evident in typography.

The chief characteristic of this "functional" typography lies in the approach, in which the simplest and most natural arrangement of every job is the main consideration; perfect practical and technical solutions are the main objectives. A noteworthy design factor is the abandonment of the traditional centering of all elements on the page or surface; there is, instead, a tendency to line up these elements or groups on the left-hand side. All elements and groups are handled as asymmetrical flat design. Traditional ornament is almost entirely excluded; the traditional types, however, are used within the limits of this conception of style. Sans serif may be said to be the representative letter design; and it is with this design that this history must necessarily close. The future of letters is something one may not think about with any profit; sans serif or the old-style pattern may be the letter of the future—much depends upon the judgment and taste of the people who use letters. As for the general style, however, that seems destined to remain; and the present-day letter designer should bring to his work all possible understanding of, and experience with the style of his own time.

Part 1. Writing and Hand-Lettering of Our Own Century:

Again, it seems best to separate the chapter into two parts: the first dealing with writing or hand-lettering; and the second, with type. The first part of the century witnessed the revival of early manuscript styles. Characteristic of this entire movement, whether under the domination of Edward Johnston, in England, or Rudolf von Larisch, in the German area, was the insistence on writing with the broad pen. It seems incredible that the basic, organic concept of our letters had to be rediscovered; but such was the case. The overpowering corruption caused by pointed-pen usage and nineteenth-century style aberrations had obscured the origin of all sound letter design. Both Johnston and Von Larisch had numerous disciples, whose influence in England and Germany was of great importance in re-establishing, at least among students and designers of letters, an understanding of the value of broad-pen usage. The relative merits of the two schools will be taken up in separate, brief analyses. Insofar as their influence in the United States is concerned, one of the only early indications came from the late Sallie B. Tannahill, who taught for many years at Columbia University. In her book, *P's and Q's*, there is recorded a first interest in Johnston in 1907; and a contact with the influence of Von Larisch while on a trip to Germany in 1912. However, interest in the revival of traditional, broad-pen letters in the United States was

nothing like the enthusiasm that existed, from the early 1900's onward, in both England and the German area of Europe.

The development of what was called "commercial art"—a category including the design, illustration and lettering employed in the advertising, publishing, and printing fields—had, perhaps, the greatest influence upon the lettering produced by American designers during the first quarter of the century. It took considerable time for this kind of art to detach itself from the apron-strings of the fine arts of the period, for its limitations to become evident, and for many of its rules to be worked out. Most of those practicing commercial art from 1900 to 1920 had to learn it in the practice; and any knowledge of lettering had to be gained in much the same way. The almost exclusive method of lettering was the built-up technique. Historic designs were not well understood; and style, on the whole, was bad. Will Bradley, whose work had a wide influence, was among the foremost of the early designers. Despite the tremendous growth of advertising, the situation changed little until after 1920. Lettering books published during this period were—for the most part—the work of architects, who had little understanding of the graphic necessities of this entire field. However, there was a gradual improvement in the teaching of lettering. Men who had made a reputation in advertising art were called upon to teach the principles of page design, advertising illustration, and the proper use of lettering and type.

In the mid-1920's advertising, publishing, and printing in the United States was subjected to what was then called "modern influence." The appearance of most of the advertising, books, and printed matter was changed within a short time. This radical change was the result of European—largely German—influence that invaded the American scene following the 1914—1918 war. Some of the change was brought about by European artists and designers who immigrated to the United States after 1918. It must be understood that the vast mass of work done during this period—up to 1930, perhaps—was but poorly comprehended copying of the beginnings of a new style, mixed with all sorts of historical and regional European style elements. As for the lettering involved: of first importance was the wide and often bad use of sans serifs, gothics, and block-letters; the other major tendency was to use letters with exaggerated contrast and much decoration. This latter use of letters, especially, was called "modernistic"; actually, it was nothing but a continuation of nineteenth-century fat-face and ornamented letters in new concoctions. Obviously, there is little in this particular phase of letter history which is new and requires illustration; practically all

173

of this lettering was of the built-up variety. The great concern was really with overall design of the page or surface; the whole period was one of experiment. Those who wish to see the sort of work that brought about most of this change and experiment may do so by examining—in libraries or private collections—the back-issues of *Gebrauchsgraphik,* a magazine concerned with international graphic art, which was founded in 1924 by Professor H. K. Frenzel, in Berlin. This publication, printed in English and German, was the most influential of its kind—American art directors, designers, etc. subscribed to it and used it as a sort of text-book of "modernism"; its effect was incalculable. Another influential magazine during these years, which, however, had a much smaller circulation and effect, was *Arts et Métiers Graphiques,* started in 1927 by Charles Peignot in Paris. The recent war disrupted the activities of both these publications; *Gebrauchsgraphik* resumed publication in 1950.

The development of the headline in American advertising requires a brief analysis. In the early part of the century, headlines were lettered or set in capitals —it seemed the logical thing to do to achieve importance. Gradually, as it became clear that lower-case letters were much easier to read, the usual headline made predominant use of lower-case letters; after all, the reading of the headline of an ad is vital to its function. For a more informal style, though, the use of italics—both hand-lettered and set—became more and more the fashion. During the 1930's, all sorts of script styles, the roundhand particularly, were revived and substituted for much of the italic usage; the lettered scripts were almost entirely carefully drawn and built-up—following the historic styles closely. In the ten years from 1938 to 1948, the tendency was to use freely-written, brush-scripts to achieve a much greater degree of informality and impact in the headline. Finally, the penmanship variety of script, this also freely-written, was revived. It must be emphasized that the present format of American advertising is the result of much experiment—graphic, optical, and merchandising. The headline is a part of that experiment; there is much about it that is peculiarly American.

The only really new feature in lettering of this half-century is the brush-letter, now used for headlines, captions, placards, etc. There were, of course, brushletters in use before: the sign-writers have always used square-cut brushes and a peculiar, sleight-of-hand technique to paint signs, placards, etc. Although this combination of the carriage-painter's technique, oriental brush-writing, and various technical quirks is still used, it has been much modified by the use of square-cut pens and the influence of sound letter design. Sign-writing style has

improved greatly in the last few decades; some familiarity with sign-writing technique is helpful to a designer of letters for reproduction. The brush-letter that must be considered new is that done with a pointed brush, much in the manner of all oriental brush-writing. Actually, this lettering is a corruption. Since it has achieved such wide acceptance, though, it may be illustrated and explained. Good brush-lettering can only be done by those who have a wide knowledge of letters and great technical ability.

Edward Johnston:

Johnston, as a true follower of William Morris, was interested primarily in a revival of the hand-written book, with all its attendant factors of vellum, reed and quill pens, gilding, hand-binding, etc. A brief study of his handbook, *Writing and Illuminating, and Lettering,*—first published in 1906—will reveal this interest. It is a good book for those who propose to use vellum, cut reed and quill pens; to apply gesso, size, and gold leaf; and to prepare simple, hand-stitched bindings. The section devoted to broad-pen writing, however, was Johnston's important contribution to the art of lettering. Although this section may seem of little interest to the present-day graphic artist, combined with Johnston's influence and effectiveness as a teacher, it became a powerful agency in reviving the use of all the traditional, broad-pen hands, and stimulating a general, new evaluation of letters and types. Even handwriting was affected. It is not necessary, of course, to show examples of the early writing styles used by him; uncials, half-uncials, insular writing, Carlovingian minuscules, the Gothic hands, Humanistic writing, etc., may all be studied in the earlier chapters of this history. In the work of such English letter-artists as Graily Hewitt, A. Eric Gill, and Percy J. Smith, the influence of Edward Johnston has been carried along to the present. His influence in Germany—brought about by disciples such as Anna Simons and the interest of the German government in training design students by the use of lettering courses—was as great, possibly, as in his native country. He had, however, no great concern with the contemporary graphic problems; most of the activity centering in his school was essentially revivalistic, archaic. This aspect of the school constitutes a serious deficiency that no amount of enthusiasm for its many laudable features can quite obscure.

Eric Gill's letters were copied from an instruction chart; they reflect his life-long interest in inscriptional designs. One of the chapters in Johnston's handbook was prepared by Gill; it is concerned with cutting letters in stone or wood

175

and should be consulted by all who are interested in designing for inscriptional purposes. A comparison of the capitals with the classic Roman alphabet will show the following basic differences: the relation of the thick stroke to the height of the letter is 1 : 8, instead of about 1 : 10; and there is a much greater contrast between thick and thin strokes. Letters that vary considerably from the classic designs are the E, F, and L, which are wider, the M, which is narrower, and the wide X. The lower-case letters and the italics, in their contrast and delicacy, are more closely related to the work of the eighteenth-century writing-masters and type designers than would seem possible in a school devoted to reviving manuscript styles. A comparison with the Shelley specimen of roundhand and with the contrast in Bodoni type will reveal this relationship. However, these letters were meant principally as visual aids for students—to show proportion, general design, etc. When written with a broad pen they were bound to look something like the second page of examples. These typical broad-pen letters may be found, in just about this style, in various books by members of the Johnston school. They have become a sort of standard for all teaching of the broad-pen roman and italic wherever the Johnston influence has penetrated. Comparison with the Humanistic writing, with the cancellaresca, and the antiqua and cursive of Francisco Lucas will show their origin and afford a basis for making one's own variations, which are bound to occur in freely-written letters. A broad, steel pen —held as indicated—was used in writing them. It is to be noted that neither the roman nor italic capitals are in the proper size-relation to the lower-case letters; the former are a bit small and the latter a trifle large. The capitals, in general, should be slightly shorter than the ascenders of the lower-case.

Rudolf von Larisch:

"Good instruction in letter design is—aside from its practicably usable results— a specific art-training medium of great value." This sentence, translated from the Von Larisch handbook, *Unterricht in Ornamentaler Schrift,* gives a broad explanation of his ideas concerning letters. From 1905—the year in which the book was published in Vienna—to the present, these ideas and his teaching methods spread, in one way or another, throughout Europe. They have also been used in the United States; but not always credited to their originator. Of course, it is only natural that the theories and instruction procedures of Rudolf von Larisch should have found their most complete acceptance in the German-speaking countries. F. H. Ehmcke, the type designer, has usually been credited

AVMWODC
GQEFLSBP
RKXYIHJT
UNZ abcdefgh
ijklmnopqrstuvw
xyz & *abcdefghijkl*
mnopqrstuvwxyz
1234567890

Capitals, lower-case, italics, and numbers based, with minor changes, upon letters by A.Eric Gill.

AVWM-OQCGD-E
FLBPRS-HIJTU-N
Z-KXY 1234567890
afgstxz ~ocedbqp~
hmnru~klij~vwy

Pen position

ABCDEFGHIJKL
LMNOPQRSTUV
VWXYZ agggfstxz~
ocedbgpq~hmnru~klij~
vwvwyyz 1234567890

Typical broad-pen letters.

with introducing and spreading the Von Larisch ideas in Germany proper.

The difference between the methods of Edward Johnston and those of Rudolf von Larisch are well worth examining. It has often been said that the two men approached the same problem from different sides; but this does not seem to be quite the case. Johnston's entire interest was in reviving the historic writing styles. In doing this he taught the use of the broad pen, introduced sane and simple techniques for producing letters—techniques which dispensed with the whims and arbitrary virtuosity of the "penmanship" school of writing-masters. All of this represented a great service in the interest of sound letter design; the present-day letter-artist must undergo a certain period of exercise with the historic hands if he is to understand letters thoroughly. However, the present-day demands upon the letter designer are not to be satisfied by a mere proficiency in the use of manuscript letters. This fact was recognized by Von Larisch; and he introduced many devices into his teaching program to satisfy the contemporary demands—making this program the most complete and effective that has, up to now, been devised. His chief interest was in developing the creative abilities of students; he tried to help them understand the design value of letters, to have them give their letters and written pages the rhythm and harmonious unity that a good design should have. He not only worked with the broad pen—to achieve an understanding of historic styles—but also insisted upon the use of all sorts of writing tools: the stylus, ball-pointed pens, cork writers, brushes, etc., in order that the aspiring letter-artist might begin to understand all manner of graphic effects. The necessity of selecting appropriate letters to match various types was made clear to the student. Beyond the actual writing or drawing of letters, he demanded their utilization in all sorts of techniques and materials: letters were carved or scratched into plaster or other soft substances, cut into wood, pressed or hammered into sheet metal, etched on glass, cut out of paper, etc. It is apparent that Von Larisch aimed to equip his students with a well-rounded understanding of the use of letters; he even made excellent observations concerning the electric signs of his period. In the endless disputes which occur in the field of letters and types between the adherents of traditionalism and those of modernism the deficiencies of both camps are often ridiculously apparent. The most sensible and satisfactory approach for the present-day craftsman is to be found in some such well-rounded, unprejudiced, unfettered outlook as that of Rudolf von Larisch.

The sort of exercise that Von Larisch advocated as the most helpful to students of letters is shown in the third page of examples. These specimens were produced under the instruction of F. H. Ehmcke, of course, but they illustrate the idea quite sufficiently. The top specimen was done with a brush and the other two with a broad pen. It must be emphasized that all were made directly with the writing tool, without preliminary penciling. The variety of graphic effects that one may achieve is, naturally, infinite; it is exactly for an understanding of this point, and for the ability to maintain any given effect or rhythm that the student must strive.

The Headline:

The next three pages of examples illustrate the use of letters in headlines, titles, etc.; they cover the period from 1930 to the present. If one wishes to study the letters used for commercial purposes during this period one must look at the advertising headlines. It is impossible, of course, to show all the nuances of style. Scripts, sans serifs and brush-letters were the really new factors in the headline; and these styles are shown in enough variety to give the reader a good idea of the general usage and the trend. The capitals, lower-case and italics used for headline lettering in the earlier part of the century are not shown because they were based, to a great extent, upon type designs such as Caslon, Cloister and Bodoni. In fact, the practice of planning a carefully lettered headline to match the type selected for the text matter of an advertisement still prevails.

The first of these three pages shows a progression from the so-called formal script to brush-script. The roundhand, which was the most popular of the scripts, had the greatest influence upon the headline. A variety of roundhand is shown in the top line. In the upright script of the second line one may detect characteristics of the ronde and of broad-pen technique. The third line is an even-weight script done with a speedball pen; its style is that of roundhand. This even-weight technique was often employed to achieve a tone that matched sans serif type. Line four shows another letter suggesting the use of the broad pen; the wave movement of the line fitted the design of the original page. The last line is a brush-script, based upon general script style, but showing the technical peculiarities and limitations of the brush as a writing tool. Lines one, two, and four were built up: carefully drawn and rendered.

The second of our pages shows the use of sans serif letters. These letters, whether they fit the definition in the preceding chapter or belong to the gothic

EIN SONNIGER SOMMERTAG
MITTEN IM SOMMER WAR ES.
DIE HOLLUNDER BÆUME DUF-
TETEN. SIE HATTEN IHRE WEIS-
SEN BLUETEN GEŒFFNET UND

Je mehr wir uns von der Abhängigkeit
von allen ausser uns stehenden Gewal-
ten und Hoffnungen emanzipieren de-
sto mehr wird in uns der Wunsch erwa

ja es sind nun zehn jahre, seitdem diese
gedichte zuerst erschienen, und ich gebe
sie, wie damals, in chronologischer fol-
ge, und ganz voran ziehen wieder lieder,
die in jenen frueheren jahren gedichtet

Typical Von Larisch exercises – done by students at the Kunstgewerbeschule, Düsseldorf.
From "Ziele des Schriftunterrichts" by F.H.Ehmcke, 1929.

Season's Greetings

Colombia Honduras

Caribbean Cruise Liner?

Caribbean and West Indies

of the Great White Fleet

Scripts used during the 1930's ~ reproduced from advertising work, etc. done by the author.

Cruises..
on the

GREAT WHITE FLEET

Weekly Sailings to the friendly Republics

and Islands of the Caribbean

on American Flag Liners

Letters from a poster by the author — showing use of script and sans serif in the late 1930's.

PACKAGING

EXPOSITION

Sans serif letters based on "gothic" type — from a broadside designed by the author, 1946. Note slight concavity of uprights.

family (to be discussed among today's type faces), express the desire to avoid traditional letter designs, to favor a mechanical or constructionistic sort of letter as the expression of our time. Within limits, such letters are most effective. Of course, they must be of the built-up variety, must be given the most careful finish; but need not, as some designers assert, be done with draughting instruments—ruling pen, compass, etc. This question is similar to that concerning constructions for the classic capitals; and the answer is the same: no dependence upon constructions or instruments will replace the highly-trained hand and eye, will be a substitute for the necessary understanding of design.

The last of the three pages of headlines brings us to the present. All of the lines were written freely. The first line shows the result of writing with the broad pen; this practice holds, perhaps, the best promise of a sensible future for freely-written letters, for handwriting in general. Line two can only be achieved with a considerable ability in the technique of the pointed pen; this revival of penmanship seems to lack any future; it is, most likely, a passing mode. The use of the bowl-pointed, and speedball pens, as shown in the fourth and sixth lines, displays the possibilities of an even-weight script or letter. Such usage has severe limitations: the even-weight effect fits with very few types or other graphic treatments; it is monotonous. The position of the pen in relation to the writing has, in each case, been indicated. Lines three, five, and seven are, of course, brush-letters. The brush must be held almost upright; there is no way, therefore, of indicating its position on this page. These examples of brush-letters represent the ultimate in free usage—any further laxity in the designs would result in letters unreadable to the point where their use in advertising would be of doubtful value.

It must be emphasized here that this brush technique is completely foreign to the tradition of our letters; its chief effect is corrupting, insofar as the basic design of our letters is concerned. The trend should be clear to the reader at this point: starting with the built-up scripts about 1930, the tendency was to handle, not only these scripts, but all letters in an ever freer and looser manner. This development is degenerative and must end in corrupt design and consequent illegibility. The only antidote seems to be more use of the broad pen—not so much in a revivalistic way, but merely as a simpler and more dependable writing tool; and, it reminds one constantly of the correct, the sound tradition of our letter-designs.

184

Pink pearl of the West

Gold pearl of the Orient

PEARL OF THE CARIBBEAN—

Silver pearl of the Indies

Pearl-fishers of the Mediterranean—

Pearls of purest ray serene....

House of Beautiful Pearls !

Personal Writing:

Most present-day calligraphers recommend—as did Johnston and his disciples—the acquisition of a formal broad-pen hand for one's personal writing. It may be well to point out again that no current, or everyday, writing is formal; most of the so-called formal script styles and formal hands for personal use are essentially current writing. Only the fact that these scripts and current styles are more severe than the usual handwriting gives them any claim to the name formal; actually they lack completely the qualities of the truly formal styles, such as the Carlovingian, Gothic or Humanistic book hands. The sort of writing that one employs for correspondence, notes, etc. is, and has always been, current; an explanation of everyday writing was given in Chapter II.

Before the widespread use of printing, current writing retained much of the dignity and design of the formal manuscript styles; often, the current hand was a cursive variety of the prevalent formal book hand. This relation may be examined in the earlier chapters and illustrations. The current hands of Gothic and Renaissance times were, of course, written with a broad pen. Manuscript writing came to an end with the invention of printing; and it was only the current hands that survived in the chancelleries and business offices of Europe. It may be advisable to refresh one's memory in this connection by looking through the first parts of Chapters VII and VIII. The introduction of the pointed pen ruined all severe style; and its use has left us, at the present time, with a general writing style that is too often a scrawling, scratching business, as illegible as it is unlovely. It is only natural that the revival of traditional formal styles should have been accompanied by the desire to improve the everyday writing practice. Whether this is a practical endeavor for the great majority of people remains to be seen. Certainly, with a little practice, most people could produce vastly better everyday writing than they now do. The final specimen page of this part of the chapter is inserted as a reminder of this problem of personal writing; it is something quite aside from trade practices, commercial necessities, and the like.

The first example was reproduced from a letter by Maxfield Parrish, who did a great deal of lettering in conjunction with his paintings and illustrations; Claude Fayette Bragdon and Howard Pyle, contemporaries of Parrish, were also noteworthy in this respect. Here is a quickly-written hand, evidently done with a broad pen. It is based, to a great extent, upon the ronde. The sufficient distance between lines is one of the prime requirements for a page of interesting, good-looking writing. Most of us are apt to have our lines close together, allowing

I am afraid I cannot answer your letter
much to your satisfaction. The work I have in
hand is magazine work which I can say nothing
about. I am illustrating "Dream Days" by
Kenneth Grahame — John Lane. My experiences
as an amateur photographer are so very limited
that they contain nothing of interest. I take photo.

Portion of a letter written by Maxfield Parrish in 1900 — from collection of Traphagen School of Fashion.

On the fifteenth of July I began a care-
ful survey of the island. I went up the
creek first. After about two miles the
tide did not flow any higher, and the
stream was no more than a brook.

A current writing hand — freely copied from one of Alfred Fairbank's writing cards.

The next day I went up the same way
again; and after going somewhat far-
ther I found that the brook ceased
and the country became more woo-
dy than before. In this part I found

An experiment in adapting personal writing tendencies to the broad pen.

ascenders and descenders to interlock. This practice leaves no eye-track between lines, makes for difficult reading; the page then has the appearance of a doodled, interlaced pattern. These Parrish letters are of interest, in that they show the use of the broad pen around 1900—certainly preceding the time of Johnston's influence in the United States.

One of the foremost exponents of formal writing hands in England is Alfred Fairbank. The illustrated copy of one of his writing card styles will give the reader an idea of what is usually meant by a formal writing hand. These writing cards were meant as suggestions for developing such a hand; but the suggested styles are too formal for the average person. Stanley Morison, in complaining about the whole Johnston school in this respect, said that "easy, running, cursive hands should be taught, which might be learnt by anybody in a few hours." A comparison between the Fairbank style and the experiment with a personal tendency is of interest. It is by some such method, perhaps, that the letter-artist or the average person may achieve a broad-pen writing style that will not be artificial and will be at once easy to use and to read, and pleasant to look at. The important factor is the personal solution; there may be many such solutions so long as they fit the description given above; that of Maxfield Parrish certainly fits.

Final Notes:

We have, with these final phases of writing and hand-lettering, reached the present; our history, insofar as this part of it is concerned, is finished. There remain but a few points to be discussed and these, from their nature, belong in a few final notes.

It has become customary to refer to all virtuosity, or even ability, with the pen as calligraphy; and, perhaps, this is permissible. There is, though, something indiscriminate about classifying both broad-pen and pointed-pen writing as calligraphy. The two writing techniques were not and are not the same, either aesthetically or technically. Without doubt, the earlier manuscript styles should enjoy the designation of calligraphy—as long as we employ that word, which means simply "beautiful writing." But the arbitrary and, for the most part, ostentatious display of penmanship that developed with the introduction of the pointed pen might well be called just that: penmanship—perhaps pen-showmanship would be even better. The holes in its too often badly-designed pages were filled with masterful but somewhat senseless flourishing. Penmanship, on the

whole, was a pretty sort of thing, full of vanity and sheer dexterity. Of course, the history of any art or craft is full of terminology that is often misleading and incorrect; and, usually, this terminology has become so deeply entrenched that it is not possible to change it. Calligraphy, therefore, is a word to be spoken with much care and precision. One should be certain that the beautiful writing in question is really beautiful and not the mere acrobatic expression of a hopelessly barren style period.

A few words must be written about certain mechanical processes, particularly in photography, which have invaded the domain of the letter-artist. Photostatic enlargements, reductions, reversed effects, etc. are all helpful to the designer who works with letters. Photostats are not only time-saving; but add fresh possibilities.

The process known as photo-lettering is also of importance. It is a sort of combination of the idea of typesetting and photography. Individual alphabets are drawn in all sorts of styles by expert lettering artists; and these may be "set" photographically into words or headlines of any desired size, length, weight, etc. Photo-lettering is a mechanical process, useless in itself unless supervised by persons who thoroughly understand designing with letters. It must be obvious that there will always be necessary adjustments that the camera cannot make. Despite supervision and adjustments, however, the photo-lettered job will always lack the freshness and charm of the individually solved and executed design.

A final note may be added concerning the lettering used for architectural or engineering drawings. For this purpose hard-to-read, savorless, even-weight letters are doggedly retained. When it became impossible to procure enough people to make these mechanical drawing letters with any degree of interest and accuracy, various templet and pattern devices were resorted to. This procedure has helped to maintain a uniformity in the lettering on the drawings or prints issued from any one office; but it has not made the letters any more attractive or readable. Besides, the proper management of these devices calls for almost as much knowledge of lettering techniques as might be necessary to produce really good letters. This problem of letters for mechanical drawings has been much argued; it has not, as yet, been properly solved. To anyone who has worked with such drawings it is obvious that a more direct and satisfactory method of lettering would be highly desirable. Such a method could only be found in the use of freely-written, broad-pen letters. But this is a point for the future to decide; much depends on training given in architectural and engineering schools.

All these mechanical aids, while they may be of great service to industry in getting work done, can never be a substitute for the trained artist or craftsman. He must use them insofar as they are of help in his work; no further. A too great reliance upon mechanical devices, of whatever kind, deadens the spirit. These technological changes and new departures are tools that have exact uses and equally exact limitations; man has always handled tools and these new tools are fundamentally no different from the most primitive varieties. Design is not a product of any set of tools; it is simply the result of the craftsman thinking earnestly about his work. The brain, the eye, the hand, and, above all, the spirit of the artist or craftsman enter into his design; the lettering artist will find his greatest pleasure and surest reward in the use of letters as design.

Part 2. Type Design in Our Own Century.

One might presume that, following the horrible example of the general nineteenth-century bad taste, type design and usage in our own century would have become simpler and less confusing fields of endeavor. Such is not altogether the case. Those who work in these fields are confronted with the largest conglomeration of types ever. The revival of fine traditional styles, which started in the nineteenth century, has continued; but so has the pilfering, the recutting of all sorts of earlier styles. To the beginner, the aspect of typography must be discouraging and bewildering. What must be stated immediately for his benefit is that the majority of these types may be cheerfully ignored; they are passing modes, much as they were in the nineteenth century. The remaining faces, still a large number, may best be handled by some system of type categories; all typographers have methods of their own for recognizing and classifying type. It is thereby possible to bring some order into what must seem, outwardly, an extremely disorderly and disorganized branch of letter design.

No single method of type recognition or classification is here recommended. The typographer or the designer who works with type may have a system which serves him as a memory aid; but it is only his particular way of keeping his tools where he can find them—the tools in this case being the types he has found suitable for various purposes. He certainly does not perform his work by the application of such a system. Actually, all the necessary information for setting up type classifications for oneself is to be found in the earlier chapters. Neverthe-

less, a brief summary of fundamental categories and styles seems desirable. There are four basic type constructions: Gothic, roman, cursive, or italic, and script. These may overlap somewhat in the style sense but not in construction. For instance, there were cursives and scripts in Gothic style; but the Gothic minuscule represents a definite construction. Similarly, the cursive or italic has become an appendage to the usual roman face; but it has really little in common with the roman. This is the particular criticism of Stanley Morison, which has been discussed. Cursive type was once, as we have seen, a self-sufficient, basic construction, in which entire books were printed. Scripts, of course, are characterized by connected or almost connected letters, based upon the handwriting styles from Gothic times to the present. Surely, any sensible classification must start with a Gothic category, which will include the textur, schwabacher and fraktur styles. Half-Gothic may lean toward the Gothic or roman and be so classified. The roman category divides into the types based on early Italian area designs—particularly those of Jenson and Griffo—and the so-called modern faces based on Bodoni, etc. It is quite possible to include a transition style, which is typified by Baskerville. Cursive or italic types divide mainly into those resembling either the Arrighi or Granjon models. The so-called italic done in the manner suggested by Morison is really slanted roman; it has sometimes been called "oblique." The script classification takes in types all the way from Civilité to the present-day advertising scripts. To these four groups, with their subdivisions, may be added the sans serifs as a class; although the gothics and the sans serifs, as defined, vary greatly in style and construction. It is best to divide the class into the constructions based on classic or traditional roman proportions, those based on the Gothic even-width principle, and a third division taking in what might be called block letters. Finally, there may be a class, with subdivisions, which would take in display and ornamented types. Of course, even the most elaborate system will not classify all the nuances, in-betweens, hybrids, etc. of past and present-day type design. The examples shown in this final portion of the history, with the commentary pertaining to them, will carry these suggestions concerning personal memory aids a bit further; beyond this point it is the business of each typographer, craftsman, layout artist, etc. to arrange classifications to suit himself.

Traditional Capitals:
The first page of specimens in this final section of history shows, once more, tradi-

tional capitals in the medium of type. Both these alphabets were designed specifically as capital-letter types, for use in special texts, titles, or as initials. The first —designed by the late Frederic W. Goudy—is a typical Goudy type, characteristic of much of this American designer's enormous output of letter designs and types. Obviously, it is based upon Roman inscriptional letters; the name, Forum, is very well chosen. On the whole, however, this is a somewhat roly-poly design— lacking the severity of its Roman forbears. A letter by letter comparison with the pages of earlier capitals will be instructive. Such factors as the exaggerated entasis in the letters A, V, and W and the squarish character of the rounds are noteworthy. Large serifs are another feature of these letters—the comparison will reveal this. The J is disturbing, in that it has no terminal—looks like a broken letter; the Y design, although it is to be found in Roman inscriptions, seems a bit out of place in this alphabet.

The Weiss initials are based on a definite sort of square capital used in medieval manuscripts. While the Goudy design betrays no underlying technique, these initials show the influence of broad-pen writing. They belong to what some typographers consider a class of calligraphic types. The broad cross-strokes of the A, E, F, H, L, T and Z suggest the turning of the pen as practiced in calligraphy; the even-weight, slightly bowed serifs are such as would be made by a broad pen moving sidewise. O and Q show a flatness in the rounds and the W an irregularity, both of which are characteristics of freely-written, broad-pen letters. A note by E. R. Weiss, in the 1931 Bauer specimen that included these initials, has a final sequence that is of interest: "I wish. . .that everyone would understand. . .that these types fit well into the indestructible tradition of the alphabet designs and yet understand, too, that they are of today; every generation changes the old forms to suit itself, exactly as every generation will again translate ancient Homer. These types are 'modern,' to use this word, which is so often misused, especially for things which by tomorrow are no longer 'modern'—they will serve well for all printed matter, whether it is based on older styles or seeks to establish a new one."

The Influence of Jenson:
William Morris's Golden type inspired the production of quite a few faces based upon the Jenson roman. Some were produced for private presses and others for the ordinary, everyday printer. The former are not available to the general public and may be dismissed without much comment. The Doves type, cut by Ed-

FORUM TYPE CAPITALS ONLY

A B C D E F G H
I J K L M N O P Q
R S T U V W X Y Z

Forum type ~ capitals only ~ cut by Frederic W. Goudy in 1912.

A B C D E F G H I J K L
M N O P Q R S T
U V W X Y Z

Weiss initials ~ designed by E. R. Weiss for the Bauer type foundry, Frankfurt a.M., Germany, 1928

ward Prince for the Doves Press of T. J. Cobden-Sanderson and Emery Walker, at Hammersmith, England, was a fine face indeed; but it consisted of just one size of roman. Moreover, the punches, matrices and entire stock of type now lies at the bottom of the Thames, having been cast there in 1916 by Cobden-Sanderson himself in a ceremonial leave-taking from active life. Bruce Rogers, in the United States, produced the Montaigne type, closely copied from the Jenson letter; but this, too, was a privately-owned face, in one size. Both these types were cut in the early years of the century. Cloister, however, is a practical, workaday type. In a way, it exceeds the effort of Jenson by possessing a good, matching italic. A comparison with the Jenson page will help in studying the design of the roman. The capitals, insofar as they may be compared, follow Jenson closely. Jenson, of course, did not use a J; his Q has a much longer tail; the Jenson designs correspond to the second R and T in the example; and his Z is much wider. The lower-case letters compare favorably all through the alphabet. In studying the italic it is best to check the designs with those of the Granjon and De Colines examples; although the design follows the former, the weight and certain other details are nearer to the latter.

The usual name for Cloister in the specimen books is Cloister Oldstyle. At this point it may be well to indicate that the term old-style is just about as misleading as the word modern. This terminology is careless and inaccurate, but more or less entrenched. Old-style might properly apply to the roman faces developed along the lines of the late fifteenth-century designers. However, it would be much better to refer to them as types in the Aldus-Griffo tradition; that would make some sense. The distinction between these so-called "old-style" types and those in the Bodoni-Didot manner—the so-called "classical" or "modern" faces —is obviously taken care of; it was to make this distinction that the term "old-style" was adopted. Now, the average typographer should have a type-classification system that enables him to keep the old-style and modern types apart without the use of these confusing terms. Classical or modern types might better be called "contrast" types; this term is certainly more descriptive. Cloister is decidedly not an old-style type; it was dubbed so because it was a product of the so-called "old-style revival." Between Caslon and Jenson, though, there is a world of difference. Cloister is, quite simply, a type in the Jenson tradition. Anyone who has followed this history carefully understands letters and types well enough to dispense with such words as old-style and modern, except by way of explaining an out-of-date terminology. Whether these few words of admonition can help in ridding us of this terminology is quite another matter.

ABCDEFGHIJKLMNO

PQRRSTTUVWXYZ

CLOISTER abcdefghijkl

mnopqrstuvwxyzct

AABBCDDEEFGGHIJ

JKLMMNNOPPQRRS

TTUVUWXYYZ

Qu & abcdefghijkklmnopqrsst

tuvvwwxyzct

Cloister roman and italic —
designed about 1913 by M.F.Benton for
American Type Founders Company.

Garamont and Griffo Up-to-Date:

The next specimen page shows the ultimate in the old-style revival: careful renderings of the original Garamont and Griffo types. Beyond this point it is not possible for revivalism of this sort to continue. Such types as this Garamond and the English Linotype Company's Granjon are excellent reproductions of the fine type style developed during the golden age of printing in the French area. The Bembo type provides a faithful rendering of the Griffo trial face; that upon which the French designers of the sixteenth century based their style. Thus the revival, which started in the mid-nineteenth century, is brought to a satisfactory conclusion. It is not necessary to show Caslon derivatives, or new cuttings of Baskerville; their present-day usage has been noted in Chapter VIII, under the history and description of the designers and their types. Bodoni and Martin types, which do not fit into the old-style revival, have also been put on the market in a variety of new cuttings. It is apparent that what started as an old-style revival ended as an indiscriminate revival of the work of all the earlier designers. To the list Arrighi may also be added; his italic was finally revived in several cuttings—the Blado italic being noteworthy.

The Stempel Garamond is a foundry type; such types are set by hand, letter by letter. About the only major criticism to be made of it—both the roman and italic —is that the descenders are too short. A comparison with the Garamond roman and Granjon italic of the Egenolff sheet will show the source of the design. It is to be noted that this italic is a bit rounder than Granjon's.

Bembo is a machine type. For setting books the trade practice is to use the monotype or linotype almost exclusively. Setting books by hand, although it is still practiced by private presses and for limited editions, etc., is a slow and costly process. A review of what was said about the Griffo type in Chapter VI and the Estienne type in Chapter VII will help in studying this design. While Griffo's lower-case has been painstakingly reproduced, the capitals are not copied from any one of the sets of capitals made by him; but are a composite design in the spirit of his type. Lower-case letters of especial interest are the h, m and n, with their slightly curved final stems.

Sans Serif:

The first type in this style was called Egyptian. About 1832 Thorowgood produced a Grotesque and Figgins a Sans Surryphs—the former name suggested a bizarre letter and the latter one that lacked serifs. Grotesk is the definitive name

Qui sequitur me, non ambulat in tenebris: dicit Dominus. Haec sunt verba Christi, quibus admonemur, quatenus vitam ejus & mores imitemur, si velimus veraciter illuminari, & ab omni caecitate cordis liberari. Summum igitur studium nostrum sit, in vita Jesu Christi meditari. ABCDEFGHIJKLMNO PQuQURSTUVWXYZÄÖÜÇ abcdefghijklmnopqrſstuvwxyzäöüçáàâéèêë

ABCDEGFMNPQuRRT

abcdefghijklmnopqrſstuvwxyzäöüe̱m̱ṉṯz

A Garamond produced by the Stempel type foundry, Frankfurt, a. M., Germany, 1925.

TYPES IN THE TWENTIETH CENTURY

The Bibliographical Society, founded in 1892, inc its members two most knowledgeable men repr founders and printing: Mr. Talbot Baines Reed and M Both supported the revived Old Style, and their teac no Modern Face ever being used in books published

Bembo ~ the original Aldine design as rendered by the Monotype Corporation of London, 1929.

for these types in continental Europe; sans serif is favored in England and the United States. Paul Renner's Futura is considered by many to be the best of the sans serif faces. Although—strictly speaking—it may be considered a revival, it really represents the period in which it was designed; it is definitely a product of our own times and techniques. Futura was designed as a book face and serves this purpose well if properly used. When it first appeared, however, it was so misused that its use in books was soon abandoned; instead it became the most popular of the present-day advertising and display types—often under other names. Originally a foundry face, it may now be had on all the varieties of type-setting machines.

Daniel Berkeley Updike, in his book, *Printing Types,* writes, "A test of the excellence of any type is this—that whatever the combination of letters, no individual character stands out from the rest—a severe requirement to which all permanently successful types conform." Futura meets this requirement very well indeed; it is a precise masterpiece of its kind. The capitals are based upon the classic Roman alphabet, insofar as widths and proportions are concerned. "Thick-and-thin" is lacking, though; the effect is one of even weight. Throughout the entire font, nevertheless, there are delicate adjustments of weight in order to avoid heavy spots in the designs. This is easier to see in the lower-case, where the bowls meet the stems. These letters show no underlying, traditional technique—either of broad-pen inspiration or of the graver. Renner believed that there was no longer any necessity to imitate the appearance of hand punch-cutting in a type design—since practically all types are cut by the punch-cutting machine, which will cut any design whatsoever with mechanical accuracy. He felt that the whole of type production and use should be critically re-examined; and that all the non-essentials, which are the result of earlier production methods and use, should be eliminated. Such a process of simplification would then, possibly, lead to a really new and functionally beautiful type style. It was Renner's conviction that the pilfering and copying of historic type designs was a wretched business; not that he was opposed to tradition; but he had very definite ideas about art and the handicrafts in a world of mechanical anarchy. His statement concerning period typography and printing is well worth quoting: "It is not our problem to dress up every literary text in a period costume; we should see to it that this text is clothed in the style of our own time. After all, what we want is living typography, not a typographic theatre or masquerade."

Along with the introduction of sans serif there were presented a few practices

A B C D E F G H I J K L
M N O P Q R S T U V W
X Y Z a b c d e f g h i j k
l m n o p q r s t u v w x
y z 1 2 3 4 5 6 7 8 9 0

Futura — designed by Paul Renner for the Bauer foundry — first used in 1925.

MEMPHIS

hat in der Werbe-Typographie einen

guten Klang. Er bezeichnet eine Type,

die als Ausdruck des Fortschritts, als

neues zeitgemäßes Gestaltungsmittel

bekannt und beliebt ist.

Memphis — produced by the Stempel foundry about 1930.

that, outwardly, seemed new, but that were in reality old. Lining up material at the left is not new; it was practiced by the earliest printers and only abandoned by a later and stuffier epoch, which felt that all things must be balanced on a central axis. There was also much to-do about texts set entirely in lower-case, the capital letters to be dispensed with. This practice was extremely "modern." Actually, this was the general practice in Carlovingian manuscripts, when there was no dual alphabet. The problem of capitals and lower-case is a specific German problem, because of the capitalization in that language of all nouns; and it was from German experiments that the whole idea of using only small letters came to be adopted. During these years at the turn of the quarter-century, the German designers and type-foundries were unquestionably foremost in the development of new and fresher types and their use in a more practical and interesting typography. Both types and typography were widely accepted by American advertisers, designers, and printers; and their utilization is now an everyday matter.

Egyptian:

The Egyptian or square serif types are definitely revivals; they are also definitely display types. Names such as Karnak, Luxor, and Memphis are well chosen; those which suggest modern building construction—Beton and Girder—are questionable, in that this style is a period revival; there is very little that is new about it. None of the Egyptians should be used for text matter; the heavy, slab serifs make them hard to read. However, they make excellent headlines or subheadings and combine well with all traditional romans. They do not combine with sans serif. Some writers on typography feel that the square serif types comprise a special type category; they might better be classed with the ornamented types, for that is their logical place. Compare the Memphis with Thorne's Egyptian, in Chapter IX.

Fat-Face Revival:

Ultra-Bodoni has little to do with Bodoni; it was designed to supply the demand of the late 1920's for exaggerated-contrast or modernistic types. It has already been mentioned that these letters were just a continuation of nineteenth-century fat-face. The immediate inspiration for this design was a fat-face cut about 1870 by George Bruce's Son & Company, an American foundry. A comparison with Thorne's fat-face in Chapter IX will, however, show the original source of the design. It is not as readable as the Thorne face; and could never be used for any-

ABCDEFGHIJKL
MNOPQRSTUV
WXYZabcdefg
hijklmnopqrst
uvwxyz12345
67890

Ultra Bodoni ~ a 1930's revival of Fat-face.
Produced by American Type Founders Company.

ABCDEFGHIJKL
MNOPQRSTUVWX
YZ&$abcdefghij
klmnopqrstuvwx
yz1234567890

Alternate "Gothic" ~ Gothic even-width principle ~ American Type Founders Company.

thing but titles and headlines. Compare the squared-off counters—the white areas enclosed by the designs—in the Ultra-Bodoni with the rounded counters in the earlier face.

The Gothics:

The Alternate Gothics were produced about 1903; they belong to nineteenth century type production. Under ordinary circumstances such types would long since have been discarded in favor of new modes. These gothics, though, have fitted in so well with present-day ideas of typography and with the general use of sans serifs that they are still among the most popular of display types. It is best to retain that name, although it has been much criticized. The style is based on the Gothic even-width principle; but, since these are not actual Gothic letters, the name should not be capitalized—the relation is similar to that between Roman and roman. Alternate Gothic is an excellent type for advertising or job printing. For headlines, sub-heads, etc., this face usually looks best when letter-spaced. Almost any of the traditional roman types may be used as the body face for such ads or printed matter; certain lighter gothics may also be used; but not a type such as Futura, whose style principle is completely opposed to that of the gothics. On the whole, both the sans serifs and gothics have just such italics as Morison would have wished—the normal letters have merely been given a slight slant and are usually slightly condensed.

Punch-Cutting:

Neuland is a capital-letter type, provided with numbers, various symbols, crosses, etc. Rudolf Koch, whose fame as a calligrapher and type designer spread far beyond the borders of Germany, cut this design directly in metal. He became interested in the punch-cutter's problem through collaboration with him in type design and through his own work with wood-cuts. In a preface to the specimen-book of Neuland he says, "This type is made as in olden times by the punch-cutter being his own designer. The shapes have been fashioned directly out of the metal by the tool, without being previously drawn on paper. These shapes are the result of the tool—that is, the white, inside areas of the letters have been, so far as they are not within reach of the file, simply punched; the outer edges have been filed." This method of designing produced a letter remarkably original in its appearance. It has been much used for display work; where a sturdy, wood-cut sort of letter seemed desirable.

LÜBECK-HANNOVER
ABCDEFGHIJKLMN
HAMBURG-BREMEN
OPQRSTUVWXYZ
✚ 1234567890 ✚

Neuland ~ a Rudolf Koch design ~ for the Klingspor foundry, 1923.

ABCDEFGHIJKLMNOP
QRSTUVWXYZ12345678
90Ā abcdefghijklmnopqr
stuvwxyz *It is with type a*
Printing has been called m

Lydian ~ designed by Warren Chappell for American Type Founders Company, 1937.

Punch-cutting, such as produced the Neuland, is not much practiced nowadays. The original manner of manufacturing type started with cutting a punch; each letter or symbol was engraved in relief on the end of a narrow bar of soft steel, just as Koch described the process. This bar of steel was hardened for use as a punch; it could then be driven into copper to make what was known as a "strike," a perfect impression of the character on the end of the punch. The strike was dressed to make a matrix—the depth of the drive, the surrounding metal, etc. all had to be meticulously adjusted in order to fit the mold and make possible a perfect type-metal casting of the required letter, or symbol. Such a casting, when cleaned and polished, is the ordinary type character.

The medieval printers and type-founders did their own designing, cut their own punches, made the matrices, and cast the type. Gradually, all these operations became separate crafts or trades; those who performed them became specialists and knew little about any of the operations except the one with which they were directly concerned. Few type designers could cut a set of punches today. Very often punches are no longer made; matrices are made directly from the enlarged letter-designs by a pantographic process. To Rudolf Koch, however, much of this specialization was a sloppy and unworkmanlike way of doing things; he felt called upon "to educate craftsmen and to alter the present-day working methods." In many ways his approach was similar to that of William Morris. At the Offenbach Technical College he taught calligraphy and the love of letters; about him assembled a group of talented and devoted students who have carried on his gospel. This was a belief in the medieval tradition of craftsmanship, when craftsmen were artists but without vanity and pretension; he felt that the ablest members of society should be willing to use their hands as well as their heads. The likelihood of a revival of this tradition is doubtful; but it appears certain that for all really fine artistic production a love for one's work and a mastery of all its branches remain indispensable. All these things and more were taught and lived by Rudolf Koch until his death in 1934.

Calligraphic Types:
Lydian is a good example of a calligraphic type. Its American designer, Warren Chappell, worked under Rudolf Koch at the Klingspor foundry; and Koch's influence is apparent in this design. All of the Koch types, with the possible exception of Neuland, were based upon writing of one kind or another. Throughout the capitals and lower-case of Lydian there is a definite even-width tendency,

ABCDEFGHIKLMN

abcdefghiklmnopqrstuvwxyz

Meistersinger Schopenhauer

abcdefghiklmnopqrstuvwxyz

1234567890 1234567890

MNOPRSTUWXZ

Nicolas ~ Cochin —produced about 1913 by G. Peignot & Fils, Paris.

ABCDEFGHIJKLM
NOPQRSTUVWXYZ

abcdefghijklmnopqrſstuvwxyz

1234567890

Koch Antiqua — designed by Rudolf Koch, 1922.
Produced by the Klingspor type foundry, Offenbach a. M.

which reflects the designer's fine understanding of the Gothic letter. A comparison should be made with the rotonda letters and Erhard Ratdolt's half-Gothic type in Chapter V. The italic, in the fourth line, illustrates the belief that italic should slant no more than about five degrees; it is, in many respects, just a slanted variant of the roman. What is called cursive, in the last line, is a much more playful pen-letter, quite self-sufficient as a design. Lydian type has proved to be an extremely popular display letter.

Type Design in France:
French types of the first half of this century had little effect outside of France. Stanley Morison has pointed out that the work of all the leading French designers—Auriol, Giraldon, Grasset and, even Naudin—lacks any "permanent calligraphic foundation." Most of the types would not begin to conform to the Updike definition of what a "permanently successful" type should be. Exceptions to much of all this are the Cochin types, the Cochin and Nicolas-Cochin—based, as their names suggest, upon eighteenth-century designs. (Charles Nicolas Cochin was one of the renowned French engraver-illustrators of the eighteenth century.)

The first of these types is a book face. It is not as well known in the United States as the Nicolas-Cochin, which has provided an interesting job-printing letter—useful for pamphlets, folders, leaflets, etc. The original source of this design is not to be found in the earlier chapters of this book, having been derived, not from any earlier type, but from the caption style used by the eighteenth-century engravers. The design was worked out by Gustave Peignot. Ascenders are quite tall. The rugged finish of all the letters suggests the hand-cut punches of the early type-founders—this is a mannerism, which has been adopted by various designers to obtain an antique effect. In this type it is not too disturbing; it has, at least, something to do with the quality of the aforementioned engraved captions.

Antiqua:
Rudolf Koch, who was the modern master of the Gothic letter, also produced a most individual antiqua, or roman. Its origin lies in a written hand developed by Koch in the course of his teaching. Through the initiative of the type-founder, Karl Klingspor, this hand and an accompanying cursive were translated into the type medium. The lower-case, in its tall ascenders, calligraphic ruggedness, and general roundness bears a slight resemblance to the Nicolas-Cochin. Classic

A B C D E F G
H I J K L M N
O P Q R S T U
V W X Y Z a b c d e f g h i
j k l m n o p q r s t u v w x y z 1 2 3 4 5 6 7 8 9 0

Bernhard Cursive — designed by Lucian Bernhard for the Bauer foundry, about 1925.

A B C D E F G H
I J K L M N O P
Q R S T U V W X
Y Z a b c d e f g h i j k
l m n o p q r s t u v w x y z
1 2 3 4 5 6 7 8 9 0 *Trafton Script.*

width relations in the capitals are exaggerated—the narrow letters are quite narrow, with the exception of E and L; the wide letters are quite wide. The entire alphabet has been given a styling that shows evidences of the designer's individuality and exuberance. But the T and g are disturbing—the latter characteristic of Koch. This type and its cursive have been used in the United States under the name of Eve. Although it is adapted to certain small books—poetry, for instance—its greatest use has been in "class" advertising.

Script Types:

Bernhard Cursive and Trafton Script have been, perhaps, the two best known and most widely used script types in the United States. Both were designed for the Bauer foundry—the Trafton in 1933, about eight years later than the Bernhard. Their style and purpose fit in with the extensive use of script, as described in Part 1 of this chapter. Curiously, it was the Bauer firm which most accurately gauged the demand of the American market for a new script type. In introducing the Trafton Script, created by the American designer Howard Trafton, they were extremely successful.

Bernhard Cursive is a well conceived script; the proof lies in its present popularity, long after many other productions of the same period have vanished. It is not based on any one earlier letter; antecedents are to be sought in such types as Bodoni's French Cursive and in a variety of eighteenth century engraved scripts. The whole spirit and flavor of these types and styles have been skilfully combined in a logical, more up-to-date design. Exceedingly long ascenders and tall capitals characterize this type; to avoid great separations of the succeeding lines, the descenders are short. Of course, the use of this script is confined to advertising or matter which is of a feminine nature.

Howard Trafton translated an American advertising script letter into the type medium. This he did so well that, when the type first appeared, many were under the impression that headlines set in Trafton were hand-lettered. In a way, it follows the general dimensions of Bernhard in the relation of the body-letters to the ascenders and the capitals. However, it is a narrower style; and while the round Bernhard is based on an engraved letter, the Trafton is founded on a somewhat freely-written script, such as had come into fashion in advertising work. The earlier script has old-style numbers, those of the Trafton are lining. This difference in the treatment of the numbers is indicative; Bernhard Cursive is, to a great extent, a period type; Trafton Script is pretty much of the present. The latter has, also, a greater range of usefulness.

ABCDEFGHIJK

LMNOPQRSTU

VWXYZabcdef

ghijklmnopqrst

uvwxyzæœfffifl

ft:,!?"""&()123

4567890

Narcissus — designed by Walter Tiemann for the Klingspor foundry, 1921.

IMPORTING BIG SCOOPS

READING JOURNAL

Greco Adornado— from the 1929 specimen book of Continental Type Foundries.

Ornamented Letters:

The twentieth-century designers have continued to produce ornamental or decorative types—not in the profusion of the nineteenth century, but certainly in considerable numbers. In most instances these types are re-cuttings of earlier letters—essentially revivals. Nothing has been added to decorative type-design which could be considered very new. A few of these renderings of earlier faces have been of considerable interest. Narcissus is such a type. It is based upon a letter put out by Fournier *le jeune,* about 1745. This "shadowed" letter is excellent for titles, chapter heads, etc.; it is easily one of the best of present-day decorative types.

Greco Adornado was introduced to the United States about 1924. It is a type of Spanish origin, produced by the Fundición Richard Gans, of Madrid. It is based upon wood-cut technique; and resembles certain shaded letters that were used during the nineteenth century. This type, also, belongs to the shadowed letter class—on the whole, one of the most satisfactory styles of decorative type.

Conclusion:

Since many of the conclusions and summaries concerning the various phases of letter design have already been made at the point where they seemed most fitting, there is not much that need be said at this point of departure. Certainly, the revival of traditional letters and types has been carried as far as possible—that particular road has reached a dead end. It should also be apparent that pilfering or copying traditional letters does not exactly constitute designing—however necessary such copying is for the student or, at times, for the commercial designer. The focal point of present-day development lies, perhaps, in the sans serif types; although the emphasis of present-day design rests rather upon a new employment of letters and types than upon new varieties. As has already been said, one may not think with any profit about the letters and types of the future. Those who work with letters must solve their problems from day to day in the style and spirit of our times; and in as unfettered and practical a way as possible. If this history has enabled the reader to understand traditional letters and types, and made it possible to see their interrelation in the perspective of time, it has accomplished some of its purpose. If what has been said concerning present-day style, functional typography, craftsmanship, practical working methods, and an unfettered approach have been of help, then the remainder of the author's purpose has been fulfilled.

Lettering

Section Two—A Practical Course in Lettering

Chapter XI.

Lettering as Design

Basic Considerations:

The history of writing and letters is visible in the design changes which took place over the centuries; even the lay observer may understand much of this history by examining the illustrations in the historical section of this book, from beginning to end. Throughout this section the reader has been constantly advised to observe the design of the letters and types illustrated; now, in this practical section—despite the concern with materials, tools, techniques, etc.—design will be considered the most important factor in each of the exercises and projects. Unless the student or craftsman has creative design as his foremost intention, he will miss all the pleasure and satisfaction which he might have from his work— lettering will mean nothing more than the performance of a sterile discipline, the following of accepted patterns and routines. Lettering, however, is not an isolated discipline—whenever there is lettering to do there is an ensemble, or general effect, to be considered; lettering must be placed and styled properly; and given the correct tone or pattern on the page or surface. However simple the problem, therefore, a consideration of the layout or overall design is necessary. Actually, lettering and layout are inseparable, the former always entailing the latter. Even relatively poor lettering will seem acceptable if the layout is well-designed—this indicates that design is really the most important factor in all graphic art. It behooves the student or craftsman, then, to approach his work with this in mind; to strive for good design in all phases of his production—the single letter, the word, line, page or surface, or the entire book.

The elements of a page layout are usually three: lettering, type, and pictorial or decorative units. These must be so arranged on the page, or any given surface, that the effect is pleasing and satisfactory to the eye. This means that the lettering or layout artist must understand, not only lettering, but type, illustration, and decoration as well. As a matter of fact, every really good lettering man can arrange type better than many practicing compositors simply because he under-

stands letter and page design. The problem of suiting letters to all sorts of illustration techniques is solved by knowing graphic effects—it is not necessary to be an illustrator, although many letter designers are. Certainly everyone who genuinely loves letters is a good decorator, accomplished in handling flat, or surface, decoration..The preceding, then, is a description of the competent letter designer. One need only consider the work and careers of the great designers of letters of any period to see that this is true; Albrecht Dürer, Geoffroy Tory, John Baskerville, Giambattista Bodoni, Rudolf Koch, and Eric Gill all answer this description in one way or another. The names of dozens of other designers and craftsmen, who are equally deserving of mention, might be added. Of course, this way of working is not acquired overnight—it is necessary to cultivate, to develop, the widest possible background and understanding of art.

There has been, and still is, much confusion concerning the basic nature of lettering and page layout. It should be apparent to all who have looked through the history section carefully that letters were always flat designs—even when they were more or less realistic pictures. A consideration of the page will reveal that when it is used for type or lettering its surface must be preserved in order for it to function properly. In other words, the layout which is used upon it must be conceived in two dimensions, as a flat design. Perspective effects destroy not only the legibility of letters but the function of the page as well. The possible three-dimensional illusion of drawings and illustrations used on a page is not of importance to the layout—they should be related to it just as though they were silhouettes or rectangular patches of a certain tone or color. It is best to mention here the reason for avoiding a few terms throughout this book; words such as "form," "skeleton," and "anatomy," carried over from the plastic arts and applied to lettering can create nothing but confusion. It should be realized once and for all that lettering and layout have nothing much to do with three-dimensional or sculptural form and its terminology. The basic optical fact about every letter is its silhouette or flat design.

Legibility has often been proclaimed as the ultimate aim of lettering and, from the strictly literate standpoint, this is true. As a matter of fact, everybody insists on legibility; and, apparently, they get enough of it to satisfy them. But what they don't necessarily get is good design; all the bad and ugly lettering and layout are the result, primarily, of bad design. When a line of lettering has been properly designed, observing completely the requirements of function, it will be legible. (With those who say that legibility should be the first consideration,

the author will not disagree; but will insist that man's consciousness of design long preceded his concepts of legibility.) If the student or craftsman is to get some fun out of his work, he must approach it creatively, designfully; not by thinking in terms of legibility—no amount of striving for that as such will surely produce an effective and interesting design. But the proper shaping of each individual letter, a skilful combination of the letters into words, followed by the imaginative arrangement of these on a flat surface—as lettering alone or in association with other elements—will not only result in a fine design, but in a legible one as well. This will give aesthetic satisfaction and a heightened effect to the matter presented. Rudolf von Larisch often spoke against what he termed "brutal legibility." The aspiring letter designer would do well to learn to recognize and avoid this brutal quality, which is often to be found in low grade advertising in newspapers.

The Craft of the Letter-Designer:
The designer of letters is essentially a craftsman; and should learn and understand his craft as well as possible. Students often do not realize, when they are attracted by the idea of being an artist, that they must learn an exacting and difficult craft. The letter designer is generally recognized as a craftsman—and where, in this book, he is now and then called an artist it is strictly in this sense. Actually, in trying to be a craftsman, in the soundest sense of the word, one joins the company of the world's greatest artists—who were and are exceedingly skilful craftsmen; and, in most cases, did not and do not care to be considered anything else. Insofar as painters are concerned, it is of value to take issue here with a misleading comparison which is to be found in many essays and books about lettering: this is the suggestion that a page of letters has the same aesthetic qualities as characteristic fine painting—let us say, by Titian. It should be clear, from what has been said under Basic Considerations, just why this idea is erroneous. Such comparisons must surely be made thoughtlessly; otherwise they reveal a faulty understanding of both this sort of painting and of letters.

Naturally, to become a skilful lettering artist it is necessary to develop a technique—the hand and eye must be trained, the use of tools and materials must be learned, and constant practice must be maintained until a professional and salable ability is acquired. When this technical skill has been achieved it is of use principally in carrying out design conceptions accurately and faithfully—it does not in itself constitute a capacity for creative work. Hints concerning technique

215

will be found throughout this section, wherever they seem to fit best. One thing which students worry about unduly is that the fulfillment of arduous and exacting assignments to strict specifications may blight their personalities. This really never happens—personalities come through practically everything. If twenty students do the same assignment, with the same instructions, dimensions, colors, etc., the result is always twenty different conceptions—showing the same number of personalities. The best way for the student to train himself is to work to definite sizes and specifications; a letter-designer's ability comes from doing a great deal of actual lettering to fit definite conditions.

Tools are mentioned and described as they are introduced in the various problems. While most of the basic styles of letters may be said to have been the result of working with one definite tool, the square-cut pen, those who now insist that this is the only tool which should be allowed as the basis for letter-design are needlessly restricting the designer. Actually, lettering for present advertising and the graphic arts should be based on an understanding and use of all the tools available, which include type, various technical factors, reproduction possibilities, and the like. There are right and wrong ways of using all tools, even the lowly but all-important eraser. What the craftsman must have is a knowledge of the exact value and the limitations of each of the implements or devices he uses. The only way to acquire that knowledge is by much use of the tools, many mistakes, and an observant, careful manner of working. Patience, observation, and care are the qualities which must be cultivated; each individual will then discover ways of working and of handling tools which suit him best.

Plan of the Course:
This section is arranged as a series of exercises. The illustrations are really charts or diagrams that show practical methods of working out basic letter-design, and page-layout problems, with as complete and concise a coverage of the field as possible. Written letters, built-up letters, and the use of letters in conjunction with type and pictorial elements are shown in the reproductions. These are restricted to line-cuts; but they represent the lettering techniques and design effects employed to produce the printed page. Both traditional and present-day styles are included. This means the kind of lettering and layout that was and is being used in books, magazines, newspapers, folders, and leaflets. Although the requirements are a bit different from those of the printed page, this also applies to posters, book-jackets, film titles, labels, stickers, packages, etc. Since the em-

phasis is upon design, the built-up letter has been favored—allowing by far the greatest opportunity for complete control by the craftsman of all the elements of his design. The freely-written letter has been treated fully, especially in the exercises devoted to fundamentals—the historical section, of course, depicted and discussed early written letters. Such problems as monograms, trademarks, letterheads, cards and the like have been handled in a broad, general way; any other method is subject to being out-of-date within a short time. All illustrations are accompanied by an explanatory text and, where necessary, diagrams. Tools and materials are listed for every problem. The spacing of letters is treated separately after the first four exercises. Hints of a theoretical or aesthetic nature are to be found throughout; as well as indications concerning those elusive characteristics of good letter-design and layout, such as style, mood, emphasis, rhythm, tone-color, reading speed, etc. In the latter part of the section there are three problems which include text set in type. The progression is from the earlier, traditional layouts to present-day arrangements. Every exercise, therefore, is one from which something may be learned; or that may be used as a pattern. There is enough here on which to found a complete lettering course; students will, however, need demonstrations and guidance in order to master fully the problems and get the most out of them. The trained teacher should have little difficulty in organizing a lettering course, from this material and the historical section, which would fit into any curriculum. Finally, the letter designer, layout man or typographer should find the approach to lettering and layout interesting; and of just as much use to him as the historical section. Workers in other arts or crafts can use what is set forth here by the simple process of subjecting it to the limitations of their particular art or craft. The fundamental interest which the author has attempted to arouse is not one based on passing fancies in letters or current tricks of the trade; but upon the concept of designing with letters and type.

Lettering with the Broad Pen

How to Start:

To work out the first four exercises the following equipment, tools, and materials are necessary: an adjustable drawing table or a drawing board, a penholder and a square-cut lettering pen of the size illustrated, a pad of graph paper ruled in light blue lines, and a bottle of india ink with a quill stopper.

New pens are usually a bit oily and tend to repel the ink; this film of oil must be wiped or burned off—by holding the pen in a match flame for a moment. The pen or holder may be equipped with a reservoir attachment, which is a little spoon- or tongue-like device for holding a small supply of ink—situated either on top of, or underneath, the pen. The illustration shows two types. Inking the pen is achieved by placing a drop or two of ink between the pen and the spoon or tongue with the quill stopper of the ink bottle or a cheap brush—never use a good sable brush. What the reservoir accomplishes is to produce an even flow of ink—it prevents the possibility of a heavy charge of ink coming into contact with the paper, as happens when the pen is dipped. Dipping causes an undesirable effect of heavy, flooded letters succeeded by light, dry letters, as the ink gives out. Pens may be used quite well without a reservoir, by putting a drop of ink into the back of the pen and allowing it to run through the slit—a pen only functions because it has been split and the ink travels along the slit to the point or working edge. This method of inking will work perfectly for the smaller-sized pens, the size necessary for these exercises included; for very broad pens, which need considerable ink, a reservoir is essential. The main idea is to have the ink flow smoothly and evenly through the slit and leave the working edge cleanly as the various strokes are produced. If a globule of ink collects at the end of the pen it will cause flooding and blots—the pen should be wiped clean and inked again; it is also best to wash the pen clean after every use, since dry ink will not only clog the slit and reservoir, but corrosion will set in and reduce the useful life of the pen.

The table-top should be tipped up to an angle of 45 or 60 degrees from the horizontal; the drawing board can be rested against any table or desk and held in the lap at the required angle—everyone discovers the convenient angle. Practically all commercial artists work on a board held in the lap. The proper relation between the surface of the work on the board and the pen is shown in the diagram. This method of working makes it possible to sit up fairly straight and comfortably—and the ink does not run out of the pen too fast. Do not work on a flat table, hunched over the paper.

Light should come from the left—sometimes a front light is also very good. Do not work in the glare of strong sunlight. Left-handed persons should have the light from the right. It might be pointed out here that all of our letters were clearly designed and developed under the influence of right-handed scribes—this does not bar the left-handed student from participating in lettering; but it requires that he develop his own technique.

The paper or pad may be held straight in front of the writer or at a slight cant or tilt of the paper to the left; here, again, practice and experience will determine the best position. For left-handed students the cant, if any, will be to the right. The main objective at first is to be able to make perpendicular strokes without exactly having to concentrate upon them—if the beginner discovers that his uprights have a slight lean to them, he should experiment with a slight cant until they are truly perpendicular. In other words, the slight lean of the normal upright stroke may be overcome by a compensating tilt of the paper.

The beginner should now try a few exercises, holding the pen about as shown; this is the normal writing position—it is familiar to the average individual. Holding the pen at an unvarying angle to the work, experiment with the six simple strokes—inking the pen as already explained. The square end of the pen must, of course, be kept flat on the paper while making the strokes—never turned up on one corner. At first, the pen should be moved lightly over the paper—later, when the letters are more familiar, more pressure may be used. It should be visibly clear that all of the letters in the first two exercises can be written with these six strokes. The differences in stroke width—the thick-and-thin of the letters—are the result of using a square-cut pen in this way. Oblique strokes made from left to right are the full width of the pen; the perpendiculars are not quite so wide. Oblique strokes made from right to left, and cross strokes, are thin because the pen is traveling sidewise in making them. The curved strokes start thin, become thick, and end thin. The student must note the direction of the strokes

in the diagram—this is the way the hand moves normally and, therefore, best. The stroke is always downward or across, from left to right; study the logic of these strokes and the basis of letter design will be clear. After doing a few exercises with the basic strokes the beginner will have enough understanding of his hand and the pen to start on the letters.

Capitals, or Majuscules:

The layout of the page should be similar to the arrangement illustrated. The usual graph paper is ruled in five millimeter squares—approximately three–sixteenths of an inch; all letters must be two squares in height; and two squares must be allowed between lines. The letters in the illustration are about one-third smaller than they will be in the exercise—they have been reduced in the reproduction process. Leave a margin of three or four squares at the top and sides, and five or six squares at the bottom—the exact arrangement will depend on the size of the paper or pad. An even overall tone is just as important in this exercise as well-proportioned letters—study the tone of the example carefully; it will be found to be the result of careful spacing; that is, the white areas between the letters are approximately the same, regardless of the letters juxtaposed. It may be necessary to indicate the positions of the letters lightly wih a soft pencil; but the letters are to be written directly with the pen—no actual pencil preparation of them should be used. Do not spread or crowd letters to achieve an even right-hand margin—this is always naturally and properly uneven in lines of freely-written letters.

As written here, the letters are based largely on the classic Roman capitals, with some influence from such type designs as Garamont and Caslon—freely-written letters will always reflect the personality and taste of the lettering artist. Examine the classic letter proportions carefully on the pages devoted to them in the historical section—check the widths, weights, and serifs. The first line is made up of the triangular letters—observe the slightly varying angles, etc.; line two contains the round letters—the O is the basic round, not quite a full circle; the narrow letters make up the third line—they are all somewhat over half the width of the O, with slight, individual width variations; line four is made up of the letters with midpoint junctures—check the angles of these joints; the letters based on the upright stroke are in the fifth line—H and U are of the same width, not quite as wide as the O. N and Z are the letters which disobey the stroke rule; if the rule were followed, N would have three thick strokes and Z three thin

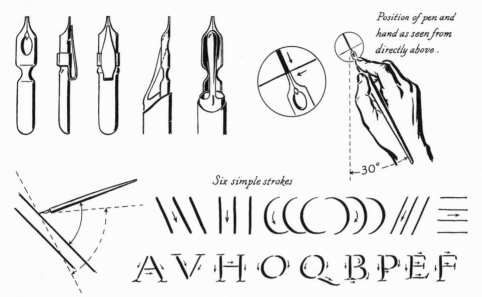

30°

Six simple strokes

\\\\ \\\ ||| (((())) /// ≡

A V H O Q B P E F

Freely written capitals — make the serifs as finishing strokes — without too much fuss.

AVWMAVWMAVWM≈

OCGDQOCGDQOCGD

EFLBPRSEFLBPRSEFLBR

KXYKXYKXYKXYKX

HIJTUHIJTUHIJTUHIJT

NZNZNZNZNZNZNZ

THE ROMAN CAPITALS ·

THE TRAJAN COLUMN·

strokes—neither of them then fitting with the rest of the alphabet. By arbitrarily making the outside strokes of the N light and the oblique stroke of the Z heavy, both letters suit the thick and thin design of the others. The pen must be turned a bit, one way or the other, in order to make strokes against the rule; this is also necessary for the first stroke of the M. Cross-strokes, and the joints of the K, X and Y, are at the optical center of the letter—slightly above actual center. The exception is the A, whose cross-stroke is below center for optical reasons; in the Roman letter the cross-strokes of the F, P, and R vary from the rule for the same reasons. The beginner need not trouble too much about these delicate differences at first; but he should notice optical illusions and learn to cope with them. A few of these will be illustrated and explained in discussing spacing.

As soon as the first six rows of letters have been completed, it will be best to letter several lines of coherent text, in order to practice the rhythm of letters and areas. Allow just enough distance between words so that the break is apparent— the objective is to retain the same tone and general effect as in the first six lines. By trying this exercise a number of times with pens of varying widths some insight into the problem of page color will be gained. Do not throw away practice sheets immediately—not even after an instructor or teacher has made corrections or notes; save them until you understand fully what is wrong with them—in other words, until you can do much better.

Small Letters, or Minuscules:

The first diagram on the second page of illustrations explains the layout of the exercise in small letters; the graduations in the upper left-hand corner represent the horizontal blue lines of the graph paper; all these exercises are based on the standard $8\frac{1}{2}'' \times 11''$ pad. A margin of one or two squares may be left at the top, two or three at the sides, and six at the bottom. It is apparent that small letters need four guide lines: an ascender-line, waist-line, base-line, and drop line. The body of the letters, as typified by a, lies between the base- and waist-lines; the ascender is that part of the stem between the waist- and ascender-lines; and the descender is between the base- and drop-lines. Descenders are usually about two-thirds the length of ascenders. It will be noted that the ascenders and descenders do not interlock in this layout; interlocking should never occur.

Here it may be noted that, while the Roman capitals represent a long evolution from pictures, the minuscules are a development from the Roman capitals. To understand this the student can do nothing better than make a development

afgtsxzafgtsxzafg
bcdeopqbcdeopqb
klijvwyklijvwyklij
hmnruhmnruhmn
afgtsxzafgtsxzafg
bcdeopqbcdeopqb
klijvwyklijhmnru
minusculesminus≈
Name ~ Group No.

abcdeopqabcdeopqab
hmnruyhmnruyhmn
ftsxzzfftstxzftsxzftsx
vwvwyvwvwyvwvwy
abcdeopqabcdeopqabc
hmnruyhmnruyhmr
ftsxzfftstxzzftsxzfts
cursive letters cursive j
Name ~ Group No.

1234567890123
1234567890123
1234567890123
1234567890123
1234567890123
1234567890123
Arabic Numerals
Name ~ Group No.

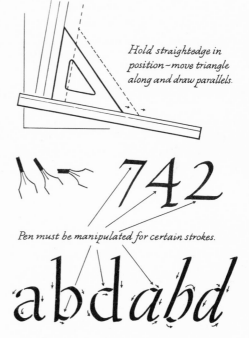

Hold straightedge in
position ~ move triangle
along and draw parallels.

Pen must be manipulated for certain strokes.

Diagrams of typical exercise pages ~ suggestions for planning, pen manipulation, etc.

chart. Such a chart would show each letter in the following progression: first, the Roman capital, then the uncial and half-uncial, followed by the Carlovingian, Gothic and Humanistic minuscules, and finally, the generally accepted present-day letter. In some such exercise as this lies, also, the understanding of many little style elements of small letters.

The arrangement of the lines of letters is once more, insofar as possible, in families. Small letters, however, are not as easily grouped as capitals; they are much more individual—for this reason, they are easier to read. It is possible to read a line of small letters with half of the body of the letter covered; half-covered capitals are generally unreadable. The first line is composed of letters that have little relation to one another or to the rest of the minuscule alphabet. Line two obviously presents relationships of rounds. In the third line the v, w, and y are clearly allied, as are the i and j, k and l being arbitrarily grouped. The final line is one of letters based upon the construction of n; u, aside from the finishing strokes, is the same letter upside-down; r is the beginning of n; m is not exactly two n's—each is narrowed a bit so that the m will not be too wide.

Before proceeding, it would be well to look at the Carlovingian minuscules illustrated in Chapter IV, the Humanistic small letters in Chapter VI, and the "typical broad-pen letters" in Chapter X. A number of familiar type designs also will influence the present-day scribe. This is as it should be; the broad pen will control the production of the letters anyway. Again, it may be necessary to indicate the position of the letters lightly, with a soft pencil; but the actual letter should be produced freely by the pen. Try to keep the lines an even color by leaving about the same area between letters. Note—in the a, b, and d in the lower right-hand corner of the page—the small extra strokes which are necessary for good letter production. Try manipulating the pen slightly. In the last line write some coherent text, keeping the same color as in the lines above. This exercise may be supplemented by sheets of all the historic minuscule designs as mentioned above.

Cursive Minuscules:
The arrangement of the sheet of cursive minuscules is the same as that of the preceding exercise except for the grouping of letter families. In the first line are the rounds, to which the *a* has now been added. The second line is based on *n; y* has been added to this group. Unrelated letters are in the third line. Line four includes the *v, w,* and *y* grouping, with a showing of variant designs. It is best to draw some light pencil guide lines at intervals across the paper—these should be

parallel and not slant more than ten degrees. The illustrated method for doing this is based on the corollary in plane geometry: "If two straight lines are perpendicular to a third straight line, they are parallel to each other." This is a useful practice; and should be incorporated into the lettering artist's technique. In fact, quite a bit of plane geometry can be turned to good service by the designer.

With the slant lines indicated, the page is ready to proceed. Look at the example of the Humanistic cursive in Chapter VI, the examples of cancellaresca in Chapter VII, and the present-day, broad-pen cursive in Chapter X. It is well to remember that the slant should be slight—otherwise the pen will not function properly. If possible, change from the square-cut pen to one with a slight skew to the right—see the pen positions on these three examples. Check the Francisco Lucas stroke procedure (page 91) and that shown in the lower right-hand corner of the exercise page. Try again to manipulate the pen. These letters are condensed; they are much more even-width than the upright small letters; and they should be written closer together and faster. It is quite possible that the pad or paper must be canted to the left to make the strokes come off the pen properly. Write a line of coherent text at the bottom, as shown. Cursive capitals have a separate development; sheets of them and of the various styles of cancellaresca should be written as further practice.

Numerals:

The method of laying out this sheet needs no explanation; both the non-lining and lining numerals are to be written; a line of letters or of numbers may be used at the bottom. An examination of the numerals illustrated in Chapter IV (page 33) is advised. Again, an even overall pattern is the important objective. The pen must be turned quite a bit in making the cross-strokes of the 2, 4, 5, and 7; this is a further example of necessary pen manipulation.

Spacing:

The term "spacing" is not a particularly good one. Present-day use of the word certainly carries the meaning of volume, and of more than two dimensions. Since lettering is a variety of flat design it might be much better to speak of "arranging" letters; and to refer to the spaces between letters as areas. In the following brief discussion of spacing this will be done; it would be very difficult, though, to change the customary, deeply entrenched terminology.

There are almost as many explanations of how to arrange letters as there are books about lettering, The following quotation from Frank Chouteau Brown's

Letters and Lettering is characteristic: "The effect of even color over a whole panel is obtained by keeping, as nearly as possible, the same area of white between each letter and its neighbor; but the shape of this area will be determined in every case by the letters which happen to be juxtaposed." Since the possible combinations run into millions, this is almost like saying that one must trust one's eye or feeling about even tone in the lettered word, line, or page. In the final analysis, that is just about what is done by the trained lettering artist. But there are some systems, rules, and cautions which may be examined briefly.

One method of arranging letters is called the "counter system." The counter has already been defined as the white area enclosed in the letter design; it is, of course, an integral part of the design. In fact the early type founders cut their designs around the counter—this part of the punch being first countersunk by the use of a counter-punch. The origin of the name, counter, is clear enough. This system proposes a balancing of the areas between letters with the areas represented by the open counters. An examination of the first three lines in the illustration on page 227 will explain the idea. Obviously, the shapes of these intervening areas and of the counters will vary greatly; but the actual area—in square millimeters, inches, etc.—should be about the same. The sequence, $a = b = c = d = e$, etc., as shown, provides a graphic illustration of the method; for small letters it works approximately as for capitals, as the diagram shows. Actually, part of the white area—between the letters and in the counters—is not effective; there is a certain amount of irradiation from the black designs, which gives to each letter an optical influence a bit beyond the edge of the design. The effect of this factor is suggested in the diagrams.

The fact that the spacing problem in Gothic letters became a matter of making equidistant, upright strokes has been mentioned. This "stroke system" is characteristic of Gothic style; but a good part of all small letter arrangement—both in upright and cursive designs—depends upon the effect of even stroking. The lettering artist uses a combination of these systems, plus a well-trained eye and taste. The classic capitals are the most difficult letters to arrange; minuscules or—to use the type name—lower-case letters are not nearly as difficult; while cursive letters, or italics, are still easier to handle.

From the foregoing explanation of systems, several general rules may be derived. The area allowed between capitals should approximate their counters; a good basic rule-of-thumb is to neutralize the O—this should never have the effect of staring out of the line like a solitary eye. The same general rule applies to all

AVWMNOJ

CGQSLAIHI

$a =$ Q $b=$ S $c =$ L $d =$ A $e=$ etc.

extra stroke for bracket — ascender-line
waist-line

hmnripbareasq

beak — descender — finishing stroke — base-line — drop line

branching — arch — ascender
hook, lobe, etc. — stem — counter

Land of Smiles ≈

bowl — Serifs made by turning pen. — swell

Optical line-up.

AOJY
CVIT

YOUR NAME

YOUR NAME

John Baskerville

John Baskerville

How to scale a drawing.

small letters. Between words, a break of one full o is usually sufficient; between lines a minimum distance at least as great should be allowed. Of course, lines of lower-case or italics should never be planned so that ascenders and descenders could touch or interlock. Lines of capitals may be brought closer together—they then give a strong, horizontal decorative effect.

The cautions concern optical illusions—optical effects in general. All design is subject to certain misleading or distorting effects; the eye, while it is a wonderful organ, is not perfect enough to make allowances for such effects. In these instances the trained designer will make an almost intuitive adjustment to satisfy the eye and banish the distortion or illusion. A few of the usual trouble spots in letters must serve to illustrate the point; these are to be observed in the two lines of capitals and in the so-called "optical line-up," explained in the next paragraph.

All of the round letters, C, G, O and Q, will seem smaller than the other characters in a word of capitals unless they are extended a bit above and below the guide lines. The letter S is often subject to this rule, although less so than are the wide rounds. If the bottom of the J is not carried below the guide line, it will seem too short. The points of the N, V and W should also be carried slightly below the bottom guide line. When the A is styled as a pointed letter, the point ought to be brought above the guide. The optical principle involved is that in which a round or point never seems to be on the line when it merely touches, or "kisses," it; to be optically on the line it must go through it. The letter I should usually be allowed a little more area on each side than is allowed between the other letters in a line. There is a tendency, since I is so narrow, for it to appear squeezed. The outside legs of the M must be spread slightly in order to avoid a bow-legged appearance, the strength of the V-shape causing this distortion if the legs are exactly upright. All these cautions concern capital letters; but, when the same or similar designs appear in the lower-case or italics, they are equally affected. The "optical line-up" is a visual representation of how round, triangular, or overhanging letters may be optically lined up; the principle explained above functions here also.

Scaling a Drawing:

Students usually need name cards for use on their desks, portfolios, lockers, etc.; these may be lettered in capitals, lower-case, or cursive. Note that the name is placed above the actual center of the card, at the optical center—a bit higher. It

is suggested that the cards be made 3″ × 5″, which is the size of the usual file card; and that the dimensions and position of the lettering be arrived at by enlarging one of the examples on the page, in the manner shown in the diagram. It is best to do this on tracing paper. This method of enlarging or reducing a drawing in proportion is very useful in all phases of art work and should be learned early. The underlying principle rests upon the simple geometry of similar triangles; the rectangle of the example is placed in one corner of the working size, which in this case is 3″ × 5″; but, which may be established at any convenient point along the diagonal. All dimensions are brought out to the side of the smaller rectangle and carried from this point to the side of the large rectangle by a line from the common corner of both rectangles. Guide lines may now be put in and the letters laid out; the large layout will be exactly in proportion to the smaller. All the dimensions of even a complicated drawing may be enlarged or reduced in proportion in this way; the use of the diagonal is also the simplest way of checking drawings or photographs for reproduction size.

The Colophon:
The word colophon is of Greek origin; it has the general meaning of a finishing stroke. This device was used in both manuscripts and printed books before 1500, when the title-page began to appear. Our interest, however, is not so much in the history of the colophon as in its usefulness to the lettering artist or designer of the present. A bit of observation in the field of printed matter will reveal that this device is still widely used; it is the basis for endless layout and display ideas; it is simply a method of putting the message into a shape or pattern which will interest the eye. This shape or pattern must not be arbitrary; the copy or text will always fall naturally into some arrangement, which can then be more skilfully designed.

The layout of the colophon problem is explained in the diagram and the lettered text. Draw the center line lightly; construct the triangle; and, for the lettering, draw a series of very light pencil guide lines, one-eighth of an inch apart. All of this may be done with a T-square and triangle or with a ruler and triangle; the parallel horizontal lines may be drawn, after ticking off the even eighths, by using the method of drawing parallels previously illustrated. Be sure, though, to get the layout square on the paper.

When the guide lines are in, indicate the divisions which will contain the bodies of the lines of letters. The body of the first line will be in the second di-

vision; that of the second line four divisions below—and so on. Between the bodies of succeeding lines of letters there will be one division for a descender, one clear division, and one for an ascender. Indicate the text lightly with a pencil of medium hardness; do not cut into the paper with the pencil—the surface of the paper must be smooth to assure clean pen strokes.

This is a smaller letter than any yet tried; try a few lines on tracing paper in order to become familiar with the rhythm of small writing. The chief objective once more is to keep an even overall color. A square-cut pen with a width about one-fourth the height of the body of the letter is required—in this case a pen one thirty-second of an inch wide. Write the letters freely; do not dip the pen; maintain a definite speed and rhythm.

The floret at the bottom must be drawn carefully and painted in with a pointed brush. Keep it far enough away from the line of lettering so that the two do not make an optical union, or seem to be connected in some way. A tempera color should be used; in this case it may be made with a tempera white and a bit of some strong coloring agent such as prussian blue or vermilion. Try to match the overall tone of the lettering—otherwise the decoration will not suit the letters. Tempera color should not be thin and washy nor should it pile up in ridges; in the first case it will be too thin; in the second, too thick. The perfect tempera will brush out flat and smooth—and dries with a velvety finish.

The Placard:

The freely-written placard is one of the most widely-used ways of conveying information. It may be handled either in an informal or in a formal manner. The placard illustrated is of formal design, based on a central axis; a colophon idea, which assumed a vase shape. The layouts in these first two chapters of lessons are mostly formal—they may also be called traditional. Dimensions for this layout are given in the diagram; the dimensions for the lower-case and italics indicate the body of the letters; ascenders and descenders should require no explanation. The large O starting the italic section is an initial; it has been included in the dimensions. Remember that capitals are not quite as tall as the ascenders of the lower-case.

Before proceeding with the layout of the letters, it would be best to review all exercises in the three styles—capitals, lower-case and italics. Indicate the letters lightly in pencil; work from left to right, judging the centering of the lines as well as possible. If necessary, work out each line on tracing paper and center it

The COLOPHON was used at the end of early printed books to give authorship, publication date, printer's name, etc., the function later taken over by the title-page. General-ly set in geometric shape, the co-lophon is still a most use-ful device to the mo-dern designer.

$3\frac{7}{8}''$

divided into even eighths

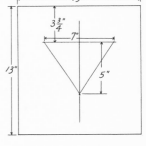

Layout for colophon exercise.

KNIZE
TIES

they're all Silk - - -
for Town and Country Wear

Original designs in Exclusive shades
- - -cut on extra-generous lines
Knize-tailored - - -

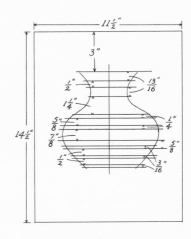

Layout for placard.

later, while tracing it through. Do not score the paper during the pencil preparation. A plate, or vellum bristol is best for this placard. A pen of the same size as used for the exercises will do for the capitals; for the last two sections use the next smaller size; this is done so that the last sections will not seem darker than the capitals—the overall tone will be even. Write freely; try to produce a crisp and clean appearance about the entire job. The little marks of the ellipsis are made by turning the pen, so that the horizontal stroke is broad. Make several additional placards of your own design, taking copy from advertising or other placards.

The Manuscript Book:
One of the best methods of learning to use letters and types is to write a manuscript book. Such a project must be worked out gradually, over a period of time; only the general outline of the project and a few of the problems it entails can be explained here. Of course, the choice of a text may vary, as well as the format of the book itself. However, the remarks made here will be based on the book pages shown in the illustrations; these pages are $8\frac{1}{2}'' \times 11\frac{1}{2}''$; the book was made up by a binder, with board covers and a linen backbone; the paper should be fairly good—it must stand up under preparatory work, inking, and erasures. For a manuscript of eight or nine pages, a stapled book of sixteen pages with a cover of heavier stock is quite adequate; this may be made in the same way as the booklet described in Chapter XV.

With the book prepared, the choice of a text is the next step; this must not be too long. In order to check a short essay for suitable length one must first count the number of characters in a line, including punctuation and the breaks between words. Multiply this figure by the number of lines in the essay; this will give the approximate total number of characters. The average number of characters in a line of the manuscript page shown here is forty, on the page six hundred and forty; it should be easy to reckon how many pages the essay will require in its written format. All books must be planned in this way. A line of forty characters is considered ideal, about twenty-seven is the minimum and around seventy the maximum.

The layout of the pages is the next consideration. Book pages, with few exceptions, are never considered singly. Facing pages are always regarded as a unit; the margins—top, side, binding and bottom—are then worked out for the best overall effect. The diagram at the bottom of the page shows the proportions of

In the 18th century, France offers one of the most striking examples of an age reflected in the work of its painters. No era can be said to have exalted the quality of charm more than did this one. Love of pleasure and elegance, an easy morality, were pictured with a taste that was at best discriminating, at worst artificial. The paintings by Watteau, Nattier, Boucher, and Fragonard are representative of the period.

The latter part of the 18th, and first half of the 19th centuries might well be known as the age of portrait painting. In England, the work of Reynolds, Gainsborough, Romney, Angelica Kauffmann, Raeburn, Lawrence, and others, preserved for us the

5

$7\frac{7}{8}''$

Layout of a text page for a manuscript book.

How to fill and use the ruling pen.

A
HISTORY OF
PAINTING
~
Student's Name
Name of School
1949

$7\frac{7}{8}''$

$5\frac{1}{2}''$

Diagram of a title-page.

$8\frac{1}{2}''$

3

5 2

6

$11\frac{1}{2}''$

Diagram of facing pages ~ showing proportion of the margins.

A
HISTORY OF
PAINTING

All

1

Diagram of page one.

these margins to one another. These are proportions for de luxe editions; for ordinary books, the side and bottom margins are somewhat smaller. It is apparent that these proportions are interdependent; they will need certain adjustments in each individual book design. In working out a book according to the dimensions given here it is best to start with the title-page. The outside dimensions of the border correspond to those of the text block; it is clear that if the rectangle is laid out carefully, and the corners perforated, the succeeding pages will be marked for the text block. It will then be necessary only to connect the perforations with a light pencil line.

A blank fly-leaf should precede the title-page; titles are always on a right-hand page. It may be designed somewhat in the manner illustrated; the layout is accurate in proportion; the borders, decorative elements, and date should be in tempera color. The pen used for lettering the title will, of course, be larger than that used for the name, school, etc.

Page one will be the right-hand page following the title. It may be handled as illustrated, with nine lines of text. All the text pages should be carefully ruled with light pencil lines, one-eighth of an inch apart; there should be exactly sixty-three even divisions on the full page. These divisions must be ticked off from a ruler laid along the side of the text rectangle. The body of the letters of the first line will be in the second division; the body of the sixteenth line will be in the next to last division; the method of placing the sixteen lines is the same as that used in the colophon. It is best to mark these divisions lightly with the number of the line. A strip of paper, with the length of forty characters marked off on it, should be tried on the original essay or a typewritten copy of it. This trial will show where the manuscript lines will end—bad word breaks should be avoided by either packing the letters or opening them up a bit. Of course, all the preparatory work should be done lightly with a medium hard pencil; do not mar the surface of the pages.

The actual writing of the manuscript should be done in a methodical way, the pace, rhythm, stroking, etc. being about the same throughout. Every effort should be made to keep the page color even. The pen must not be allowed to become encrusted with ink; inspect it after every page; wash or wipe it clean as necessary. Keep some water handy to irrigate the slit by dipping the point of the pen into it. Learn to keep a piece of paper under your hand at all times; this prevents smearing your pencil preparation and keeps perspiration and body oils

off your job. This hand paper may also be used for trying the pen after each ink-ing—before using it on your manuscript.

A few words should suffice to explain the use of the ruling pen as illustrated on page 233. Although the lettering artist may not need it often, he should know how to use it expertly. The pen may be filled with the quill of the ink bottle stopper or with a brush; learn to carry out chores such as these with the left hand. Ruling pens may be employed with tempera color as well as ink. It is essential that both blades of the pen rest on the paper; then the ink or color will flow out between them in a sharp, even line. Consequently, the ruling pen must be held upright, as shown. The width of the line is controlled by the thumbscrew; this should be held outward. In filling the pen, be sure that no ink or color is left outside the blade at a point where it might come into contact with the T-square or ruler. If this bit of liquid comes into contact with the straight-edge it will, through capillary action, lead the whole charge of the pen under the straight-edge. Draftsmen take precaution against this by always wiping the inside blade of the pen after filling it. The outside borders suggested for the title-page should be drawn with a ruling pen; the heavy border is made by ruling outside guide lines and then filling in with a brush.

By the time the beginner has completed a manuscript book he will know a good deal more about freely-written letters than when he started. Throughout this chapter additional work has been suggested as a means of increasing knowl-edge and ability; and it would be advisable to make several manuscripts in dif-ferent styles, as a means of becoming more familiar with the problem of han-dling text. A manuscript poem is an excellent project. Be sure to use the method of basing the text width on the longest line; carried-over lines are thereby avoided. Poetry should also be lined up on the left; indented lines make reading difficult and, except in certain instances, should never be used.

It would also be of great help to the student to look at early manuscripts; one always discovers valuable things in them—designs, pen usages, overall effects, etc. Most libraries or museums in the larger cities have at least a few manuscripts which are on display at various times or may be seen privately by the individual or the class. Facsimiles of manuscript pages are available in book form; and may be studied when it is not possible to see originals.

Lettering with the broad pen is really writing; it should be done freely, quickly, and with the greatest attention to design. The pen should be used with-

out great pressure or effort. It will control the production to a certain extent; but there is nothing to prevent the artist from experimenting and considering design throughout each job or project. The qualities of good lettering are in design, legibility, and individuality. If one size of pen does not satisfy, try another; if one letter does not suit, select another. The pen may be manipulated to produce almost any desired arrangement of strokes; one must know at all times what is going on at the working end of the pen—feel this as a sort of second nature. The only way to attain mastery is by doing a lot of work.

Built-Up Letters

Their Importance:

The built-up letter is one which is carefully drawn instead of written. There has been much discussion, even controversy, concerning the relative merits of freely-written, and built-up letters. Certain aspects of this have already been touched upon, particularly in the comparison of the Johnston and Von Larisch schools. Most of the disagreements result from a lack of understanding on the part of individuals of one phase or another of letter design. Both freely-written and built-up letters have their place; the competent lettering artist will have a mastery of both practices and a fine taste in the use of each.

Built-up letters have always been in existence alongside written letters; all in-scriptional writing—Egyptian hieroglyphs, Roman capitals, etc.—is essentially built-up. Lettering for architecture must be carefully planned and drawn before it is cut. Type designs also are almost entirely of the built-up variety; only the earliest types were copied from written letters. Whenever it is necessary to work within the limitations of a definite design conception, the letters must be drawn instead of written; the result, in whatever medium, is just a careful rendering of this drawing. In written letters the tool has a great deal to do with the final result; tools and technique, in built-up letters, are employed solely to realize a conception.

It is understandable that freely-written letters do not, in most cases, work well with type. Their best use, of course, is for manuscripts, documents, testimonials, etc.; but they may be used for a wide variety of printed matter, where little or no type is involved. Wherever type is important in the design of the page, letter-ing which is to appear with it should be of the carefully-finished, built-up kind—styled to suit the type. The designer who uses lettering in conjunction with type must give preference to the built-up letter.

Lettering which does not, in some way, make a graphic unity with the other elements in a layout is certainly not well chosen. Since almost any graphic treat-

237

ment may be reproduced, printed pages show a great variety of graphic effects. Art directors use all the techniques within the limits of reproduction to tell the story or solve the problem presented by a specific job; the lettering artist must be able to work out the lettering suggested in the art director's layout; the necessity of obtaining exactly the same effect, style, size, etc. has been mentioned previously. The built-up letter is the only solution for practically all such jobs. In the series of exercises which follow, the basic practice of using built-up letters will be thoroughly explained; it will be apparent, however, that one cannot be a purist in this matter of freely-written, versus built-up letters—much preliminary work must be freely-written, while most final conceptions will be carefully drawn.

Built-Up Capitals:

It is best, in learning built-up technique, to follow the same procedure as in the written exercises; that is, to work with the capitals first; then with the lower-case and italics. The capitals are, of course, the basic letter; arranging a line of capitals is also the most exacting of design problems. The dimensions given for this first exercise are rather large—purposely so, because small-size, built-up letters are too difficult at the start. Illustration board or kid-finish bristol of the size given, tracing paper, several pencils, HB, 1H, 2H, and a flexible, pointed pen are necessary for this exercise. The pen should be of the Gillott 170 or 303 types; these are English pens, but American equivalents are available.

The real beginning of any job such as this is in a so-called layout, or rough sketch; the suggested sketch at the top of the page solves some of the problems of color and the grouping of the letters. Such a rough may be made in ink, color, or pencil. In advertising art, much of the rough layout work is done with pencils of various sizes, from the ordinary variety to graphite sticks. The chisel edge, as illustrated, is used exactly like the broad pen—the square stick of graphite or chalk works in the same way.

A tracing of the sketch is then drawn more carefully. Most of the refinements are carried through; letter and stroke widths are checked with a bit of paper as shown; this "ticking-off" process is a necessity for the beginner. When all the letter-spacing and styling have been settled on the tracing, the job is ready to be put on the final surface. The back of the tracing paper must be rubbed with a soft pencil or any finely-ground, non-aniline chalk; this should then be smoothed with a swab of cotton; all excess is thereby removed and the coating spread

INVENTORY

Sketch~made
with broad pen
or chisel-edged
pencil.

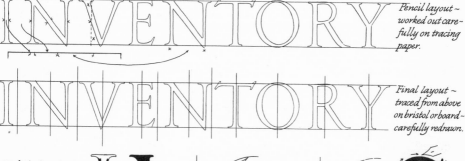

INVENTORY

Pencil layout~
worked out care~
fully on tracing
paper.

INVENTORY

Final layout~
traced from above
on bristol or board~
carefully redrawn.

Method of rendering
built-up letters ~
filling in as one goes
along ~ in order to
check weights.

Outlines are made by
following the line ~
really a succession of
short, connected strokes.

Varying pen position indicates turning of paper to suit hand.

Placard ~
in built-up
capitals.

INVENTORY
SALE

3"

1 15⁄16"

1 3⁄8"

15"

4" approx.

20"

239

evenly. By following this method a good, even tracing is assured; and there will be no smearing from the excess graphite or chalk.

The tracing must next be placed exactly in position over carefully drawn guide lines on the board or bristol. These guides should be square on the rectangle of the job. Trace the work through accurately, with a hard pencil; but do not score this final surface. After a careful redrawing with a fairly hard pencil, the layout is ready for inking; this redrawing should correct any faults caused by a slight shifting of the tracing; the drawing should also be somewhat more accurate than was possible on the tracing paper.

A flexible, pointed pen is the tool most used for rendering built-up letters for reproduction; this pen is charged with ink by dipping it. The technique of this rendering depends mostly upon the "followed," or built-up, line, which is explained visually in the illustration. This is a controlled line; it is made, in most instances, by drawing the pen toward one; the paper must be turned to suit the convenience of the hand. Review the normal strokes in the first exercise in Chapter XII. Clean, smooth edges are made by building them up with a succession of short, connected strokes; the pencil drawing must be followed with absolute accuracy. When working on a left-hand edge one keeps that sharp, allowing any unevenness to fall within the letter; although it may seem difficult to the beginner, the operation is reversed for a right-hand edge—without any change of pen position or paper. Do not outline an entire word or line first and then fill in the letters. This is a faulty method, which does not allow a check of weights and color as the work progresses. Each letter should be finished as one goes along; any deviation in tone should be noted immediately and corrected in the final retouching of the job.

Retouching, whether in black or white, should be kept to a minimum. There is generally something to retouch, however; imperfections in the paper cause unevennesses; a bit of fuzz may spoil the pen line; a stroke may be ever-so-slightly narrow or wide. Often, most of the retouching may be done with lampblack and a small brush with a good point; where it is necessary to use a bit of white, try to apply it so that it cannot be noticed. If there are blots or smears, let them dry thoroughly; and then rub them out carefully with an ink eraser. When the ink is out, finish with a softer eraser. The surface of the board is preserved by this procedure; and one may usually draw and render again over the erasure. Never scratch out anything with a razor blade.

The final factor in this exercise is the decorative spot. Here the layout returns once more to the colophon idea: the finishing stroke. A good scheme is to take one of the zodiac signs and redesign it to fit this particular job; it must be worked out as a horizontal shape. Plan this on tracing paper. Attempt to suit the thick and thin relationship of the design to that of the letters. Paint trial designs on a bit of tracing paper and test them in position, choosing a suitable tempera color, about half-way in tone between white and black. Do not place the design too close to the letters; each element on a page needs area around it. When a visually satisfactory result is obtained, draw the design on the board and paint it in the chosen color; there should be graphic unity in the exercise, if all of it has been carefully and sensitively done. Graphic unity depends upon the technical and stylistic correspondence of the various elements to one another.

Built-Up Lower-Case:

The second exercise should be done entirely in tempera color, using a brush instead of a pen. Only the size of the bristol board is given; all other dimensions may be obtained by scaling the diagram. Follow the same method of preparing the final drawing as described in the first exercise. It may be best to copy a type face or the Eric Gill alphabet from Chapter X.

When the lettering is ready for rendering in color, the first task is to mix a suitable tempera. It should be light in tone; any dark color on white bristol will look like a black. When choosing the color for the letters, have in mind a second color for the decorative spot; one which will harmonize with it. Tempera color should be of a definite consistency; to obtain this consistency requires some practice. One must also keep this consistency while working, by dipping the brush in water and stirring the color; otherwise it tends to thicken and sometimes separate.

The brush should point well; and must be held about as shown. Rendering built-up letters with a brush is a somewhat faster process than with the pen; some lettering artists prefer the brush. However, the competent craftsman can work with the pen and brush equally well; both have their special uses. The principal reason for holding the brush upright is that one can thereby see all around the point and follow the penciling with great accuracy. It is also necessary to manipulate or "roll" the brush slightly between the fingers in following curves. Brush rendering needs to be demonstrated, as do all the techniques de-

scribed in these exercises; but the various teaching points cannot be stressed verbally too often.

The spot presents somewhat the same problem as in the first exercise. It should be worked out as a flat design, not an illustration. Try to relate it to the letters. It should be noted that in these layouts the bottom margin is about thirty per cent greater than the top. This larger bottom margin must be maintained on formal pages or any formal rectangular area; it is an optical necessity.

Built-Up Cursives:

For the third exercise in built-up letters, cursive letters or italics should be used. Everything which has been explained concerning preparation applies to this exercise also; there is no need to repeat it. Copy one of the cursive types for style; the initials are swash capitals. Use guide lines to control the slant. This is a pen letter. Be sure that the a's, u's, and e's are alike; the top of g should be like an a; n must resemble u in width; c must be related to e. Letter design is a fairly logical activity in many ways, once one has a thorough understanding of history and style.

This time the spot is based on the styling of the swash capitals; it must be a horizontal design to suit the shape of the work size. The individual should choose one of his initials and try to style that as suggested in the illustration. This decoration is once more in tempera; turning of the work is indicated by the various brush positions; the brush, however, permits more pliant movement than the pen.

The Lettered Poster:

This project, done entirely in built-up letters, is a good test of the beginner's ability to retain even color and to achieve a graphic unity. The three styles, which have been used separately in the preceding exercises, are to be combined; they will be worked in ink, with a pen. A border composed of letters is to be the chief decorative element; this will be in tempera. It is best to start with the border; and base the contrast and style of the other lettering upon the effect of this border.

The bristol should be at least three-ply, since it must stand considerable handling. Bristol comes in single weight, two-ply, three-ply, etc.; the heavier weights are made by pasting two, three, or more single sheets together. One learns to know the weight simply by handling the board; but it may be established by

Thomas
Jefferson

Placard — in tempera — using lower-case letters and spot.
Built-up letters done with a brush.

Brush
must be held
upright.

Hand rests
on little finger and
pisiform bone.

$11\frac{1}{2}''$

$14\frac{1}{2}''$

August
Clearance

15″

20″

Placard ~ built-up italic letters ~ rendered with a pen.

Manner in which initials may be designed as decoration →

243

examining the rough edges of the full sheet, where the number of sheets pasted together will be evident. The size given here is one-quarter of the standard sheet of bristol board.

The border is 5/16″ wide and its outside edge is 11/16″ from the top and sides of the board; the bottom margin must be 1″. For a panel such as this, the traditional proportions of the margins are something like 11:7:5—bottom to top to sides. This relationship may be had, if desired, by a slight adjustment of the border. The important thing to remember about the relation of dimensions like these is that they should not seem to be divisible by one another.

The decorative effects that may be obtained in the border are almost infinite, according to the style of letter used to make it. A few suggestions have been shown, to give some idea of these. Perhaps the most interesting material is to be had from Gothic letters. In any case, copy some style of capital carefully; try to keep an even tone in the border; this is pure decoration, and one may forget legibility. In working out this border, the ornamental value of letters should become apparent; the whole problem of arranging the letters, as will be seen, is fundamentally one of design, not legibility.

With the border finished in a tempera color, which should be light in tone, the four lines of text may be laid out and finished in ink. Dimensions for these lines should be scaled or reckoned from the diagram. It is to be noted that the bottom margin is larger than the top; this is optically necessary for material placed within a border. Keep the tone of each line related to the entire job; the first two lines may dominate, but should not jump out of the job. All of the styling—serifs, finishing strokes, relation of weights, etc.—should be in keeping with the effect of the border. The last line should be at least ⅜″ away from the border, at each end—otherwise it will attach itself optically to the border. While working on these lines the border should be protected; the whole job may be covered with a tissue and then a window cut in it close to the border.

The spot must be worked out in the same way as those in the preceding exercises. It may, however, be a bit more elaborate. Size and placement should be copied from the diagram, with the spot upright this time. The color and graphic effect ought to harmonize with the border. The exercise, when finished, should have a quiet effect; no one line or element catching the eye in an annoying or disturbing way.

BACH PALESTRINA HÄNDEL

BRUCKNER

BRUCKNER

BRUCKNER

BRUCKNER

Suggestions for border ~ note design effects.

ORGAN MUSIC

on the Wanamaker Organ

BACH PALESTRINA HÄNDEL

BUXTEHUDE VIVALDI BRUCKNER

SCHUBERT VERDI LISZT FRANCK

During the Holidays, 4-6 P.M., Old Building

MOZART HAYDN WAGNER

14½"

11½"

Diagram of poster ~ using capitals, lower-case, and italics ~ border and spot in tempera.

14½"

11½"

Organ Music

Masters of the 18th Century

rganui

Gothic minuscules were designed, and must be used, according to the concept of evenly spaced strokes.

Gothic Cursive

Diagram of placard ~ using built-up Gothic letters ~ cursive designed to suit top line.

MOZART HAYDN WAGNER

Two exercises in which the effect of letters used as design is apparent.
Outside border is in scale of the poster.

245

Built-Up Gothics:

Both exercises on this page deal with letters predominantly as design. In this Gothic letter exercise the first line should be finished and then the second line related to it. A review of Chapter V is recommended. The work needs to be written with a broad pen, studied, traced, redrawn, and rendered. It is to be rendered in ink on bristol board.

The first line may be done in textur, schwabacher, or fraktur. According to the style used, the design of the cursive will change somewhat; try to keep the same color or general effect. Here again, it is evident that the design factor is most important in the arrangement of letters. Note the optical line-up of both lines at the left.

Designing a Card or Letterhead:

This is essentially a personal problem. Since the elements will vary greatly in every case, only the general outline of the procedure can be given. The name, address, etc. should be black and the decorative material in tempera. The first step is to decide the size of the card or letterhead and cut some "dummy" sizes. A dummy is simply the preliminary physical representation of the surface and make-up of any matter to be printed—the name is almost self-explanatory. Since the diagrams are based on a $4'' \times 2''$ card, dummy cards may be cut to this size— out of thin bristol or drawing paper.

Place one of these cards under tracing paper and work out your ideas with ink and color; shift the card and make as many sketches as you have room for, always working within the area of the card. The beginner, especially, should work for effects directly; he is not competent to judge whether a sketch in pencil will look the way he wants it, when printed. The ability to visualize comes only through doing a great deal of work in many mediums; then one knows what can be done, what to expect. Even so, it is always best to work out printed matter on actual sizes in the colors to be used; and, in most cases, with the actual paper stock. Penciling is almost always an intermediate or a preparatory operation, and should be so regarded; whenever penciling a job think of the finished rendering, not of pretty pencil marks. Try to envisage the completed job. Of course, penciling must be clean and exact; but it is not an end in itself.

When a satisfactory sketch has been obtained, make a dummy or comprehensive sketch of the card or letterhead. Work this out very carefully, so that it

The Black Cat Bookshop
353 East 56th Street, New York 22, N.Y.
Telephone PL 9-4859

How to design a business card or letterhead in one or two colors.

← A satifactory comprehensive sketch is first developed ~

This is enlarged and finished carefully as a reproduction drawing

Enlarging Methods

1. Photostatic
2. Pantographic
3. Camera lucida
4. Projection
5. Scaling
6. Dividers
7. Proportional
 squares, diagonals

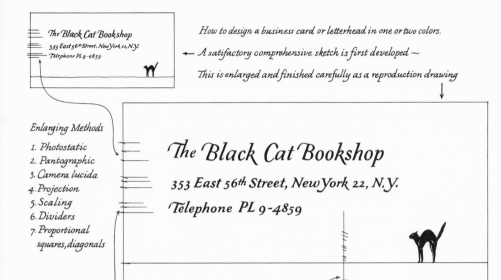

The Black Cat Bookshop

353 East 56th Street, New York 22, N.Y.

Telephone PL 9-4859

Scaling method of enlarging is indicated by retained points, etc.

Exercises in the use of two or three initials in a cipher or monogram.

Even-weight expanded

Freely-written capitals

Broad-pen script

Even-weight condensed

Condensed lower-case

Freely-written minuscules

Even-weight - light

Extreme contrast

represents exactly what you would wish to have the printed job look like. This completed, the next step resolves itself into an enlarging operation. The competent designer makes use of all the enlarging methods listed alongside the diagram. Each of these processes and procedures has special uses; the beginner should investigate as many as possible. It is necessary to enlarge the card because one cannot work conveniently in such a small size. Most work for reproduction is drawn larger than printing size and reduced in the reproduction process by photographic means. The usual working size is (1) twice size or (2) one-half larger than the desired reproduction. This project has some rather small lettering in it, though, so it is best to enlarge the comprehensive three times.

Any enlargement or reduction of a design necessitates adjustments of areas, weights, etc. within the design. Notice this while making the pencil layout for the final drawing. If this drawing is to be used for reproduction, the elements which are in color should be drawn in black also; the color is indicated on a tissue flap placed over the drawing. The photo-engraver follows this flap for the color break-up; he makes one line engraving—or line cut—for the black and another for the color. The student ought to learn as much about reproduction as possible; most drawings for commercial purposes are subject to some limitations of reproduction. These limitations should be learned early and all drawings conceived within them.

The Monogram or Cipher:
This exercise is also a personal one, since it involves the initials of the individual. It seems a small project; but to relate two or three letters in this way is one of the most exacting of design problems. The monogram may be defined as a grouping of letters in which the basic strokes of one or more of them also serve as the basic strokes of the others. The cipher, however, is merely a grouping of letters; they may be interlaced or reversed; but each letter is complete in itself. The examples shown are just a few of the possibilities; they represent certain directions in which one may proceed. What the beginner should examine is the relation of black and white areas. These must be interestingly balanced, no area seeming tense or cramped, nor any one area empty or too black. The design needs to be resolved and at rest. Basic symbols of all kinds are a subject for study here; one of the interesting books of this material is *The Book of Signs,* by Rudolf Koch.

It is best to sketch directly with ink. The sketch that is accepted as final should be enlarged to 3″ in height, and carefully redrawn and inked. This exercise is closely related to trade-mark design; and might be followed, depending upon the course, by a trade-mark problem.

All of the exercises in this chapter are similar to practical jobs that are done every day. The individual who intends to specialize in letter design ought to look at the printed matter and advertising he sees about him; and try to work out problems based on this material. Get to see originals by professional artists and designers; note the crisp, clean appearance, the meticulous finish. It is this particular look that the aspiring artist must learn to impart to his own production.

Exercises in Script

How to Begin:

Script is a special style and must be handled separately. Its revival and use in present-day advertising oblige the lettering artist to understand its history and practice thoroughly. Before proceeding with the exercises in this chapter, a review of the history of script is recommended—the first parts of Chapters VIII and IX, and that section of Chapter X which deals with script headlines, are especially of interest.

The best way really to understand script is to write it. Beginners should try broad pens in various sizes and with varying skews; just by writing quite informally, a good understanding of script may be gained. However, a definite study of the historical styles will help more. Experiment with writing in the manner of the last example of Gothic current writing, in Chapter V; then try writing based on the mercantile hands in Chapter VII. After considerable practice it will be apparent how the first two lines on the first page of exercises were done. Examine the pen position, and the width of the pen compared to the height of the body letters; then try to write something similar.

Following a good deal of work with the broad pens—at least enough to be able to manipulate them easily and lightly—exercises with the pointed, flexible pen may be undertaken. A review of the description of flourishing and roundhand technique in Chapter IX is necessary. A few flourishing exercises and some practice in holding the pen and canting the paper will be most instructive. At the start, a pen of not too flexible or fine a quality is best—a Hunt 99 is excellent for this purpose. Of course, all of this work must be demonstrated; and many of the finer points explained during the demonstration.

The first essential is to cant the paper to the left, so that the bottom of the sheet is at an angle of 20 degrees to the horizontal. The paper must be smooth bond or bristol. Lacking an oblique penholder, the pen must be pointed to the

Work with the broad pen ~
Try various styles

Write freely.
Become familiar with all
possibilities of the pen.

Flexible~pen writing is more diffi-
cult ~ pen must produce clean, even
strokes

Pen must be held in the indicated relation to strokes.
Check pointed-pen technique in Chapter IX.

A variety of bowl~and
ball-pointed pens should be
tried

The plate of the ball- and duck-billed
pens must be kept flat on the paper at
all times regardless of stroke or movement.

$11\frac{1}{2}''$

$14\frac{1}{2}''$

Broad-pen headline ~
Pointed, flexible pen
Even weight strokes
Ball-pointed psn, etc.

Diagram of
exercise in
freely-written
scripts.

right; this combination of canted paper and pen position will enable one to produce a fair, pointed-pen script. According to the size of the writing, the whole arm, forearm, wrist, or fingers may be employed in achieving the strokes. The hand will rest on the first joint of the little finger and the pisiform bone. A uniform slant is vitally necessary to a good script; the angle of slant is more or less a matter of individual preference in free writing. Spacing or arrangement, of course, should be even; the problem is no different in script than in any other style. Clean, even strokes and a meticulous appearance are characteristic of this kind of writing. As the illustration shows, all downstrokes are made with pressure; all upstrokes are light. This alternating application and release of pressure produces the characteristic shades and hair lines of flexible, pointed-pen writing.

On the whole, these letters—if at all large—are more drawn than written. Both sides of the o, for instance, must be made downward, as must the loops on top of b, l, f, etc. The tops and bottoms of the stems may be squared off by retouching. There is a definite, measured rhythm to the stroking; the pressure must be relaxed at the bottom of each heavy stroke; and the stroke turned, full and round, into the connector. The turns at the top of the stems should correspond to those at the bottom. Such connectors as those to the m, n, r, and y must be kept at the general slant of the letters; all other connectors are at another common slant which has been called the style line. In many instances the pen must be lifted from the paper and the next stroke connected from the opposite direction. As much of this writing should be produced as is necessary to acquaint the individual with most of the mannerisms, conventions, tricks, etc. of pointed-pen script.

The final lines on this page of exercises are even-weight scripts, done with ball- or bowl-pointed pens. Various styles and different pen sizes need to be tried. The student ought to collect good headlines or titles from current magazines and use them as a basis for his own work. Several exercises in freely-written scripts may be worked out, according to the layout shown in the diagram. The graphic effect of each of the pen techniques becomes quite evident.

Built-Up Script:
A headline in built-up roundhand is the subject matter of the next page of illustrations. The procedure is the same as for all built-up letters: a sketch is first made; then a tracing-paper layout; and, finally, the pencil layout for the rendering is done on plate- or vellum-finish bristol.

so rare

Freely written sketch.

so rare

Careful pencil layout.

so rare

Inking stems, ascenders, etc.

so rare

Inking shades.

so rare

Hairlines connected – details added.

Stages of working out a script headline.

Pen used with ruler for straight lines.

Side of pen rests on edge of ruler.

Position of hand & ruler – side view.

Pen position remains normal – paper is turned.

What is so rare . . .

Diagram of finished headline — placed nicely on bristol.

$14\frac{1}{2}''$

Rendering built-up script is one of the most finical of jobs; the letters require that neatness and studied elegance which has been mentioned; and one must go to some pains to achieve these qualities. Some designers believe that the straight uprights should be ruled; the method of doing this has been illustrated; it is something of a knack, and has to be demonstrated. The swells or shades may be put in next—built up about as shown in the diagram. Finally, all light strokes and hair-lines are added, the hair-line, it may be emphasized, being a followed or built-up line. This method is close to that employed by the copperplate engravers; for them, however, it is almost a necessity, since they use different tools for the various strokes. The pen artist may suit himself about his inking sequence, provided it achieves the desired result.

To produce good script of the kind called "formal" or "severe" requires much practice and experience. The student must be thoroughly familiar with one good roundhand alphabet and his technique equal to the exact rendering that is necessary. This state of affairs, of course, is not reached overnight. Again, it is essential to study the headlines in use in current magazines; copy them; get expert criticism of your work.

For most script rendering an extremely flexible, finely-pointed pen—such as the Gillott 290 or 291—is used. Do not drop such pens as these to the bottom of the ink bottle when dipping them; the slight impact may ruin their fine points, making them worthless for further use. The craftsman must try all the fine pens and choose those that best suit his hand and way of working. These pens, too, are to be kept clean; even while working they should be dipped in water occasionally and cleaned with a pen-wiper. Any bit of cloth will serve, provided it does not leave lint or fuzz on the pen.

Brush-Script:
The final illustration in this chapter shows a few simple exercises; and suggests an approach to brush-script—the pointed brush is the type meant. It must be stated again that this brush has nothing to do with the entire development of letter design in western culture. Pointed-brush usage is corruptive—not at all suited to any of our letters. However, in order to make good brush-letters—according to the present mode for them—the artist must have a complete understanding of style and a complete control of the brush. The idea that such letters are easy to make has been fostered by those who know little about letters and, possibly, less about the brush.

254

Brush Scripts

try the brush /// ≋ ~

((())) ||||| Þ ¢ ɗp ,

SS vvvv WWW :

⌣⌣⌣⌣⌣⌣⌣⌣⌣ Try simple

capitals and minuscules A B C

E F G H I J K L M N O P

Q R S T U V W X Y Z

& – a b c d e e f f g g h i j j

k l m n o p q r r s s u v w x y z

Try the simple exercises suggested, keeping the brush quite upright. This method of holding the brush has been illustrated in Chapter XIII (page 243). Make the strokes as uniform as possible. When you feel that some control and understanding of the brush has been achieved, try the letters. The limitations of the brush will become apparent. Its direction, for instance, cannot be changed except by first lifting it and allowing the hair to re-form; any attempt to force it will result in the brush sliding or slapping, making a blob at the attempted turn.

Brush-letters, like all freely-written letters, will show the handwriting characteristics of the artist. It is not possible for two people to do brush-letters that are alike. The beginner should collect brush-written headlines; and try to do something similar. These headlines, however, are rarely written down as quickly as they seem to be; they are almost always the result of considerable experiment and many trials. Often, they are made by pasting together the words from several different trials. Of course, as long as the headlines are being reproduced this does not matter; a good deal of skilful retouching may also be employed to obtain a desired effect. For display purposes, the letters may remain somewhat faulty, as long as the general effect is clean and fresh.

The corrupting influence of brush-letters has been noted. Beginners must guard against having their ideas of basic design influenced by brush usage. Learn to employ the brush; but make it produce as good letters as possible, within its limits. Bad design is not only illegible but uninteresting.

It must be apparent to anyone who examines the scripts produced at the present time—whether freely-written or built-up—that there is great individuality among craftsmen. The student, however, should learn good, basic design first; individuality, although important, is secondary—it will be achieved in the course of time.

Chapter XV.

Problems of Integration

Layout Exercise:

Lettering, it has been said, is rarely used alone. Almost always, there is the necessity to integrate it into a page with other elements. Not only the graphic effect of these elements—type, decoration, and pictures—but, often, the literary and psychological effect must be taken into consideration. The lettering must reflect the general style, mood, and intention of the page. This is a problem of design in the fullest sense; such a problem cannot be handled by one who does not understand page layout thoroughly. The illustrations in this chapter deal with a few fundamental considerations of integration; it is not possible to give ready-made formulas for solving such problems—only an approach is suggested.

The diagrams at the top of the first page of illustrations for this chapter merely outline an exercise, or a series of exercises. The project might be called an exercise in taste or a matching problem; it consists in arranging a piece of type matter, a headline or title, and a small illustration, design, or spot; so that the three elements make a unit. Each individual, of course, will achieve a different result—even if the type matter used is the same. The three excerpts at the bottom of the page may be used as suggestions. The beginner should look at current magazines and note the great variety of ways in which such problems have been solved.

The first step in working out this design is to select a suitable block of type from a magazine. Choose one printed on white paper, which will not offer too great a contrast with the bristol board. The size of the type should be at least 10 point—12 or 14 point would be even better, making the design of the face more evident. Do not cut very close to the type, at first.

Everyone will select a part of some story or article that is of interest to him. The next step lies in choosing a style of lettering for the headline or title that will add a certain further interest to the story and, at the same time, be stylisti-

cally suited to the type. The spot or illustration must be considered simultaneously. The best way of working is that suggested in the diagram. Graphic unity may be achieved by similarity or by contrast—depending to some extent on the style of type used; the diagram shows an effect of contrast based on Bodoni type.

It might be best to review the development of the headline, as described in Chapter X. Aside from such compelling factors as style, mood, and color, there are a few rules that govern the use of headlines in general. Scale is important; do not make headlines either too small or too large in relation to the size of the type in the text matter; they must dominate it, of course, but an error on the small side is the less offensive. Headlines should not be too curved or set at too great an angle or they become unreadable; a bit of curve or angle, though, gives the message emphasis. Often it is necessary to avoid monotony in a long headline by breaking it or putting one important word in capitals and the rest in lower-case or italics. In most instances, lettering must not cut into merchandise or the illustration; but is to be surrounded by its own necessary free area. Analyze current headline usage.

The choice of a design or illustration lies with the individual; it would, however, be best to make a flat design. Try, through the use of contrasted line weights, similar pattern, or overall tone, to produce a design that is in accord with the type and the headline.

Pasting in the type must be left until last—otherwise it will be soiled by working over it. The block of type may now be cut down carefully, close to the edge of the column. For this sort of paste-up rubber cement is best. Mark the position of the type with a pencil, as shown in the diagram. It must be square on the page. Both the board and the back of the clipping should now be given an application of cement; this must be thin and even. When both surfaces are dry, place the clipping in position carefully. One corner should be put down first; then the next; and, gradually, the whole clipping lowered into position. There must be no wrinkles. Place a clean piece of paper over the clipping and rub it down lightly. Excess cement may be removed with a pick-up, which is simply a little ball of dried cement.

This exercise is most useful in understanding the whole problem of integration. It should be done several times, using a different type each time—such as sans serif, contrast type, old-style, a gothic, etc. Either a formal or informal arrangement may be used. The business card design in Chapter XIII is an in-

Tracing paper.

Jamaica

"ISLAND OF SPRINGS"—
and rightly named, as there
are more than a hundred rivers
tumbling and splashing through
this garden paradise where sea
level temperatures the year
around average below 80° and
range to 56° at the mountain
peaks.

Kingston, the capital, is the
social center of the island, and
the Myrtle Bank Hotel, with
its lovely lawns and outdoor
pool, the natural rendezvous of
the aristocracy—traveler and
resident alike. English is spoken
everywhere and many marvel-
ous motor trips await you: Port
Royal, ancient buccaneer

14½"

Place clipping on board
under tracing paper —
work out headline and
spot by sketching freely
with pen or brush and ink.

11½"

Diagram of layout exercise
Headline and spot must be designed to harmonize with the type.

Draw lettering and spot
carefully, ink, and then
mount clipping.

The practical use of the layout exercise — sections of three pages from booklets designed by the author.

SO THIS IS JAMAICA!

Jamaica, where the cost of living is only a dollar a bottle!
"Lovely morning, sir!" The steward's dulcet tones break through
your slumbers; fragrant coffee and hot rolls bring you back to the

HE ORIENT IAL

c e

e is wealth, Commerce must
w.

259

formal arrangement. Such layouts are based on asymmetrical or dynamic balance. One may experiment with them by cutting a few simple geometric shapes of varying sizes from black and gray paper, and trying them in different positions and relations to one another, within a white rectangle.

Integrating the Headline:
The second page of illustrations suggests exercises that concern the suiting of the headline to the page. Beyond what has already been said about the headline, one must consider a number of rather elusive factors—such as period, pace, reading speed, impact, emphasis, and rhythm. These elusive characteristics of good lettering are not to be learned by doing a few exercises; skill in making use of them comes with experience. However, by working out a few headlines, such as the two shown at the top of the page, some understanding of the problem can be gained.

The first of these headlines suggests a period, that of the nineteenth century. It also has a certain gay quality. The initials were derived from a nineteenth-century ornamented type. In the second headline the intention was to suggest a festive mood. It is evident that the pace of this line is slower than that of the first; it is easy-going, rather placid. The florid initial is taken from a sixteenth-century set, by Cresci. Initials, used in this way, are the best means of creating a particular mood or suggesting a period. Never letter a whole headline in some unreadable period style; use an initial and keep the remainder of the line in a plain, readable letter.

As a further exercise—this to be connected with layout work—the problem of enlarging and rendering a headline from the layout may be tried. One may start with a rough layout of a one-column newspaper ad, as shown—without illustration or decoration beyond the lettering and the border. Such a border is useful in a small newspaper ad, to separate it from other ads or the news columns. Type need only be suggested by ruled lines; note, however, that the gray mass of type is enlivened by bold initials—these are of value in holding the reader, as well as relieving the monotony of the type. This layout may be based on actual dimensions, as indicated; and actual copy, which may be scanned and fitted. Copy-fitting is done exactly as explained in Chapter XII; the character-count procedure used in making the manuscript book is also used for setting copy in a given type within a definite area. It would be advisable to have such a small piece of copy

Gay Inheritance

holidays...

Use of initials to suggest period, mood, etc. — various experiments of this sort should be tried.

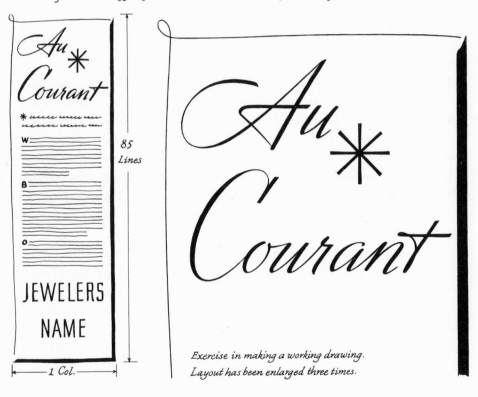

85 Lines

1 Col.

JEWELERS NAME

Exercise in making a working drawing.
Layout has been enlarged three times.

set, as a lesson in the actual practice of copy-fitting. There are various devices and systems to help the designer solve problems of copy-fitting quickly; these are all based on character count and need not be explained here.

Just as in the layout exercise, all of the elements—border, headline, type—must make an integrated whole. When a satisfactory rough has been obtained, make a comprehensive; this comprehensive must represent exactly the effect desired in the printed job. The finished drawing of the lettering and border may then be worked out.

Remember that in enlarging and rendering one always works with the purpose of getting precisely the result set down in the comprehensive layout. Look more closely into your work now for optical illusions of all kinds. Note, for instance, that oblique strokes often appear narrower, need a little fattening; and rounds, at their heaviest point, must be made a trifle wider than all other heavy strokes in order to satisfy the eye. Remember too, that neatness is one of the absolute requirements of professional work. Such a job as this, done to order, must be spotless, clean in technique—there should be no finger-marks, smears, etc.; it is best, also, to allow liberal margins around your work.

The Comprehensive Dummy:
The next page of illustrations provides a visual explanation of the procedure to be followed in making a comprehensive dummy for a booklet. This problem is much more complex than that of the single page or ad. Since the choice of material, the format, etc. will vary greatly, only a general discussion of the factors involved can be set down. All of the points that have been made concerning headlines, type, and pictorial elements must be taken into consideration; but not all of them are applicable to any one booklet. A job such as this must be thought of in very simple terms. The basic secret is to use a limited number of page arrangements; and obtain variety by a slight alteration of them.

It may seem peculiar that a problem like this is included in a book concerning letters; it is, however, just this sort of problem that the lettering artist needs to be able to cope with. He must understand, not merely lettering, but letters in their complete range of use. He is not a finished craftsman until he can do so; the true master knows, and can do, more than the job calls for.

Rough layouts may be planned on tracing paper or in a rough booklet; working in the actual format, however, gives a much better sense of fitness. It is diffi-

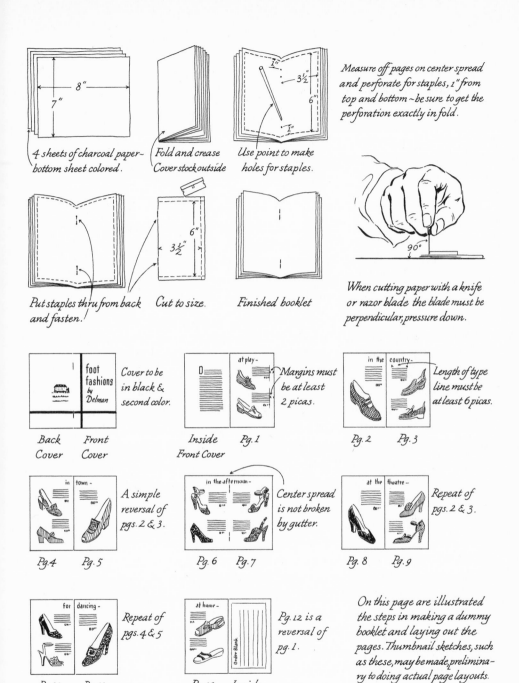

8"

7"

4 sheets of charcoal paper ~
bottom sheet colored.

Fold and crease
Cover stock outside

Use point to make
holes for staples.

1"

3½"

6"

1"

Measure off pages on center spread
and perforate for staples, 1" from
top and bottom ~ be sure to get the
perforation exactly in fold.

Put staples thru from back
and fasten.

Cut to size.

6"

3½"

Finished booklet

90°

When cutting paper with a knife
or razor blade the blade must be
perpendicular, pressure down.

foot
fashions
by
Delman

Cover to be
in black &
second color.

Back
Cover

Front
Cover

at play ~

Margins must
be at least
2 picas.

Inside
Front Cover

Pg. 1

in the country ~

Length of type
line must be
at least 6 picas.

Pg. 2

Pg. 3

in town ~

A simple
reversal of
pgs. 2 & 3.

Pg. 4

Pg. 5

in the afternoon ~

Center spread
is not broken
by gutter.

Pg. 6

Pg. 7

at the theatre ~

Repeat of
pgs. 2 & 3.

Pg. 8

Pg. 9

for dancing ~

Repeat of
pgs. 4 & 5

Pg. 10

Pg. 11

at home ~

Order Blank

Pg. 12 is a
reversal of
pg. 1.

Pg. 12

Inside
Back Cover

On this page are illustrated
the steps in making a dummy
booklet and laying out the
pages. Thumbnail sketches, such
as these, may be made, prelimina-
ry to doing actual page layouts.

cult to propose actual trade conditions; but something like these conditions should be maintained. A little book of this kind is usually a mailing piece; it has a selling job of some sort to perform—this is its chief function. Of course, under real working conditions a copy-writer would work out the headings; the general sales story would be thought out when the layout artist began his work—although, often, copy-writer and layout man work together. It is best, in this case, for the individual to work out his own sales story—some dominant idea that will follow through the booklet.

The merchandise must be considered along with the headlines. Usually it is best to group the major elements in some way. Regardless of the number of separate articles or pieces, try to arrange the facing pages—which must be worked as one layout—in as few groups as possible. Layouts should be simple, uncluttered. Descriptive type matter must be allowed for; sometimes it is possible to keep all descriptions in one place and use key numbers or letters to identify the merchandise. This will simplify the grouping. Of course, every set of facing pages except the middle spread has a gutter down the center, which limits the possibilities of the layout.

In preparing this dummy one ought to have expert supervision; so that individual problems can be analyzed, difficulties explained, etc. When the rough dummy—or tracing paper plan—has been checked and corrected, the comprehensive should be worked out, carefully and clearly. It need not be too finished; but it must give the appearance of the printed job that is being planned. The entire booklet should be a unit, each page seeming to belong where it is; the sequence ought to be interesting; no part must seem out of place or disconcerting.

Book Design:

The most difficult job of integration is a book design. Of course, the ordinary novel is not exactly a full problem; the text-book—full of illustrations, charts, and diagrams—presents by far the most difficult assignment. It is necessary for the designer to grasp the intention of the author and interpret it—using the graphic means at his disposal to do so. Where, in the field of advertising, he may make use of all sorts of graphic stunts and optical tricks, in book design he must not strongly interpose his individuality. The book requires dignity, unity, and interest throughout; but the hand of the designer must not be seen. Only those

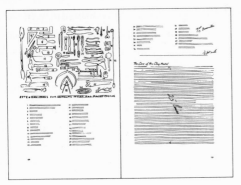
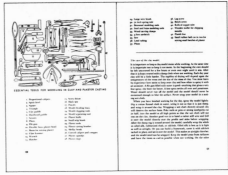
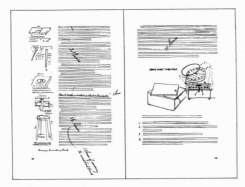

Dummy Pages · *Pages from finished book*

Comparison of dummy pages with finished pages ~ from a book designed by the author.
Pages are from "Zorach Explains Sculpture" by William Zorach.

who understand the finest points of page arrangement and type-setting will see the work of the designer. The ordinary reader will go cheerfully on his way without realizing what has been done to make his reading more pleasurable and effective.

The pages shown are meant as examples of how closely and carefully the designer has to work in arranging his material. Not every book is laid out as carefully as these dummy pages indicate; but in many cases some such dummy or plan has been made. The individual who has worked on several manuscript books and a few comprehensives will have a partial realization of what goes into the planning of a book. Format is to be determined; the type chosen; a character-count of the manuscript made; page and heading treatment decided; the text and illustrations skilfully interwoven.

Those among the readers who feel impelled to work at book design must be prepared to serve a long apprenticeship in designing with letters and type; they must also love books. It is noteworthy that most of the foremost book designers are gifted lettering artists or type designers; many of them are also highly competent in other branches of the fine and applied arts. The average book, however poor, represents an essay in culture; the book designer, to be really capable, needs to be a cultured individual. He can do much to make a book the well-designed, effective instrument of culture that it should be.

General Summary:

In this brief series of exercises and explanations most of the dominant points of designing with letters have been touched upon. The student will have to continue from this point to enlarge his own knowledge and experience. When he knows history and tradition, and has mastered the technique of his craft, he must, still, work in the world of his own generation. It will be impossible to dispense with tradition; but it should be quite apparent that one is working among one's fellow-men—not with the ghosts of the past nor, still less, with the spectres of an unpredictable future.

Perhaps the best way to prosecute this end is by collecting books and current material. The books should be good ones—well-designed, well-printed. A cheap, badly-designed, badly-printed book is a bad influence; one should not keep bad influences around. These books ought to be the best available, on all phases of designing with letters and type. A list of some worthwhile books is to be found in the bibliography.

Every lettering artist collects examples of current lettering, headlines, and the like. These collections, however, need to be renewed or changed every six months. It is not of any advantage to collect and keep thousands of pieces of "swipe" material. When something, for instance, has been used as a source of inspiration, it should be tossed out; it has served its purpose. Likewise, when material has been held for a long time and never seems to fit anything, it probably never will; its effect or influence has been assimilated anyway, most likely—get rid of it.

Study the material you collect for new and original conceptions; try to track them to their source; analyze them. In this way one works with living design—comparing the work that is now being done with tradition; and yet following, in a positive manner, the trend of graphic art. For one's own contribution, then, the most that can be done is to produce as sound a job as knowledge, taste, and skill will allow.

Chapter XVI.

Poster Design

Analysis of the Poster.

Poster design is a special problem of integration. What was said in the preceding chapter concerning integration in book design is, for the most part, also applicable to the poster. The functions, elements, essential characteristics, and factors of a poster may vary slightly according to the viewpoint one adopts; however, in contrast to the advertisement and the book page, the poster is not to be examined or read for any length of time at all. Its complete effect should be almost instantaneous. In that instant it should tell its story and leave with the beholder a compelling message. If it does not do this it is not a perfect poster, though there may be other interesting qualities about it, such as design, illustration, color, treatment, idea, etc. The reasons for any failure in this respect lie in unsuccessful integration within the special field of the poster. A brief analysis of poster design will explain most of the possible failures and, to some extent, how to avoid them.

Functions:

The primary function of a poster is to get attention. This function, however, is greatly limited by the second, which is to leave a message with the beholder that will make him react in the required way. Of necessity, this message must be clear, intense, precise. It is obvious that downright brutal attention-getting will often clash with this purpose; will, in fact, defeat it by leaving all manner of unpleasant associations. Both these functions are served by a number of characteristics or factors essential to good poster design. Fitness and selling power, which are sometimes regarded as among these characteristics, are really aspects of the two functions.

Elements:

The elements of a poster are, basically, just two: a design or illustration and a

slogan or short text. It is possible to produce a poster without any verbal message; one based on a design or illustration that is directly understandable—in a sense, a form of picture-writing, because everyone understands the message at a glance. But this is rarely done. Lettered or typographic posters—which dispense with illustration—are much more often used. Lettering is, generally speaking, the more important element in a poster. Several lettered posters have been discussed in the foregoing chapters. These were all based on formal design—on the symmetrical or central-axis tradition, in which all the lines are centered. The usual lettered poster of the present, however, must have an attention-getting quality that is only to be obtained by an informal scheme created by the letters themselves. This quality is only achieved through the dynamic arrangements of asymmetrical or occult design. But the traditional formats are not to be altogether discarded; they are often necessary in solving particular problems. The complete poster represents a unity composed of the two elements. When no part of either text or illustration can be omitted or shifted without spoiling the poster this unity has been achieved.

Essential Characteristics:
There are three characteristics or factors that are essential to a good poster. These are simplicity, unity, and surprise. The fulfillment of the functions of a poster and the proper handling of its elements depend on these factors. Writers on poster design generally list several characteristics besides the three here mentioned; some of these are really aspects of the functions, as has been noted already; and others are subordinate qualities of the three characteristics here given. These subordinate qualities will be considered in the following discussion.

Simplicity:
The most important factor in a successful poster is simplicity. It is the factor upon which the two functions most depend for fulfillment. Bold, simple design is the best means of attracting and holding attention. In order to obtain the sort of simplicity necessary, everything superfluous must be eliminated from the design. Emptiness, however, is not simplicity. All of the simplification—of the story, the action, the color, the treatment—must be realized with the greatest refinement and subtlety. There must be all possible economy in means and methods. A poster has to appeal directly to the senses, without any required

study or decipherment. Only then will the message be instantly understood and easily remembered. Such a simplicity, it is evident, has a many-sided meaning. To achieve it demands the greatest clarity of thought and precision of treatment.

Unity:

Unity is the characteristic which must be present in a poster if the elements are properly composed. These elements have to be in balance or equilibrium; the poster requires a well-organized design. Unity includes a number of subordinate qualities such as balance—balance of color, line, and tone; graphic unity, which is the correspondence of treatment, handling, or workmanship; and scale, which imparts a sense of largeness through suggestion and relative proportion. Simplicity may be said to serve, principally, the functions of the poster; in achieving unity, however, the concern is mostly with the elements.

Surprise:

The factor of surprise is one that is peculiar to poster design. Other problems of integration may have some of the poster characteristics; but only the poster must always be surprising. It needs a novel approach—interesting, attractive, unique. In some instances it also has the effect of shock. These qualities may appear in the idea, the design, or the treatment. Often the novelty will be produced by caricature, exaggeration, or humor. Again, it may be a dramatic or bizarre effect that is surprising. The characteristic of surprise is almost entirely devoted to serving the functions; it is this that attracts, and that compels a remembrance of the message. But, it must be handled with refinement and subtlety; it cannot be blatant or vulgar. The kind of surprise given will depend to a great extent on the fitness for the task of the particular poster; this fitness being an aspect of the functions.

History of the Poster.

A brief history of poster design—the art of the poster as it is often called—will be of considerable help to beginners. Although the modern poster had its start about 1866, the conception is much older. Some sort of announcements or placards must have been used in the earliest cultures. Since they would have been of an ephemeral nature, as is the modern poster, they have mostly disappeared.

One may start, however, with the Egyptians—whose paintings inspired one of the earliest and best of American poster artists, Edward Penfield. Anyone interested in poster design could do no better than to take a good, long look at the work of the Egyptians; their simplification is magnificent; their interweaving of text and illustration perfect; and they never destroyed the surface by attempted realism. One might look long and far to find better instructors in the decoration of the flat surface than the Egyptians. The line rendering of the grave stela of Ta-Baket-en-Khonsu will serve to illustrate what in many respects is a truly fine poster; although it was intended solely for use in the tomb of the Egyptian lady whose judgment before Osiris is there so graphically depicted.

All of the illustrations in this chapter are line renderings; in a sense, they are diagrams. These illustrate various characteristics of the poster and certain related subjects such as heraldry and symbolism. Insofar as possible, a poster has been included to represent each of the historical phases or the important points that are discussed. Actually, a good many excellent posters have been done simply in black and white. Color, which is a separate study, cannot be indicated here. As a matter of fact, color reproduction for the purpose of teaching color is usually most unsatisfactory. The whole problem of color should be experienced by working with color oneself.

To take a rather long jump, it may be mentioned next that theatrical posters were used in Japan during the thirteenth century. Similar work for the theatre was undoubtedly done in China at an even earlier date. All Japanese prints and decorative drawings reveal what might be called a natural poster-making ability. They all show great simplification and unity; and it is most noteworthy that the titles or mottos of the pictures are always an integral part of the whole design— the elements, that is, are excellently combined. This latter point is quite apparent in the accompanying illustration.

Early European Posters:

In Europe, there must have been posters for various purposes from a very early date. The whole system of heraldry, of course, with its highly simplified designs, its limitations, mottos, etc., is related to the poster in a very definite way; the devices on shields made it possible to tell instantly who their bearer was. Much of heraldry was symbolic; and both heraldry and symbolism can be extremely instructive to the designer of posters. Soon after the widespread development of

printing, posters and leaflets of one kind or another were printed and circulated. It is possible to record their use in a bishops' feud, for horse-races, lotteries, and for circuses and the theatre. Usually they were printed with large type or from woodcuts, mostly in black ink alone. From this early period until the nineteenth century the poster remained uniformly undistinguished. Certain posterlike signs for taverns or shops were perhaps of great interest; but there is not much left to look at. The usual printed poster was always a rather careless product, generally printed from large wooden type and with stock woodcuts.

An impetus was given to the development of the poster by the invention of lithography, which made possible much more interesting and individual drawing and lettering, directly on the lithographic stone. With the advent of chromolithography, or lithography in colors, the emergence of the modern poster could not be long delayed. In 1866, Jules Chéret, who is considered the creator of the modern poster, opened a lithographic printing establishment in Paris. The Paris school of poster artists developed from this beginning, reaching its finest production in the last ten years of the century. Out of it came such men as Henri de Toulouse-Lautrec and Théophile Alexandre Steinlen. Lautrec produced, between 1891 and 1901, some 31 posters, examples of which have now become collectors' prizes. By many he is looked upon as the greatest of poster artists—certainly he is the greatest of the Paris school. His work should be studied carefully by anyone who aspires to design posters. The integration of line, tone, and color is well-nigh perfect in most of it. Although it is sometimes a bit foreign- or dated-looking, the lettering is almost always well-placed and well-combined. It must be stressed that these posters make no pretense to realism; they are essentially two-dimensional; and have much about them that shows a strong interest in Japanese art—which was, consciously or unconsciously, one of the influences that acted upon Lautrec in the years when he was forming his style.

London:

The next area for consideration, historically, is England, where a group of most interesting poster artists made their appearance in London. The modern poster is fundamentally a product of the large urban centers of Europe, where a means of advertising with immediate appeal and effect had become a necessity. Posters became a definite part of the daily lives of the urban populations—part of their education and entertainment. Some of the English designers followed the

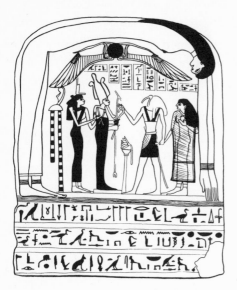

The grave stela of Ta-Baket-en-Khonsu ~
XXVI dynasty ~ 663-525 B.C. Study the composition ~
the use of hieroglyphs as part of the design.

A modern Japanese title-page ~ based on the
traditional theatre poster ~ note the complete
integration of text and drawing.

The earliest surviving dated poster.
Printed for an animal show in Geneva, 1625.
Typical of type and woodcut posters.

A typical Lautrec poster ~ rendered in line
for this reproduction ~ note the arrangement
of the black, grey, and white areas.

273

French; but the most important contributors were the "Beggarstaff Brothers," James Pryde and William Nicholson. These two men collaborated in producing a number of posters in which the arrangement of bold, flat areas was the most striking characteristic. Basically, they worked with strong, simple silhouettes. This method remains one of the most effective ways of handling the poster. It is, as a matter of fact, quite in keeping with most of the present-day theories and methods of treating the flat surface. Other noteworthy English designers of the period, the 1890's, were Dudley Hardy and Aubrey Beardsley. The former made a rather gay sort of poster, somewhat in the French manner; the latter is noted for his bizarre black-and-white treatments.

Central Europe:
The use of the poster was not neglected in the large cities of Germany and Central Europe. Germany, especially, adopted this medium, thereby developing a school of designers whose work is of the greatest interest to students of the poster. The illustration of Lucian Bernhard's poster for matches shows the characteristics that distinguish his work; extreme simplicity and careful composition. This was printed in 1905 and represents the earliest phase of his output in Germany. Ludwig Hohlwein, who started working a bit later than Bernhard, continued to produce his characteristic type of poster until quite recently—it is too dependent upon close tones and color to reproduce here. In contrast to the almost abstract quality of Bernhard, Hohlwein's posters were rather realistic and storytelling; they brought this kind of poster to its highest level of development.

It is hardly possible to show much of what was done in the various centers of Central Europe from 1900 to 1939. Notable posters were produced in Austria, Czechoslovakia, Hungary, Poland, and Switzerland. Whoever may wish to examine this work, of the period from the mid-1920's onward—European poster art in general, for that matter—is once again advised to look through the back-numbers of the magazine, *Gebrauchsgraphik*. Another publication, *Das Plakat*, will be a help to anyone interested in the earlier phases of Central-European poster design.

United States:
The processes for producing the modern poster reached our shores soon after they were invented and used in Europe; they were further developed and per-

Theatrical poster by the "Beggarstaff Brothers" ~ 1895
Study the disposition of areas - the effect of contrast.

An example of Edward Penfield's simple
style ~ a calendar-cover worked out in
a stencil effect.

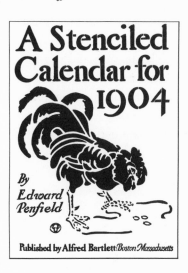

Order your coal
NOW
📢 Get it out of
Uncle Sam's way
—— he needs
the railroads
for the war

One of F. G. Cooper's posters ~ about 1917 ~
showing his typical layout and lettering.

The ultimate in simplicity - this Lucian Bernhard
poster should be studied for its arrangement ~
the original is in four flat colors.

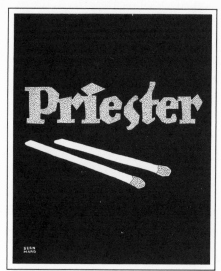

fected here; but the same may not be said for the art of the poster. However, from 1895 to about 1920 there were a few poster artists of great ability at work in the United States. These included such men as Will Bradley, Edward Penfield, F. G. Cooper, Adolph Treidler, and C. B. Falls. Bradley's work was based, to a great extent, on that of Aubrey Beardsley. The influence of Egyptian painting, with its definite outlines and simple, flat colors, upon the posters of Edward Penfield has been noted. F. G. Cooper is important in his frequent use of the lettered poster; he produced a great many amusing and flippant lettered posters in his highly personal style. In these posters he employed lower-case letters; it was he who had much to do with the change from capitals to lower-case in headlines. Treidler worked in broad, flat areas and achieved some very fine results. Falls favored a heavy outline and a broad treatment, coupled with a great simplification of his subject matter. All of these men, excepting F. G. Cooper in his lettered posters, may be said to have worked in a somewhat realistic way; but they were, one and all, genuine poster artists as distinct from the many artists and illustrators of the time who tried to do posters.

It should be pointed out here that just as poster design is a special problem of integration, so the poster artist must possess special talents; artists like Lautrec, Hohlwein, and Penfield, to mention three at random, are definitely poster artists. It would seem that to design posters requires specialized abilities; it is not every artist who can perform the peculiar conceptual process of good poster design, with its simplification and special organization. For one thing, the poster artist must know how to letter—at least well enough to use letters freely as design; and that means quite well indeed. If he cannot do this there is little chance that he can design a perfect poster—the integration of text and design or illustration will never be good enough. During the recent war the government attempted to produce War Bond posters by the expedient of commissioning painters and illustrators to make pictures and then having the text or slogan lettered in later—in some open spot, over or under the picture, sometimes across a portion of it. Posters simply cannot be made in this way; and in almost every instance where this procedure is resorted to the result will be unsatisfactory. The poster must be the conception and work of one creative personality; it cannot be manufactured, by having various people work out different parts of it.

Poster Design of the Present:
It is generally agreed that poster design at the present time is on a more or less

An example of humor ~ Helmut Beyer's poster for
a soap powder ~ done in the late 1930's in Germany.

A poster by Fortunato Depero ~ one of Italy's futurist
designers ~ note treatment of letters.

Abstraction, symbolism, asymmetry ~ a poster for
athletic games by Erich Murcken ~ Germany, 1930.

The novel point~of~view ~ a Hungarian poster
by George Nemes ~ done about 1930.

277

international basis. In many instances, were it not for the language, it would be difficult to tell whether a poster had been made in America or in Europe. Two trends have always been present in poster design: the first is what may be called variously, abstract, non-representational, concrete—it has made use of many of the optical theories and surface-design ideas of present-day painting as developed from the early 1900's onward; the second is more or less realistic in its presentation of the material of the poster—it uses many of the methods of traditional representational painting; the poster remains, nevertheless, a surface arrangement through careful area dispositions and expert manipulation of tones and colors. Of course, neither of the approaches is to be found in a pure state; they tend to merge; and sometimes one or the other will predominate in an individual's work. There is much that is abstract in the posters of Lautrec or Hohlwein; and there is much of representation which creeps into the posters of non-representational designers. The two approaches to the problem are quite apparent—especially in the United States, where a certain type of realism has been carried to the extreme. In general, this sort of realism may be accepted as the indication of an inartistic period; realism, as it is often practiced in American advertising and poster design at the present time, is banal and tiresome; it is definitely a bore to any but the most unimaginative, uncreative people. Unfortunately, this type of poster may be said to be typically American just now; it is to be found nowhere else in quite this extreme development. The poster based on great simplification, abstraction, symbolism, non-representational design, etc. looks, in the United States, very much like the same sort of poster in Europe. Symbolism is not as much used in the United States as in Europe; but many American designers have handled symbols most effectively. In this respect they have been paced by a number of European-trained artists who have contributed greatly to a revival of good poster design in America.

One should be somewhat familiar with the intentions, the underlying theories, of present-day painting in order to appreciate fully much of our poster design. This, of course, is not obligatory; any good poster—or work of art, for that matter—explains itself quite completely, without benefit of theories or verbal exposition. It must be realized, however, that the entire traditional conception of a painting—which was the product of the Renaissance and of later developments—has been abandoned for an approach that is more direct, more dynamic, more suited to our own times. There is no intention here of doing more than to

Letters as decoration ~ a catalog cover for a book-design exhibition ~ by Hans Bohn ~ early 1920's.

A leaflet cover designed by the author ~ done in poster style ~ use of symbolism.

Four examples of the use of letters in posterlike work.

A hotel label ~ designed entirely with type material ~ constructivist influence.

A book jacket done by the author ~ book jackets are really small posters ~ letters suggest flight.

suggest that the individual investigate this approach himself; much of it, of course, is experimental—there has been a great deal of confused and muddled work—but there are new visual factors and many really fresh and amusing design possibilities, which can only be worked out from this new point-of-view. There are many poster artists doing excellent work based on these new concepts of vision and design; it is not possible to mention all of them, but the work of A. M. Cassandre, E. McKnight Kauffer, Paul Rand, Lester Beall, and Joseph Binder is worth studying.

Notes on Poster Design.

It is not possible to set down sure-fire formulas for designing posters. The designer must first analyze his problem; must divest it of all incidental or unnecessary details; and discover for himself the simplest manner in which this problem may be made understandable to an all-inclusive public. After this has been done —with or without preliminary sketches or notes—one may proceed with the actual design of the poster. The first step, then, is to translate this basic idea or conception into a visual form that can be easily and instantly understood by the average onlooker. Consider the traffic signs in the illustration; a good poster must be just as easily comprehended, just as forceful.

Rough Sketches:
It may be necessary to make quite a number of rough sketches in order to translate a conception into its best visual form. The design is not likely to be clear and concise in the first trial; although it can happen. Usually, one must alter and adjust the units from sketch to sketch, until the arrangement is balanced, agreeable to look at, clear, and forceful. These first roughs may be one-quarter the final working size; if the poster is to be in color, these sketches should be in color from the start. The beginner ought not to try to make pencil sketches and then recast them in color, or even black and white. As has been said before: the beginner does not have enough experience with the various techniques to do this; as a matter of fact, it is foolish for anyone to try it. Sketches should always be done in the technique and with the materials that approximate the appearance of the final rendering. When this small rough has been worked out, a final rough about half the size of the finished poster design should be made. All the details of the

*A magazine cover — the dramatic silhouette
was actually a photograph.
Study the line and area arrangement.*

*A theatrical poster by the author —
used also as a leaflet cover.
Note the crayon treatment of the drawing.*

*Diagram of a poster by A.M.
Cassandre — note the symbolic
handling of the idea of going
forward, of progress.*

design need to be carefully calculated in this final rough; so that the finished design may be enlarged from it without very much readjustment. It is always best to cut poster sketches to correct proportions; do not leave extra white paper around them and rely on a line to control the edge; only the proximity of the actual edge will give the correct feeling for the arrangement of the surface.

Composition:

The way in which all areas and the main lines of a poster are related to one another is composition. In planning the poster, one tries to achieve the essential characteristic of unity—a balance of the elements, a proper handling of the units at one's disposal. It is well to know theories of balance, dynamics, composition, and the like; but it must be remembered that no genuine work of art was ever produced by a theory. Look at these heraldic charges, early trade-marks, and the magnificent Chinese symbol, "The Great Monad"; and try to work out your poster just as simply and directly, within the given size. To understand relationships it would be well to make little sketches such as the two suggestions given. Try them in many different ways, with all sorts of symbols and elements. These are exercises; and should be used as such. The employment of bits of paper, cut into shapes, has been mentioned earlier in the book. It will be found that the exercises are visually amusing and highly instructive. Do not become too theoretical or serious about them. The pattern must always have simplicity, unity, and a certain aspect of surprise.

The eye cannot hold more than four or five units in its field of attention; an arrangement of three units is best for beginners. If the problem has more than three elements, several of them may be grouped to form a single unit. This grouping entails the touching, overlapping, or interpenetration of these elements—a somewhat difficult organizational problem; one which easily leads to confusion. The poster must have an area of dominant interest to which the eye is always directed. To accomplish this, all sorts of pointing devices or line connections—both visible and invisible, or understood—may be used.

The choice of black-and-white poses the simplest, but also the most severe, of design problems. It would seem best, however, to make several simple posters in black-and-white before working with intermediate tones. A poster may be light on dark or dark on light; look at the examples of countercharging in the illustrations; note how this principle was utilized by the Beggarstaff Brothers.

Crossroads

Sharp Curve

Caution

Railroad Crossing

A poster should be as directly understandable as these traffic signs.

Chevron

Cross Quarterly Countercharged

Gyronny of six

Bendy Pily

A poster should be designed as simply and effectively as these heraldic charges.

Peter Vischer

Hans Burgkmair

Michelangelo

A Merchant's Mark

A poster should be as distinctive and recognizable as these early trade- and house-marks.

The Great Monad

Wave motive countercharged

Exercise suggestions

A page of suggestions concerning directness, simplicity, and clarity.

Between black and white the eye can distinguish some twenty-five different tones; but it is certainly not advisable to combine many of them—otherwise the poster will not carry well; the elements or units tend to merge and blur. Try introducing a middle tone of gray, between the black and white; then increase the number of values to five, by inserting one other between each of these three. From this stage of work one may proceed to the use of color. The simplest rule to observe in all of this work is to avoid an even distribution of tone or color.

Color:

There are quite a few theories of color—for the most part of little value to the designer, who must work with pigments, colored papers, or printing inks. It is fine to know color theories; but the only helpful understanding of color comes from working directly with colors and experiencing the visual sensations of them as they are applied. For the designer, one color may be lighter or darker than another; it may be warmer or colder; or it can be a purer color as compared to a blended or grayed one. These three classifications give one a threefold system of comparing and arranging colors; it is simple and really practical. Under actual working conditions the effect of every color is subject to the influence of its surroundings; there is no theory which will predetermine this effect; the only way to understand it is to test it. The simplest method of doing so is to mix a tempera color and paint similar squares of it on black, white, and colored papers; it will seem as though different shades or mixtures of color had been used. When these possible influences on the color are appreciated in their infinity, the way is open for a genuine understanding of the use of color. The beginner should make a good many experiments—balancing color against color and trying color upon color. He will start to understand the aggressive and recessive qualities of certain colors, as well as various contrasts that create tension or a restful effect; their possibilities under varying conditions and in varying arrangements will become apparent. Such an understanding is extremely useful in poster design. What one must attain is an almost unconscious sureness in determining and handling color; then one will work according to the dictates of one's own creative powers; and not on theories.

The Finished Poster:

The final drawing for a poster design should be enlarged carefully from the final rough sketch. It is best to do this on tracing paper; everything can be carefully

ABCDEFGHIJKLMNOPQRST
abcdefghikmnopqrstuvwxyz
Palermo · Venezia · Marseille

Kabel Black — designed by Rudolf Koch — Stempel foundry.

abcdefghijklmnopqrst
ABCDEFGHIJKLMN
uvw1234567890xyz
OPQRSTUVWXYZ

Futura Black — based on a stencil letter — Bauer foundry.

abcdefghijklmnopq
ABCDEFGHIKLMN
rstuv 1346780 wxyz
OPQRSTUVWXYZ

Beton Extra Bold — designed by Heinrich Jost — Bauer foundry.
Three type designs which may be used as the basis for poster lettering.

worked out; any adjustments can be made; the procedure is the same as that given for the built-up lettering problems. Practically all posters are done with tempera colors; it is necessary to understand the use of these tempera or opaque colors quite well before starting on a poster; the beginner should have had sufficient preliminary training in the use of such color. All material should be kept neat and clean—not to the point of exaggeration; but as much as is necessary to prevent accidents and sloppiness. Don't foul your colors by sticking a brush full of one color into a jar of another. Use a clean palette knife to take color from the jars. Some designers believe it is best to start laying in the lightest color and to continue with darker colors, to the darkest. This has the advantage of preventing "bleeding," which often happens when a light color is applied over, or next to a dark color that has an aniline dye content. Learn to establish and keep the proper consistency in the color; brush it on smoothly and evenly so that there are no ridges or bare spots. Tempera should cover the ground completely and dry with a smooth, velvety surface. Tempera may also be used in an air-brush; it must, however, be a well-ground color—not ordinary poster paint—or it will clog the brush. The use of the air-brush is a special technique, which cannot be explained here. It requires considerable practice and skill to manipulate one, and it is not recommended for beginners. Various effects related to air-brush treatment may be obtained by spattering, stippling, or sponging.

Poster Lettering:
The three examples of type faces illustrated will serve as excellent styles to follow in lettering posters. Any kind of lettering may be used, however, as long as it carries well and conveys the message. Often, when the artist is to invent the slogan, the entire plan of the poster may be built around the lettering. Think of the letters from the standpoint of design; and it will help in making them an integral part of the whole. It may be pointed out here that the average passerby will not read more than some seven words on a poster. Do not resort to so-called mechanical letters; no part of design should be mechanical; good lettering cannot be based on the use of compasses and ruling pens. If one can really draw, it is possible, with some application, to letter also. Letters may be adjusted to the design by changing their size, weight, shape, or color.

Reproduction:
Most posters are reproduced by lithography. In this process the poster is generally

photographed for color separation and the color negatives are worked over by technicians to achieve—in the reproduction—as nearly as possible, the effect of the original drawing. Very large posters are often drawn and rendered upon the reproduction surfaces by lithographic artists, who, again, try to retain the exact quality of the original in the large-size. In most schools, however, any poster reproduction will be done either by stenciling or the silk screen process. A poster, to be reproduced by these methods, must have been done in flat colors. The example of Edward Penfield's work shows a stencil technique; Futura Black is a stencil letter. In cutting stencils, little connectors have to be left to support parts of the stencil that would otherwise drop out. The silk screen process is more complicated—requires a considerable training to be used properly. Many schools have silk screen equipment, however, and can make excellent use of it in providing posters for various school activities. The process is widely used commercially and provides an excellent introduction to the various problems of reproduction.

Educational Value:
Poster work is excellent training in many different ways. It requires exacting use of drawing, of lettering, and of color. Beyond this, the analysis and simplification of the problem demand considerable clarity and precision of thought. Finally, the whole problem of selling or getting attention helps to develop a certain knowledge of human behavior, which is a valuable addition to any program of education.

Bibliography

In preparing this book it was necessary to read and analyze a considerable number of books about letters and types. From among these books the following list has been compiled. A brief note has been added, in certain instances, as a guide. The only order of listing, beyond the categories, is similarity of language or content.

Palaeography and History:

DIE SCHRIFT In Vergangenheit und Gegenwart, by Hans Jensen, Verlag von J. J. Augustin, Glückstadt und Hamburg. *This is an eclectic palaeography, upon which the statements concerning the early history of our alphabet were based.*

A HISTORY OF THE ART OF WRITING, by William A. Mason, The Macmillan Company, New York, 1928.

DIE SCHRIFT Atlas der Schriftformen des Abendlandes vom Altertum bis zum Ausgang des 18. Jahrhunderts, by Hermann Degering, Verlag von Ernst Wasmuth, Berlin. *There were editions of this work in English and French; text, however, is unimportant —it is a large picture-history.*

GESCHICHTE DER SCHRIFT IN BILDERN, by Jan Tschichold, Holbein-Verlag, Basel, 1946 *This is also a picture-history.*

GESCHICHTE DER ABENDLÄNDISCHEN SCHREIBSCHRIFTFORMEN, by Hermann Delitsch, Karl W. Hiersemann, Leipzig, 1928. *A history of the writing styles of western culture.*

RUDOLF VON LARISCH und die Entwicklung neuer deutscher Schriftkunst, Verlag für Schriftkunde Heintz & Blanckertz, Berlin-Leipzig, 1939. *This is one of a series of six monographs devoted to Edward Johnston, Anna Simons, Johannes Boehland, R. V. Larisch and Rudolf Koch; one issue concerns lettering in architecture.*

THE VIKING AGE The early History, Manners, and Customs etc., by Paul B. Du Chaillu, Charles Scribner's Sons, New York, 1890.

THE BOOK OF KELLS, described by Sir Edward Sullivan, The Studio Ltd., London, 1933.

ILLUMINATION and its Development in the Present Day, by Sidney Farnsworth, George H. Doran Company.

PENNSYLVANIA GERMAN ILLUMINATED MANUSCRIPTS, by Henry S. Borneman, published as Volume 46 of the proceedings of the Pennsylvania German Society, Norristown, Pa., 1937.

288

SPECIMENS OF SIXTEENTH-CENTURY ENGLISH HANDWRITING, by Cyril Bathurst Judge, Harvard University Press, Cambridge, Mass., 1935.

PENMANSHIP of the XVI, XVII & XVIIIth Centuries, a series of typical examples from English and Foreign Writing Books selected by Lewis F. Day, B. T. Batsford, London.

MEISTER DER SCHREIBKUNST aus drei Jahrhunderten, by Peter Jessen, Julius Hoffman, Stuttgart.

THE PRACTICE OF TYPOGRAPHY A treatise on the processes of type-making, the point system, the names, sizes, styles and prices of PLAIN PRINTING TYPES, by Theodore Low De Vinne, the Century Co., New York, 1899. *An interesting study of typography, especially American typography at the turn of the century. This book was published again in 1914 under the title,* Plain Printing Types.

A TREATISE ON TITLE PAGES, by Theodore Low De Vinne, the Century Co., New York, 1902.

PRINTING TYPES Their History, Forms, and Use, by Daniel Berkeley Updike, Harvard University Press, Cambridge, 1927. *Students should note the numerous corrections in later editions.*

CATALOGUE OF SPECIMENS OF PRINTING TYPES by English and Scottish Printers and Founders, 1665–1830, compiled by W. Turner Berry & A. F. Johnson, with an introduction by Stanley Morison, Oxford University Press: Humphrey Milford, London, 1935.

NINETEENTH CENTURY ORNAMENTED TYPES AND TITLE PAGES, by Nicolette Gray, Faber & Faber Ltd., London, 1938.

WILLIAM MORRIS Designer, by Gerald H. Crow, The Studio Ltd., London, 1934.

LETTERING OF TODAY, edited by C. G. Holme, The Studio Ltd., London, 1937–41–45. *A collection of essays on Edward Johnston, Rudolf von Larisch, calligraphy, lettering in book production, lettering in association with architecture, and lettering in advertising.*

THE FLEURON, Volumes 1 to 7, edited by Oliver Simon and Stanley Morison, London, 1923–30. *An important set of journals for those who wish to check developments in bookmaking and typography between these years.*

History of the Book:

SCHRIFT UND BUCH, by Eberhard Schmieder and Ernst Kellner, L. Staackman Verlag, Leipzig, 1939. *A delightful illustrated treatise; knowledge of the language is not essential.*

THE BOOK The Story of Printing and Bookbinding, by Douglas C. McMurtrie, Oxford University Press, New York, 1937. *Earlier editions were called* The Golden Book.

LE LIVRE Son Architecture Sa Technique, by Marius Audin, Les Editions G. Crès et Cie, Paris, 1924.

L'ART DE L'IMPRIMEUR 250 reproductions des plus beaux specimens, by Stanley Morison, printed in England for Librairie Dorbon-Aîné, Paris, 1925. *There is an English edition of this book. Since the book consists entirely of reproductions—there being just a one-page introduction—language is unimportant.*

AVENTUR UND KUNST Eine Chronik des Buchgewerbes von der Erfindung der beweglichen Letter bis zur Gegenwart, by Konrad F. Bauer, Privatdruck der Bauersche Giesserei, Frankfurt a. M., 1940.

Roman Capitals:

FRA LUCA DE PACIOLI OF BORGO SAN SEPOLCRO, by Stanley Morison, the Grolier Club, New York, 1933.

THE TRAJAN CAPITALS The Capitals from the Trajan Column at Rome, by Frederic W. Goudy, Oxford University Press, New York, 1936.

THE ROMAN ALPHABET and Its Derivatives, by Allen W. Seaby, B. T. Batsford Ltd., London, Charles Scribner's Sons, New York, 1925.

ROMAN LETTERING A study of the letters of the inscriptions at the base of the Trajan column, with an outline of the history of lettering in Britain, by L. C. Evetts, A.R.C.A., Pitman Publishing Corporation, New York–Chicago, 1938. *This seems the best of these books—useful to those who wish to understand the fine points of the Trajan letters.*

Initials:

DIE SCHÖNE INITIALE in mittelalterlichen Handschriften, Die Bücher der Eiche, Paris, 1943.

THE HANDBOOK OF MEDIAEVAL ALPHABETS AND DEVICES, by Henry Shaw, published by Henry George Bohn, London, 1856. *Excellent reproductions—good reference book.*

INITIAL LETTERS, by Douglas C. McMurtrie, Bridgman Publishers, 1928.

ALPHABETS OLD AND NEW For the use of craftsmen, with an introductory essay on the "Art of the Alphabet," by Lewis F. Day, B. T. Batsford Ltd., London; Charles Scribner's Sons, New York, 1910.

Handbooks and Manuals:

ORNAMENTAL PENMANSHIP A series of analytical and finished alphabets, by George J. Becker, Uriah Hunt & Son, Philadelphia, 1854. *This book and the two following, must suffice as reminders of the mass of books on handwriting, engrossing, engraving, flourishing, etc. which were used during the latter part of the nineteenth century.*

290

COPLEY'S PLAIN & ORNAMENTAL STANDARD ALPHABETS A set of Alphabets of all the various hands in modern use, by Frederick S. Copley, Excelsior Publishing House, New York, 1877.

GEMS OF FLOURISHING, by C. P. Zaner, Zaner & Bloser, Columbus, Ohio, 1888.

ALPHABETS A manual of lettering for the use of students, with historical and practical descriptions, by Edward F. Strange, George Bell and Sons, London, 1898. *Still useful as a reference.*

LETTERS AND LETTERING A treatise with 200 examples, by Frank Chouteau Brown, Bates and Guild Co., Boston, 1902. *Useful as a reference.*

THE SIGNIST'S MODERN BOOK OF ALPHABETS Plain and ornamental, ancient and mediaeval, etc., by F. Delamotte, Frederick J. Drake & Co., Chicago 1906. *This book is a collection of odd alphabets, of nineteenth century letters especially..*

UNTERRICHT IN ORNAMENTALER SCHRIFT, by Rudolf von Larisch, Staatsdruckerei, Vienna, 1905.

WRITING & ILLUMINATING & LETTERING, by Edward Johnston, Sir Isaac Pitman & Sons, Ltd., London, 1906.

THE ESSENTIALS OF LETTERING A manual for students and designers, by Thomas E. French and Robert Meiklejohn, McGraw-Hill Book Co., New York, 1912. *Some of the text may still be of interest to teachers.*

LETTERING, by Thomas Wood Stevens, The Prang Company, 1916. *Page alphabets by various 1916 craftsmen.*

DECORATIVE WRITING and arrangement of lettering, by Prof. Alfred Erdmann & Adolphe A. Braun, Hutchinson & Co., London, 1921. *The text is worth reading, especially for teachers.*

P'S AND Q'S A Book on the Art of Letter Arrangement, by Sallie B. Tannahill, Doubleday, Page & Co., Garden City, New York, 1923. *Much of the material is outdated and unprofessional but there is still a useful message for teachers.*

THE ART OF LETTERING, by Carl Lars Svensen, D. Van Nostrand Co., New York, 1924. *Some interesting work of the 1924 period gives this work a limited reference value.*

MODERN LETTERING, edited by Herbert Hoffman, published by William Helburn, New York. *This book was printed in Germany—contains many examples of German types and graphic art.*

THE ANATOMY OF LETTERING, by Warren Chappell, Loring & Mussey, Inc., New York, 1935. *A book with definite usefulness to beginners; it is based on Rudolf Koch's* Das Schreibbüchlein.

LETTERING A Handbook of Modern Alphabets, by Percy J. Smith, Oxford University Press, New York, 1936. *It deals entirely with freely-written pen or brush letters.*

THE SCRIPT LETTER Its Form, Construction and Application, by "Tommy" Thompson, Studio Publications, New York, 1939.

THE ELEMENTS OF LETTERING, by John Howard Benson and Arthur Graham Carey, John Stevens, Newport, R.I., 1940.

A HANDBOOK ON LETTERING, by J. Albert Cavanagh, published by the author, copyright 1939. *No history—pages of alphabets—practical points for advanced students.*

AN ALPHABET SOURCE BOOK, by Oscar Ogg, Harper & Brothers, New York, 1940. *This is a book which leans very much toward the calligraphic side—lettering judged strictly as writing.*

SCHRIFTKUNDE, SCHREIBÜBUNGEN UND SKIZZIEREN FÜR SETZER, by Jan Tschichold, Benno Schwabe & Co., Basel, 1942.

ON TYPE FACES Examples of the use of type for the printing of books, introductory essay and notes by Stanley Morison, published jointly by The Medici Society and The Fleuron, London, 1923.

TYPE DESIGNS OF THE PAST AND PRESENT, by Stanley Morison, The Fleuron, London, 1926. *This is a small book—excellent for the beginner.*

A DICTIONARY OF MODERN TYPE FACES, by William Longyear, Bridgman Publishers, 1936. *This is a type specimen book; it has been republished several times.*

TYPOGRAPHER'S DESK MANUAL, by Eugene de Lopatecki, the Ronald Press Co., New York, 1937.

LAYOUTS AND LETTERHEADS, by Paul Carlyle and Guy Oring, foreword by Herbert S. Richland; McGraw-Hill Book Co., New York, 1938.

LAYOUT IN ADVERTISING, by William A. Dwiggins, Harper & Brothers, New York, 1928.

ADVERTISING LAYOUT AND TYPOGRAPHY, by Eugene de Lopatecki, the Ronald Press Co., New York, 1935.

LAYOUT, by Charles J. Felten, published by the author, New York, 1947.

Aesthetics and Criticism:

TYPOGRAFIE ALS KUNST, by Paul Renner, published by Georg Müller A.G., Munich, 1922.

MECHANISIERTE GRAFIK Schrift–Typo–Foto–Film–Farbe, by Paul Renner, Verlag Hermann Reckendorf, Berlin, 1930.

TYPOGRAPHISCHE GESTALTUNG, by Jan Tschichold, Benno Schwabe & Co., Basel, 1935.

LANGUAGE OF VISION, by Gyorgy Kepes, Paul Theobald, Chicago, 1944.

THOUGHTS ON DESIGN, by Paul Rand, Wittenborn and Company, New York, 1947.

THE NEW VISION Fundamentals of design, painting, sculpture, architecture, by L. Moholy-Nagy, W. W. Norton & Company, New York, 1938.

Posters:

POSTER PROGRESS, introduction by Tom Purvis, R.D.I., edited by Frank Alfred Mercer and W. Gaunt; The Studio Ltd., London.

MAKING A POSTER, by Austin Cooper, The Studio Ltd., London, 1938.

POSTER DESIGN A Critical Study of the Development of the Poster in Continental Europe, England and America, by Charles Matlack Price, published by George W. Bricka, New York, 1922.

PLANNING AND PRODUCING POSTERS, by John de Lemos, the Davis Press, Worcester, Mass., 1943.

Index

294

298